PALETTE
mini
NATURE

Published and distributed by
viction:workshop ltd.

viction:ary™

viction:workshop ltd.
Unit C, 7/F, Seabright Plaza, 9-23 Shell Street,
North Point, Hong Kong SAR
Website: www.victionary.com
Email: we@victionary.com
 @victionworkshop
 @victionworkshop
Bē @victionary
 @victionary

Edited and produced by viction:ary

Creative direction by Victor Cheung
Book design by viction:workshop ltd.
Typeset in NB International Pro from Neubau

Second Edition

ISBN 978-988-75665-8-8
Printed and bound in China

PREFACE

According to the Cambridge Dictionary, the word 'palette' may refer to the range of colours that an artist usually paints with on a canvas. Today, however, more than just the primary means of creative expression for wielders of the physical brush, its role has expanded to include that of an important digital tool for crafting meaningful solutions in design. On top of manifesting pure works of the imagination as it has always done, the palette has become a purveyor of infinite visual possibilities with the power to bridge art and commerce. Since the release of its first edition in 2012, viction:ary's PALETTE colour-themed series has become one of the most successful and sought-after graphic design reference collections for students and working professionals around the world; showcasing a thoughtful curation of compelling ideas and concepts revolving around the palette featured. In keeping with the needs and wants of the savvy modern reader, the all-new PALETTE mini Series has been reconfigured and rejuvenated with fresh content, for all intents and purposes, to serve as the intriguing, instrumental, and timeless source of inspiration that its predecessor was, in a more convenient size.

INTRO

Nature's palette is as evocative as they come. When one thinks of its colours, the verdant greens and earthy browns of lush forestscapes or the undulating blues of the ocean often come to mind — soothing to the eye yet stimulating to the soul. Beyond the wider natural settings, there are also many subtleties and variations to be found in the little details through the minerals, plants, and living creatures that make up our world. Combined with their textures and materiality, they form the visual richness we appreciate as humankind.

For artists and designers, there is much inspiration to be gleaned within the spectrum of nature and its universal appeal, informing and moulding their works in infinite ways. Whether they are visual identities or sculptures that carry a message, these works have a timeless quality that are both meaningful and appealing. For example, Ava Victoria's designs for Earth Forms mix paper swatches with a purpose, as she puts transparent, metallic, and textured materials together in creating its product catalogue to mimic nature's organic rawness — in line with the pottery studio's name and products themselves (PP. 138–143). Coupled with a die-cut silhouette of the brand logo and muted natural tones, the outcome complements Earth Forms' clay, stone,

and fine china pieces perfectly. Similarly, .Oddity Studio's project on PP. 010–015 artfully and aptly reflects the mission of Substance in championing sustainability through food. Underlined by a clean visual language which includes simple illustrations of featured ingredients, the team's use of materials for its brand collaterals, such as name cards that grow into basil plants, serve to leave a lasting impression in an often-gimmicky industry. Demonstrating an understanding of this, award-winning studio Masquespacio sought to create an all-encompassing experience for Living Bakkali (PP. 596–605). In reflecting the meaning behind the restaurant's name, the team sought to design a space that immerses diners in a memorable sensorial journey, drawing its concept from the most profound part of the dessert to transport them into a mystical and magical realm beyond its cuisine. The restaurant's interiors feature a neutral palette with touches of contrast in reminiscence of the Middle East, with cosy dining enclaves tucked behind curved walls built by hand as a tribute to architecture in the region from the past.

 Over the recent years, the rise in consumerism and our fast-paced world have become an impetus for artists and designers looking to push their creative boundaries. For the former, they

are able to provoke audiences into re-evaluating their lives while holding a mirror up to society; while for the latter, to help their clients stand out on the shelves, they are having to express brand essences in an authentic manner to attract customers who are more discerning than ever today. Lyon and Lyon's work on Fabricá, a new haircare concept specialising in thin and thick hair is a testament to this (PP. 412–417). On top of using thick or thin lines to reflect the hair type the product caters to on the bottles themselves, the pastel tones chosen symbolise the products' gentle formulations and healing properties — making them more attractive to a health-conscious audience. Natural forms and elements were also an inspiration for Nastya Didenko in her 'Things I Left Undone' digital photography series on PP. 556–565. By placing stones, soil, wood, and plants into sculptural forms and totem-like compositions against dim lighting, she created a sense of tension that mirrors the struggles creatives often have when executing a project, whether it be due to lack of time, laziness, or financial inexpediency, resonating with audiences on a deeper level.

Big or small, projects that feature nature's powerful palette are bound to flourish in the deft hands of the creative who brings them to life.

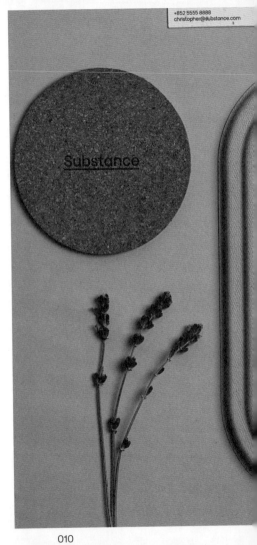

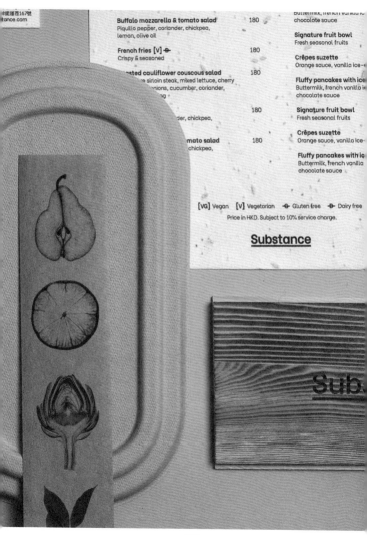

Buffalo mozzarella & tomato salad 180
Piquillo pepper, coriander, chickpea,
lemon, olive oil

French fries [v] 🌾
Crispy & seasoned 180

Buttermilk, french vanilla ic
chocolate sauce

Signature fruit bowl
Fresh seasonal fruits

Crêpes suzette
Orange sauce, vanilla ice-

Fluffy pancakes with ice
Buttermilk, french vanilla i
chocolate sauce

...sted cauliflower couscous salad 180
...e sirloin steak, mixed lettuce, cherry
...nions, cucumber, coriander,
...ng

...der, chickpea, 180

Signature fruit bowl
Fresh seasonal fruits

Crêpes suzette
Orange sauce, vanilla ice-

...mato salad 180
chickpea,

Fluffy pancakes with ic
Buttermilk, french vanilla
chocolate sauce

[VG] Vegan **[V]** Vegetarian 🌾 Gluten free 🥛 Dairy free

Price in HKD. Subject to 10% service charge.

Substance

Sub.

Savoury

Spicy Thai beef salad
Sliced rare sirloin steak, mixed lettuce, cherry
tomato, red onions, cucumber, coriander,
spicy thai dressing

Roasted cauliflower couscous salad
Sliced rare sirloin steak, mixed lettuce, cherry
tomato, red onions, cucumber, coriander,
spicy thai dressing

Quinoa salad
Piquillo pepper, coriander, chickpea,
lemon, olive oil

Buffalo mozzarella & tomato salad
Piquillo pepper, coriander, chickpea,
lemon, olive oil

French fries
Crispy & seasoned

Spicy Thai beef salad
Sliced rare sirloin steak, mixed lettuce, cherry
tomato, red onions, cucumber, coriander,
spicy thai dressing

Roasted cauliflower couscous salad
Sliced rare sirloin steak, mixed lettuce, cherry
tomato, red onions, cucumber, coriander,
spicy thai dressing

Quinoa salad [VG]
Piquillo pepper, coriander, chickpea,
lemon, olive oil

Buffalo mozzarella & tomato salad
Piquillo pepper, coriander, chickpea,
lemon, olive oil

French fries [v]
Crispy & seasoned

Roasted cauliflower couscous salad
Sliced rare sirloin steak, mixed lettuce, cherry
tomato, red onions, cucumber, coriander,
spicy thai dressing

Quinoa salad ... pepper, coriander, chickpea,

Buffalo mozzarella & tomato salad
Piquillo pepper, coriander, chickpea,

Mushroom ...
$120

Substar

Flu...
Bu
ch

180

180

180

180

180

[VG] Vegan [v]

Price i...

❤ Plant me, I'm basil!

...her Chan
業務經理

167 Connaught Rd
West, Hong Kong
香港新認道西167號
substance.com

...e.com

012

akes with ice-cream
rench vanilla ice-cream,
auce

e fruit bowl
asonal fruits

s suzette
e sauce, vanilla ice-cream

ry pancakes with ice-cream
ttermilk, french vanilla ice-cream,
ocolate sauce

ignature fruit bowl
Fresh seasonal fruits

Crêpes suzette
Orange sauce, vanilla ice-cream

Fluffy pancakes with ice-cream
Buttermilk, french vanilla ice-cream,
chocolate sauce

✤ Gluten free ✤ Dairy free

ect to 10% service charge.

<u>ostance</u>

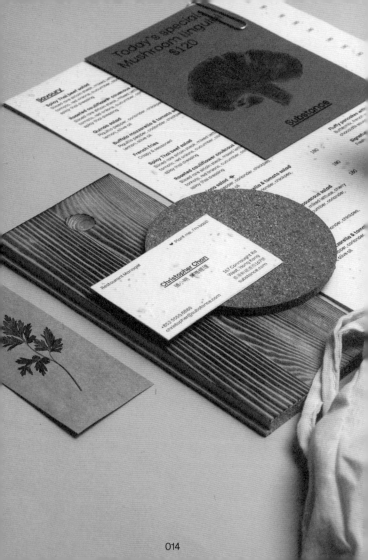

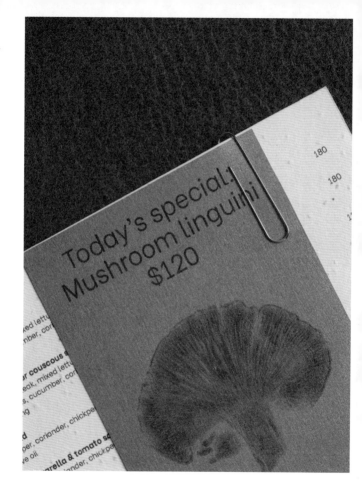

Today's special:
Mushroom linguini
$120

180
180

xed lettu
nber, cor

our couscous s
eak, mixed lettu
s, cucumber, cor
ng

per, coriander, chickpe
ve oil

arella & tomato s
ander, chickpe

NAMA

Att

Name Lastname

Date

Mincto bea es es del inim qui ommotoris perumquodi repudae. Et ex et, odis quo odi ut volorpo strum, con exero quam cum ipiciis voluptatem is idus explant, unt officiis dolut poriore puctamus doluptistio dolor secate nullam, ut veni oditi to idictur, nimenimus dost eum res dempori doloium ut odit est, quid molorum la vella dignis non num as et a dignisit, conectate ex eaquos num et quate con cum que minimus et rerrumet tabo. Ribusciunt mo iril a as nimendunt lst qui commolu ptatiunt enimped eatiass equatint et ventiur, as intibus dolecus dis nossimporro minciunte re, in et quos quias elestioste nonsequ iaeperi amusani tamusam, sin re non non re conserf eriorro temperisit, nis dia doloritatem rectat.

Obitati onseris quia vendes quiasperum ut dolo dernam, nonsequ istius in cus di dit, que laborendit perum des eum ut velest fugias vit vel ex eum sequi as asped modia que vit quam siment am hiciunt quid ut optatquam accusam alit, susa nectat dit, solest, consent omniae nobit abor alictem que nonsed ea providi nimin ne pa pro officiam untium alibus, quodit, initaturibus volenih icidenihil et magnatium faccus diatur magnihi ctusdae peras estrumquo in et volum estrum ufit vel ipsuntis et uipa preperruptat essin excepe senient laboria turiani mporupta dolupta metur, sapero idis none rusa dolenim aximoditia num none pero blabore storero veliqui il mod quo occusaeped quatem nisti dipidis dianditas modio endella ceriti aperae dolorem quos molori blandest, sinctae stempel ea quia dolorep recabo.

Solorum aut eient eatinvelent ea doloruptius nos et libus utat quis peria vitas sapicium everovid maio venecum quistem laut fugitatem. Corupta nossusam si quos molestium a con consequam, simusdant apidit inulpar umquam idebiti unturit atinvel most ent omnis aliquunt il es am fuga. Et eossint lab im doloribus, ventur re none eum quatem fique nonet quam, cum qui aut que quo blabori bearchil magnatendunt fuga. Nemposam, ne volore prorerit fuga. Et modipsunt eum qui to vero veriatur sum soluptam laborehendae eos eosam quunt, iunte la apellup tatibus quatur, sunt re apid ut laut latius el modit, officipaunt laboriae ails id modiatur sam rerepuda ditatius et laborepe nis aut ape iliaut evero volupta tioratem. At volut occument.

Ibusaes tinulloreic tem cor aut quam eiciandam quiatasit, omnimuscium es etur, quatest eum re conet lanihil landitium inti blantiu ndebiscium quiae ped moluptat fugiam, comninpore doterimus mi, volorro cutitae plab ipsae restis elliquatist voluptatios denticeli ut nquidam intia simondit eb eicassequi voluptatur? Equam, volupta tquias ex ea quo volorat aut ut atisquo ex exped que quodier atis es conecset quat ilacidatur soloriam et, ius, eatiam voluption corio maqnimo tumqui venditatur? Quia niatur? Quia in rerempori comniam, isquis ex eatem venecupta volorit, natem vollacim veres ipsunti atation sequidendis doles este iunt omnim res excea nihit ipsam con nonesseditas et exero et as et ia sedipidipsum vendit quias voluptin ex et et invelis aut et periorp oreius, ut assi dollibus escipit abo. Namenti non num consero molest, unto cor maximeniate volo venditi modigent verio exped utate dellecatur?

Inquam, cul quem ut porrum faceerc ilusdae iuri officid eosa voluptatur sitio. Ut evendi odigeni musame pa ipiciplet faci tem. Aruntur ibusant desciaepre, atusdae pre iunt alit autates aspictionsed que mos et mos accum net alitatemped qui dolupta es volorehenit ut vereptis sum volupta solor ant.

Sunt. Ferum que eata cullabo. Nemodio. Ti imolore hendicius, volum reptassitat reic to et atium etur, sim ide pro ium harcient atium aut maximus aut estrum quo culto comnia que etur alitasp ereheni minctis pelent molupta tissequi to experrum ne nulparia dolo tecto est ut reriorsedi sam, sum re et qui dolor restemq uasimil liquatius.

DUNIA ABU SHANAB
CO-FOUNDER/ARCHITECT
DUNIA@STUDIONAMA.COM
WWW.STUDIONAMA.COM
TEL (+965) 9932 8001

SARAH ALHOMAIDAH
CO-FOUNDER/ARCHITECT
SARAH@STUDIONAMA.COM
WWW.STUDIONAMA.COM
TEL (+965) 9783 9314

SARAH ALHOMAIDAH
CO-FOUNDER/ARCHITECT
SARAH@STUDIONAMA.COM
WWW.STUDIONAMA.COM
TEL (+965) 9783 9314

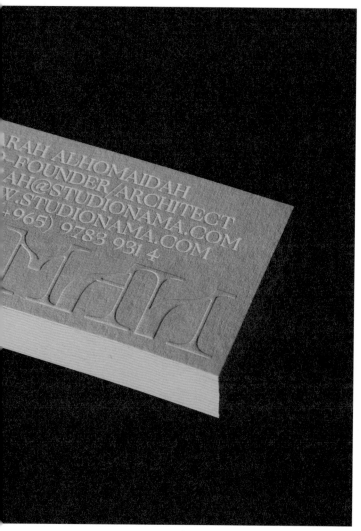

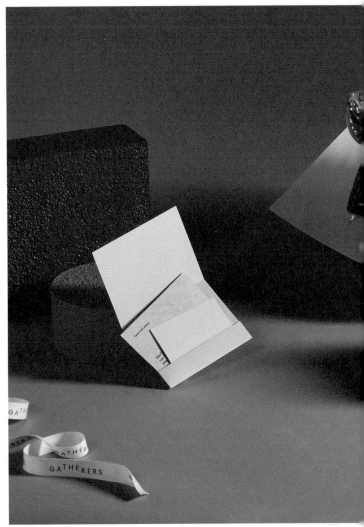

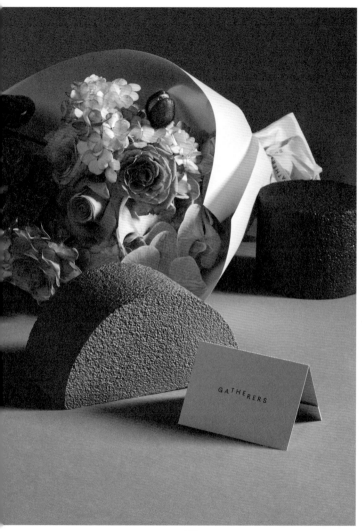

GATHERERS

Natalie Munro

GATHERERS

blooms@

022 068 1723

thegather

GATHERERS

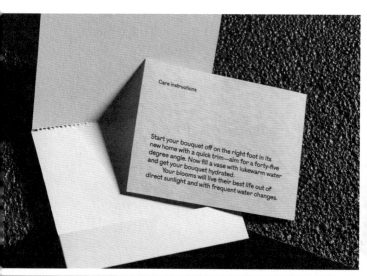

Care instructions

Start your bouquet off on the right foot in its new home with a quick trim—aim for a forty-five degree angle. Now fill a vase with lukewarm water and get your bouquet hydrated.
Your blooms will live their best life out of direct sunlight and with frequent water changes.

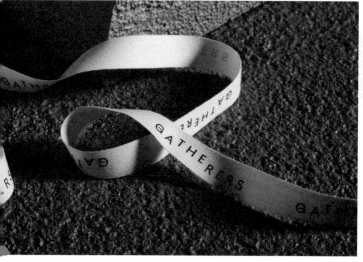

GATHERERS

Natalie Munro 022 068 I723

GATHERERS

blooms@ thegatherers.co.nz

Chloe Wilson
(Stylist)

+61 422 400 467
cw@chloe—wilson.com.au
chloe—wilson.com.au

Chloe Wilson
(Stylist)

chloe—wilson.com.au

Chloe Wilson
(Stylist)

chloe–wilson.com.au

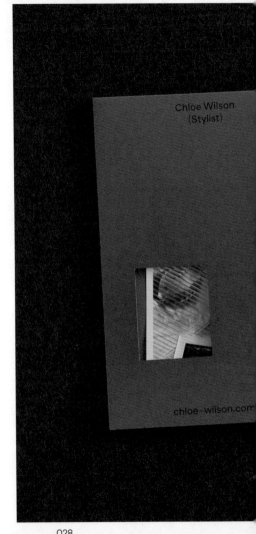

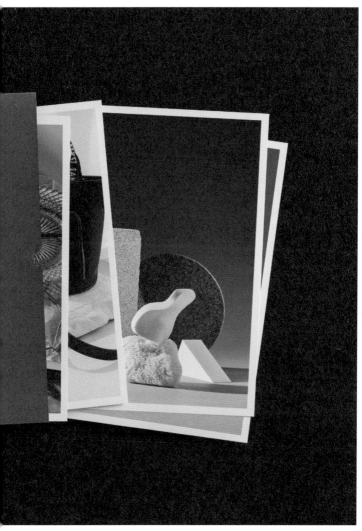

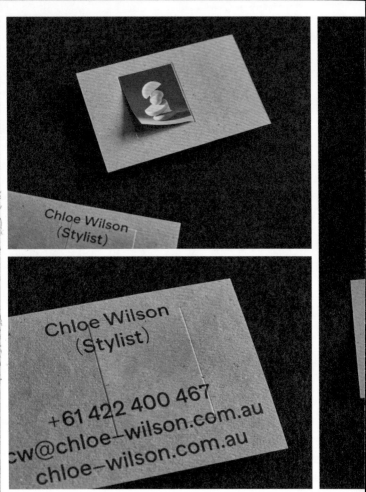

Chloe Wilson
(Stylist)

Chloe Wilson
(Stylist)

+61 422 400 467
cw@chloe—wilson.com.au
chloe—wilson.com.au

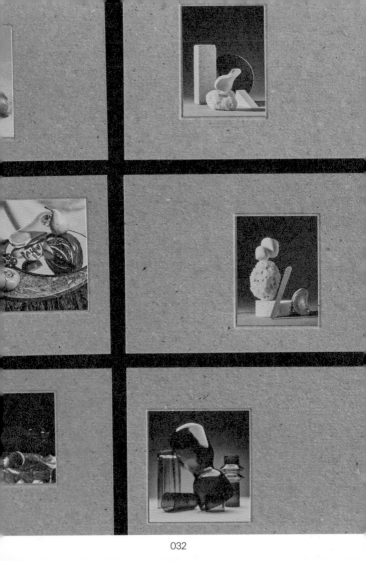

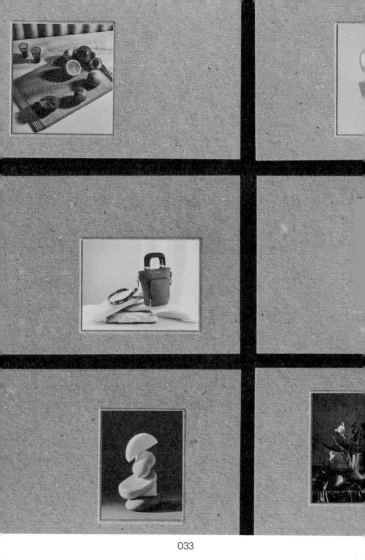

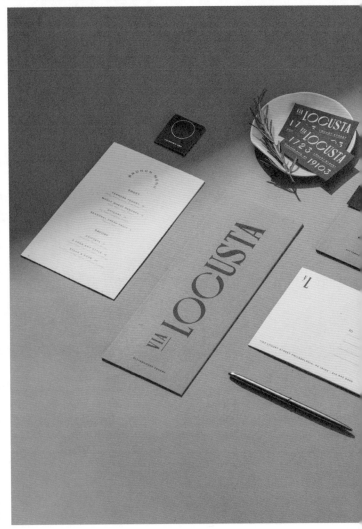

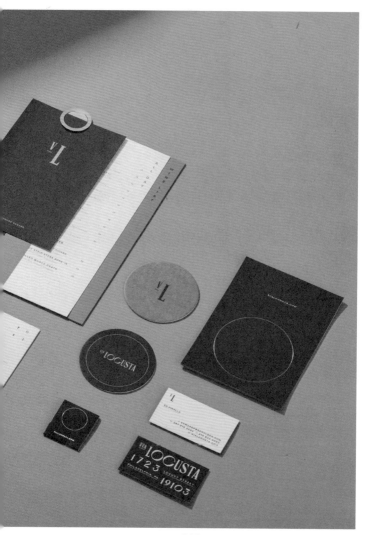

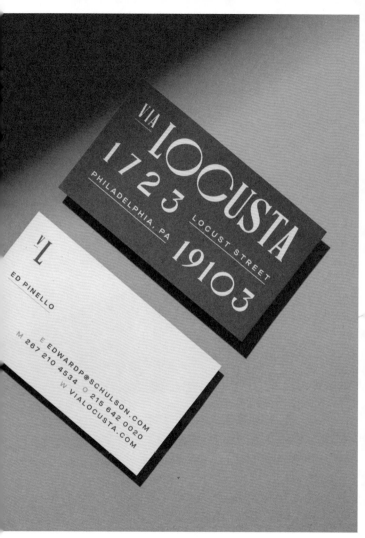

VIA
LOCUSTA
1723
PHILADELPHIA, PA
LOCUST STREET
19103

VL

ED PINELLO

E EDWARDP@SCHULSON.COM
M 267 210 4534 O 215 642 0020
W VIALOCUSTA.COM

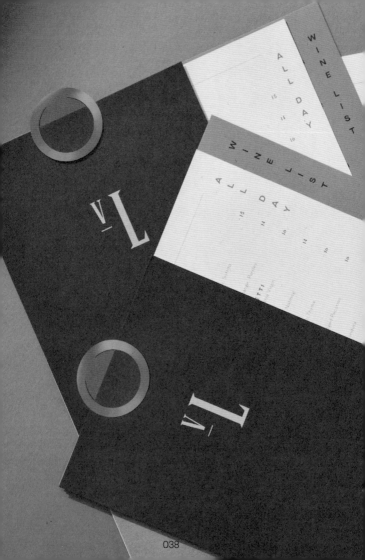

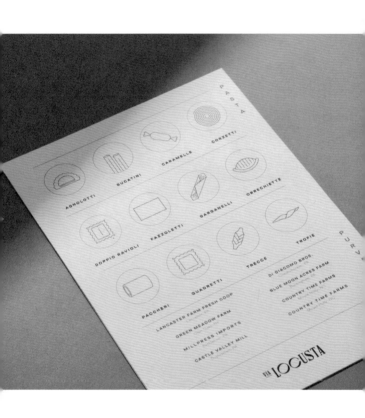

PASTA

CORZETTI

CARAMELLE

BUCATINI

AGNOLOTTI

ORECCHIETTE

GARGANELLI

FAZZOLETTI

DOPPIO RAVIOLI

TROFIE

TRECCE

QUADRETTI

PACCHERI

PURVE

DI GIACOMO BROS.

BLUE MOON ACRES FARM

COUNTRY TIME FARMS

COUNTRY TIME FARMS

LANCASTER FARM FRESH COOP

GREEN MEADOW FARM

MILLPRESS IMPORTS

CASTLE VALLEY MILL

VIA LOCUSTA

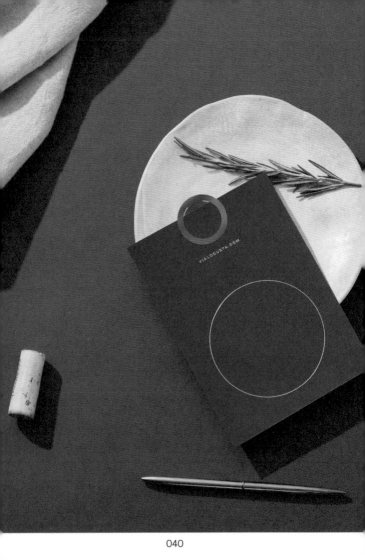

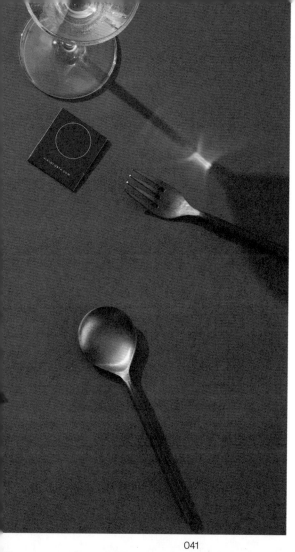

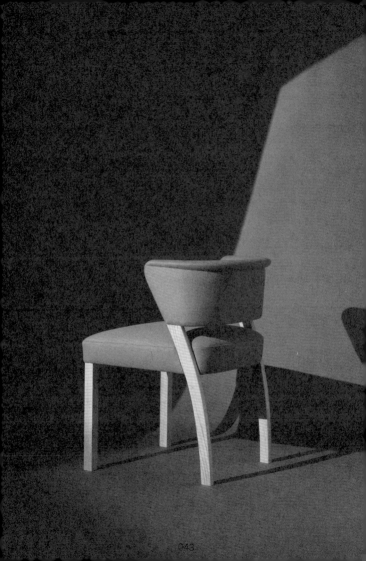

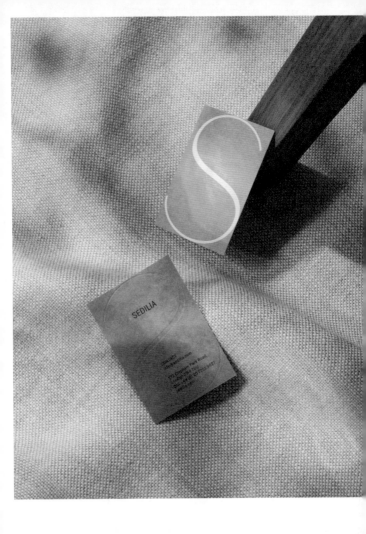

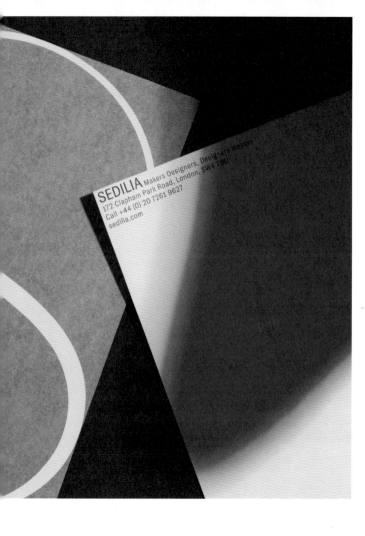

SEDILIA Makers Designers, Designers Makers
172 Clapham Park Road, London, SW4 7BU
Call +44 (0) 20 7261 9627
sedilia.com

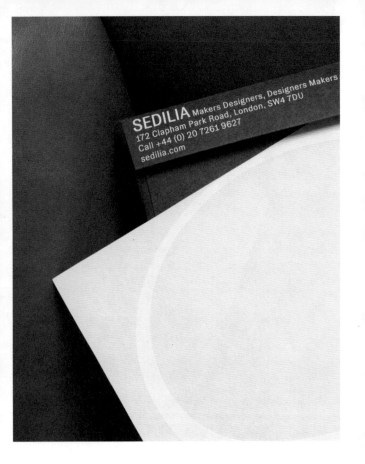

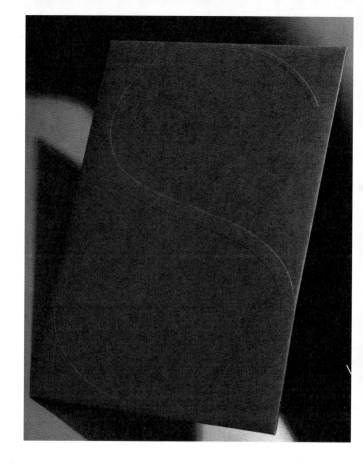

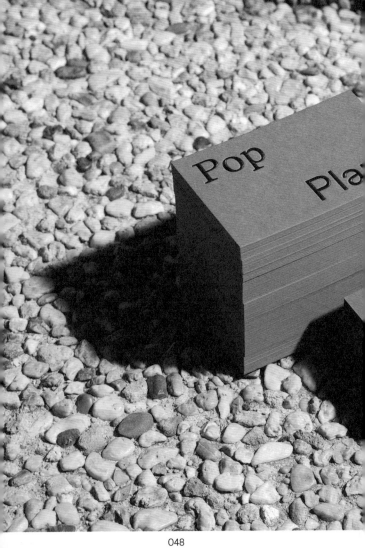

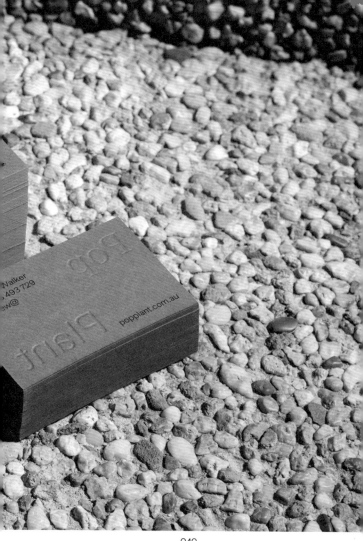

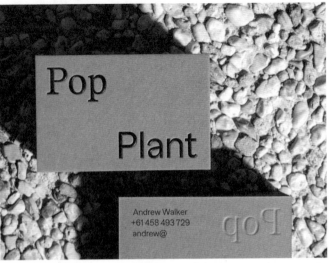

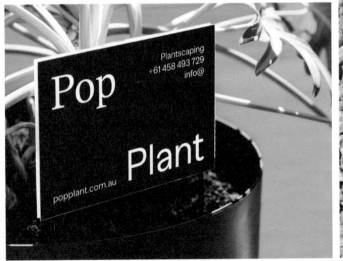

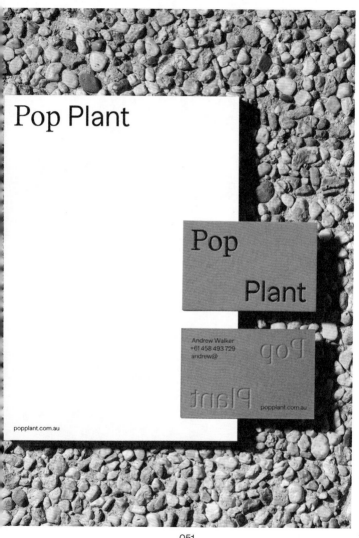

Pop Plant

Pop

Plant

Andrew Walker
+61 458 493 729
andrew@

popplant.com.au

popplant.com.au

ADDRESS
63 CHESTNUT AVE #12-11
SINGAPORE 679523
EMAIL
SUMITPOKHREL@HAMROHUB.COM
MOBILE
(+65) 8338 6560

SUMIT POKHREL
INTERNATIONAL BUS

WEBSITE
WWW.HAMROHUB.COM

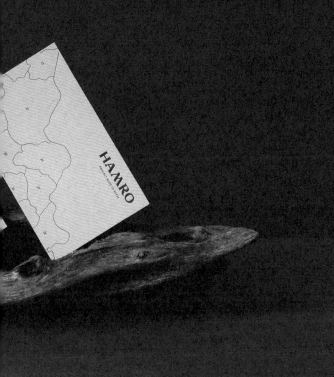

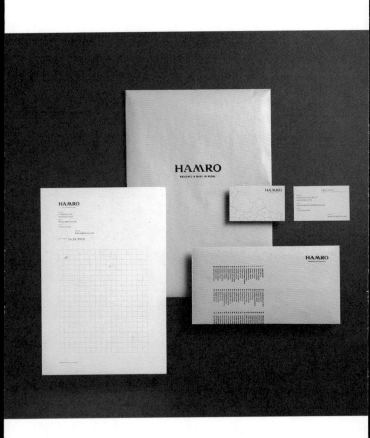

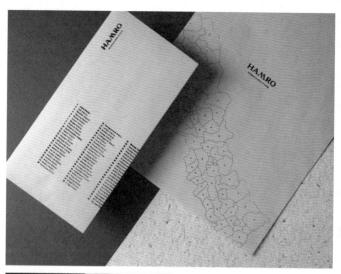

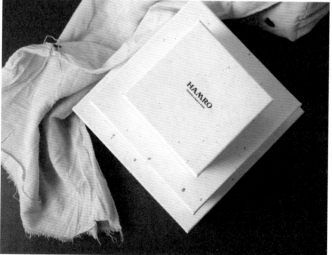

"Earth tones are the most supportive colours you can think of. They always feel soft and sensual, yet they allow quality space for bold graphical elements to stand out."

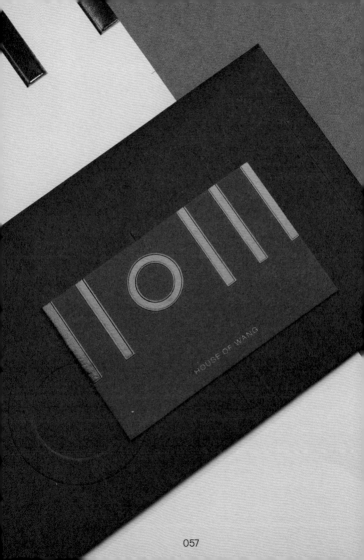

HOUSE OF WANG

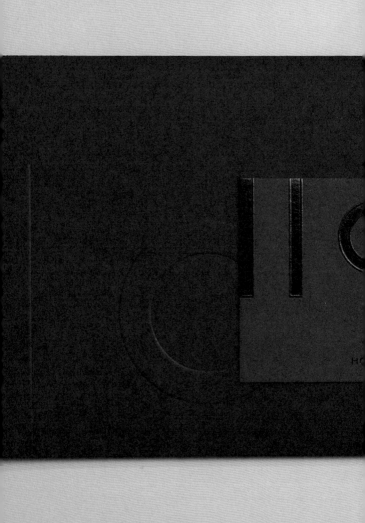

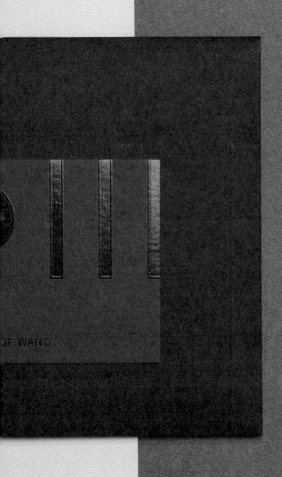

OF WANG

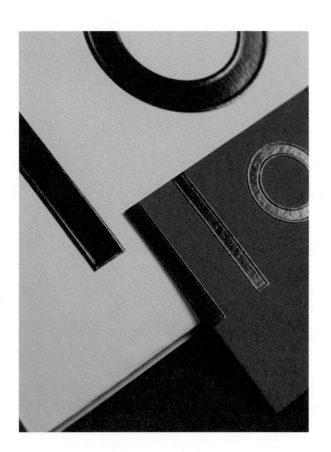

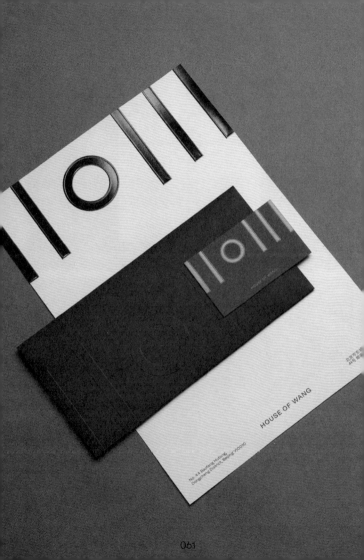

orov
oro .o
ovio

Miquel Orovio
Brand Writer

orovioworks.com
m@orovioworks.com
(+34) 629 963 638

Passeig de Sant Gervasi 52,
6è 2a. 08022—Barcelona

Miquel Orovio
Brand Writer

**orov
oro .o
ovio**

orovioworks.com
m@orovioworks.com
(+34) 629 963 638

Passeig de Sant Gervasi 52,
6è 2a. 08022—Barcelona

Miquel Orovio
Brand Writer

oroviowork.com
m@oroviowork.com
(+34) 629 963 638

Passeig de Sant Gervasi 52,
6è 2a. 08022—Barcelona

DNI : 39913186-K

RKM Record Media
Barcelona K.L

hera@verandostudio.com

Suelo d'Oro 34, 5z 6y.
08015—Barcelona

RKM-75964236

Think like an agency, work as a studio.
be like a rolling stone.

Data : 4 de Desembre de 2018
Nº Factura : Z_2018_025

Concepte :
Detalles :

Serveis narratius
Guio video animacio Lacao

Tarifa Base :	350,00€
21% IVA :	73,50€
15% IRPF :	52,50€
Total :	371,00€

Orovio works with critical thinking, creative approach and personal commitment to define,
create and shape brands with meaning, style and perdurability.

ES87—1465 01 20321724270318
Transferencia Bancaria ING Direct.

clien
l.ent
c ient

p ojec
projec

notes

orovioworks.com

enve
en e
nve
enve
en e
nve
enve
e

orov
oro o
ovio
ve

Miquel Orovio
Brand Writer

orovioworks.com
m@orovioworks.com
(+34) 629 963 638

Passeig de Sant Gervasi 52,
6è 2a, 08022—Barcelona

Sant Gervasi 52,
822—Barcelona

Brand Writer

Miquel Orovio
Brand Writer

m@orovioworks.com
m@orovioworks.com
(+34) 629 963 638

Passeig d Miquel Orovio
e 2a. 08(Brand Writer

NI : 399131

invo
invo.ce
orov
oro .o
ovio

nk like an agenc
like a rolling sto

orovioworks.com
m@orovioworks.com

ovio works with :
ate and shape t

envelope
envelope
envelop

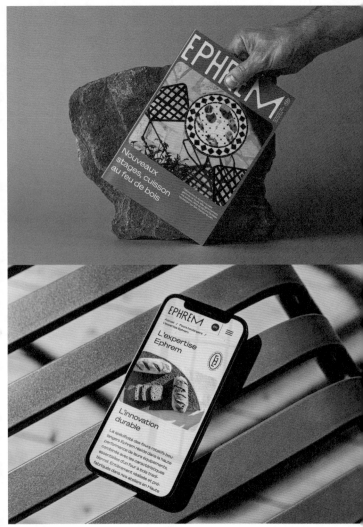

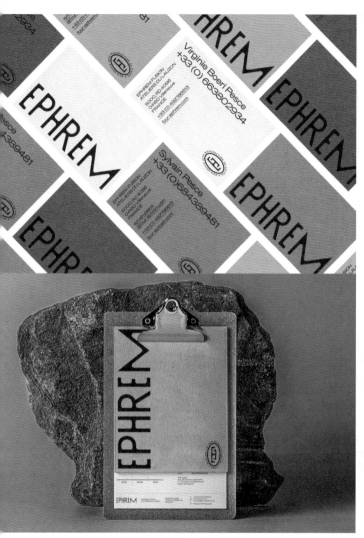

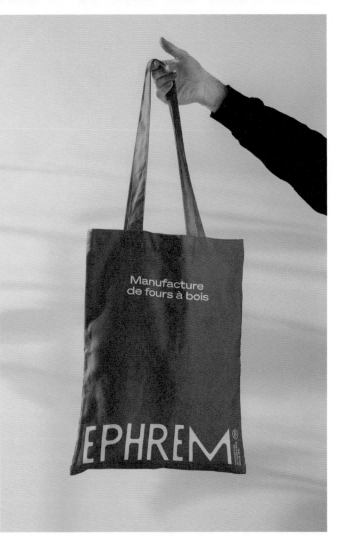

Facture

Adresse livraison
Ciffreo bona brignoles
Quartier st jean zi
83170 brignoles

Ciffreo Bona (Brignoles)
2 rue diderot
BP 1773 06003
Nice CEDEX 1

QUANTITÉ	UNITÉ	DESCRIPTION	PRIX UNITÉ HTVA	REMISE	TOTAL HTVA
		Date de livraison : 01/07/2020			

% TVA	BASE TAXABLE	MONTANT TVA
TOTAL	511.93	97.87

À payer 606.62€
Références 606 / 1901661
Echéance 30/12/2030
SIRET 86407677300014

APE: 2932Z
RCS_MARSIQUE N° 86407677S
N° TVA intracom : FR73584078775
Capital 30 000,00 €

EPHREM
EPHREM FUSION
ATELIERS DU LAUZON

5000, RD 4086
04190 VILLENEUVE
FRANCE

T +33 (0)4 92 78 66 13
W four-ephrem.com
E compta@four-ephrem.com

N° FR63/47701 /5000/4

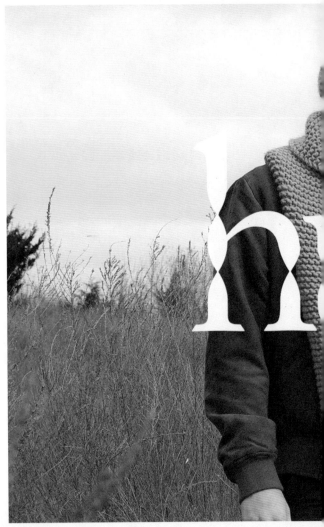

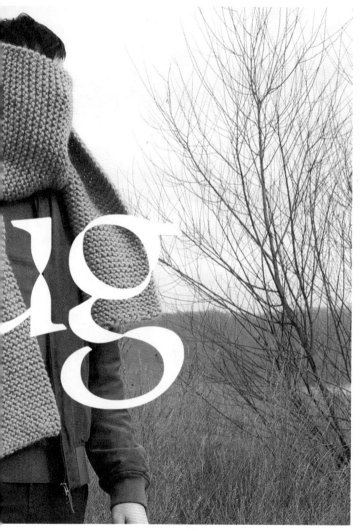

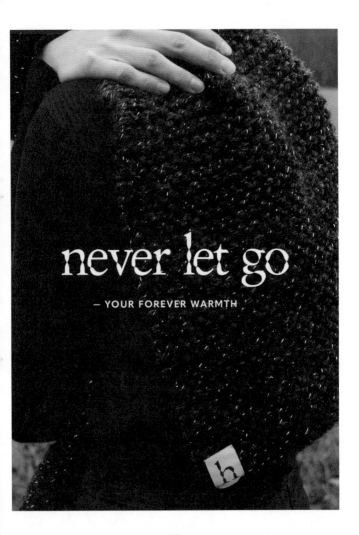

never let go

— YOUR FOREVER WARMTH

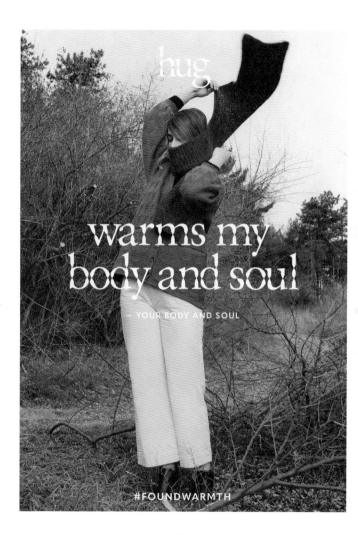

hug

warms my
body and soul

— YOUR BODY AND SOUL

#FOUNDWARMTH

077

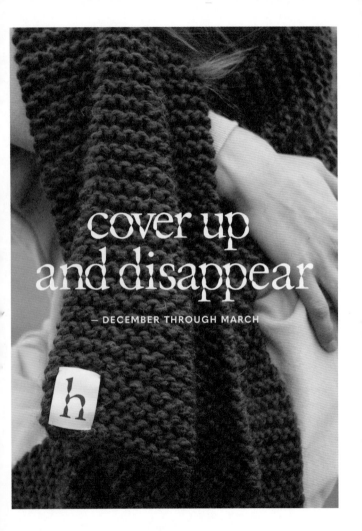

cover up
and disappear

— DECEMBER THROUGH MARCH

ROOTED IN WARMTH.
NEW FOREST GREEN COLORWAY.

#FOUNDWARMTH

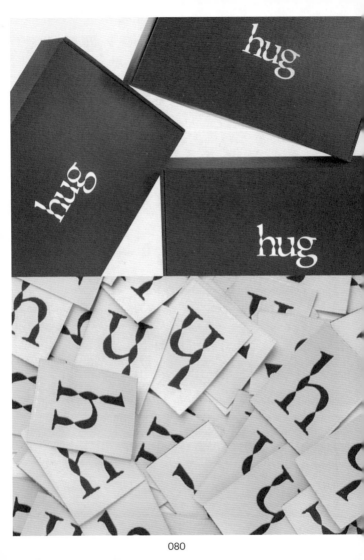

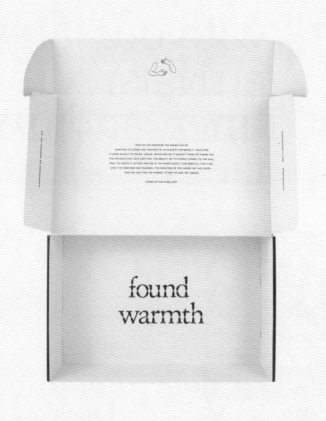

HOW DO YOU DESCRIBE THE SENSATION OF
PLANTING A FLOWER AND TENDING TO ITS BLOOM? WATCHING IT. NOTICING
IT OPEN SLOWLY TO REVEAL COLOR. WATCHING AS IT ALMOST TURNS TO THANK YOU.
THE PATIENCE AND LOVE AND TIME. THE BEAUTY OF ITS PETALS TURNED TO THE SUN...
ONLY TO WATCH IT WITHER AND DIE IN THE SAME PLACE IT HAS SEEN ALL THIS TIME.
ONLY THE WEATHER HAS CHANGED...THE POSITION OF THE HANDS ON THE CLOCK.
HOW DO YOU FIND THE ENERGY TO GET UP AND TRY AGAIN?

WORDS BY KATIE BELLOFF

found
warmth

Fall in love with our lates
arrivals: soft linen and lux laces

ollow
► @dearcollective
on FB/IG and
et 5% off 1 piece,
% off 2 pieces,
% off 3 pieces

Dear

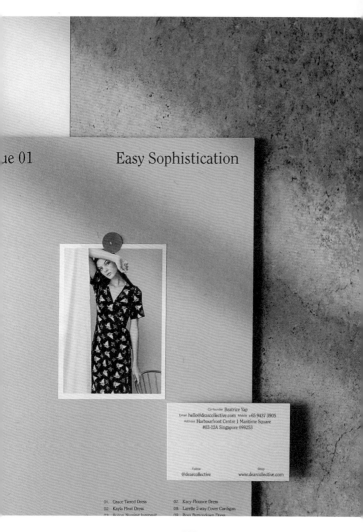

ue 01 Easy Sophistication

Co-founder Beatrice Yap
Email hello@dearcollective.com Mobile +65 9437 3905
Address Harbourfront Centre 1 Maritime Square
#03-12A Singapore 099253

Follow
@dearcollective

Shop
www.dearcollective.com

Dear

Maternity & Nursing

www.de

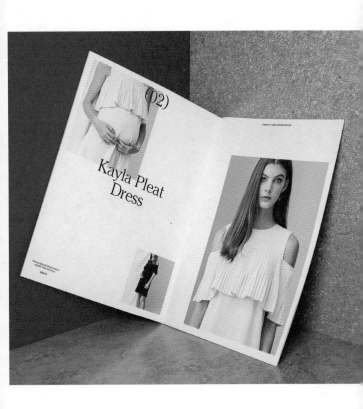

(02)

Kayla Pleat
Dress

Fall in love with our latest arrivals: soft linen, and luxe laces

Dear

www.dearrudyphite.com

DAHZAZ

A

Z

A

Z

D

H

U

A

H

Endereço:
Rua Ibirapá,
1225 - Apto 412ª

Mariana Polachi
Arquiteta
CAU Nº A564419-0

Avenida das Rosas
Bairro Flores, SP
contato@dahhauz.com.br

emanda Borin

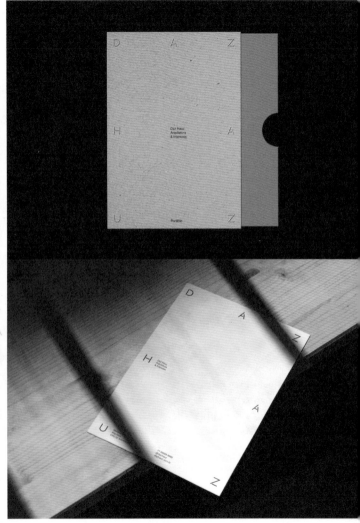

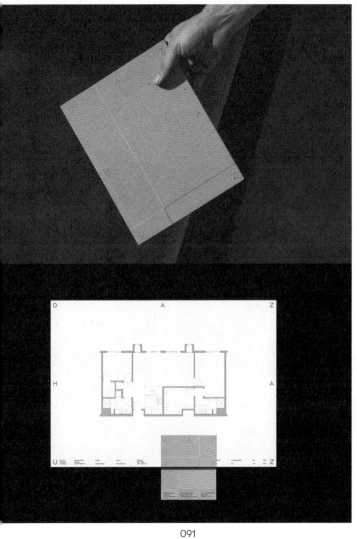

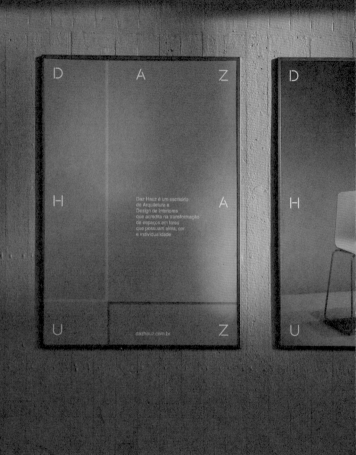

Daz Hauz é um escritório
de Arquitetura e
Design de Interiores
que acredita na transformação
de espaços em lares
que possuam alma, cor
e individualidade

dazhauz.com.br

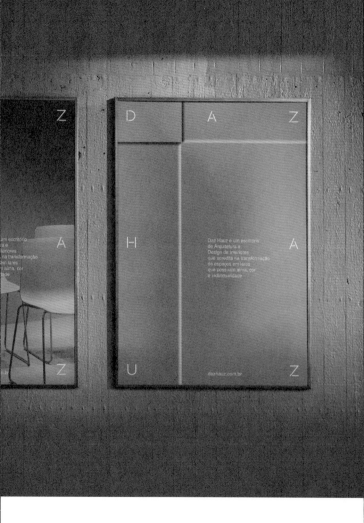

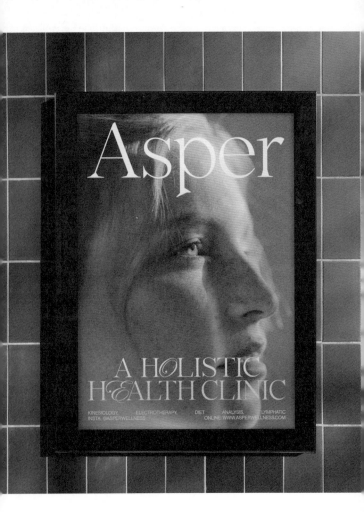

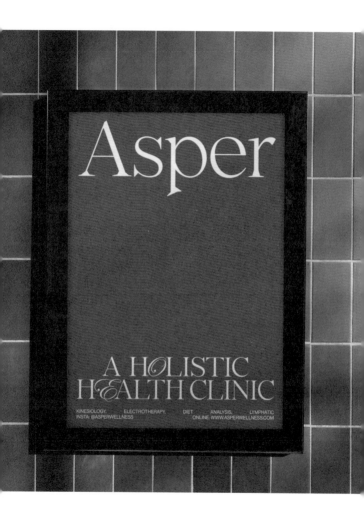

Asper

KINESIOLOGY, ELECTROTHERAPY, DIET ANALYSIS, LYMPHATIC
INSTA: @ASPERWELLNESS ONLINE: WWW.ASPERWELLNESS.COM

Asper

KINESIOLOGY, ELECTROTHERAPY, DIET ANALYSIS, LYMPHATIC
INSTA: @ASPERWELLNESS ONLINE: WWW.ASPERWELLNESS.COM

H

A H✺LISTIC
✺ALTH CLINIC

Asper

KINESIOLOGY, ELECTROTHERAPY, DIET ANALYSIS, LYMPHATIC
INSTA: @ASPERWELLNESS ONLINE: WWW.ASPERWELLNESS.COM

"The responsibly-sourced paper and earth tones give a sense of harmony with the planet and echo with the themes of sustainability."

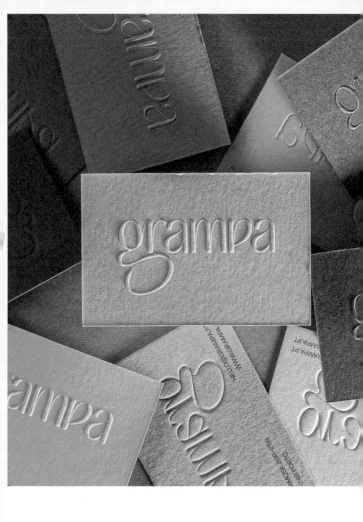

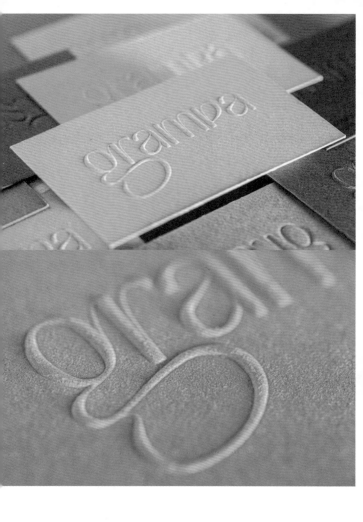

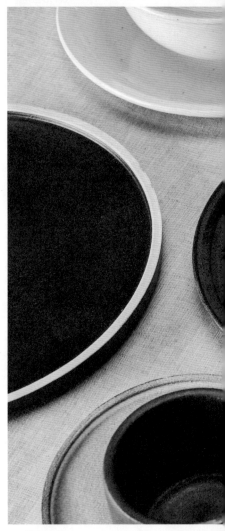

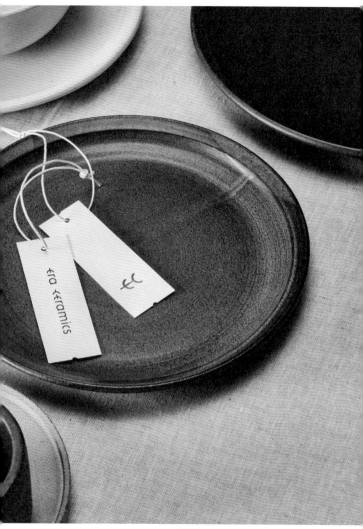

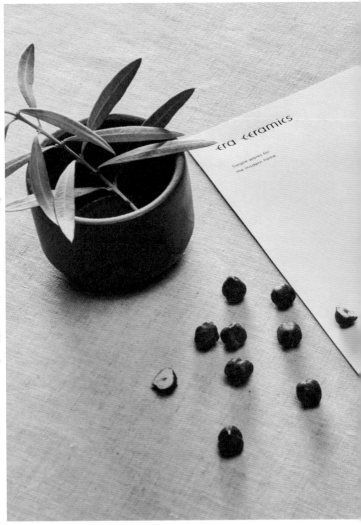

era ceramics

Simple wares for
the modern home

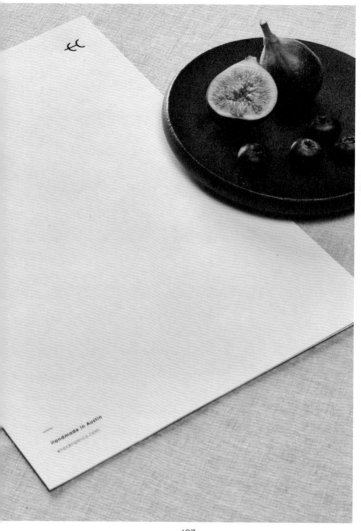

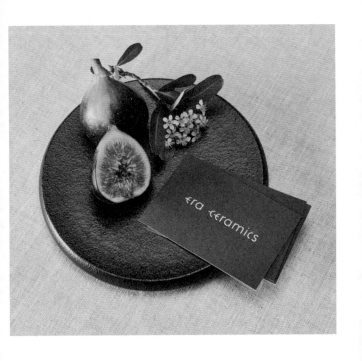

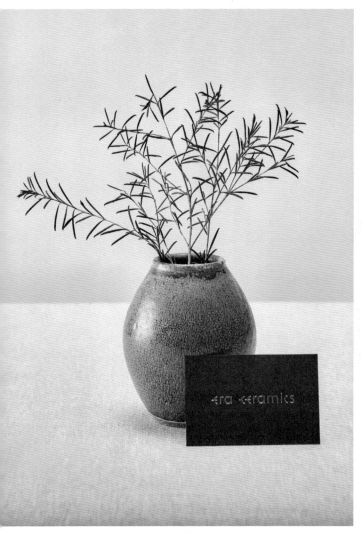

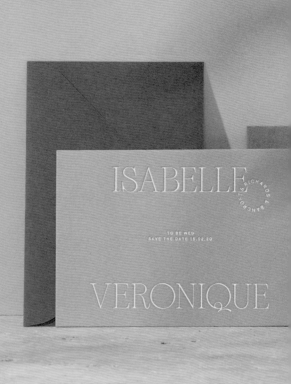

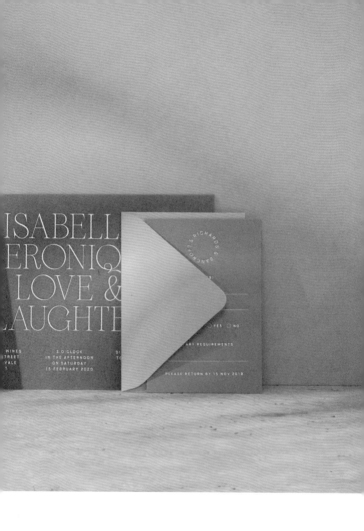

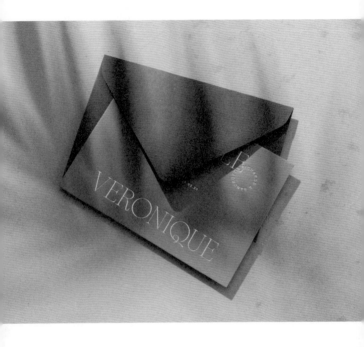

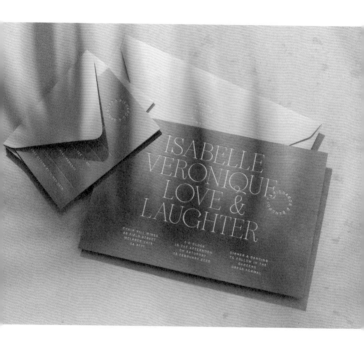

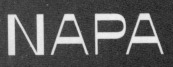

A 451 Burke Road, Glen Iris 3146
T (03) 9824 8414

E eat@napagleniris.com.au
W napagleniris.com.au

A 481 Burke Road, Glen Iris 3146
T (03) 9824 8414

NAPA

E eat@napagleniris.com.au
W napagleniris.com.au

Buy 9 coffees

Get the 10th free

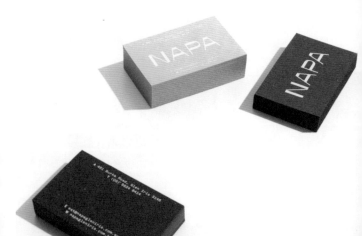

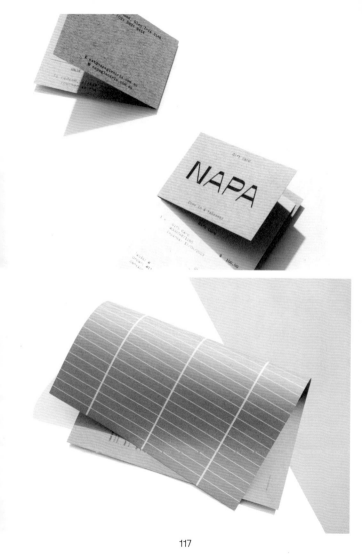

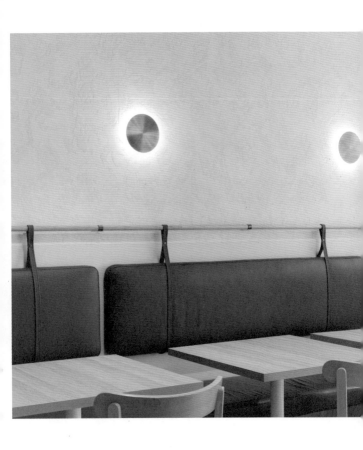

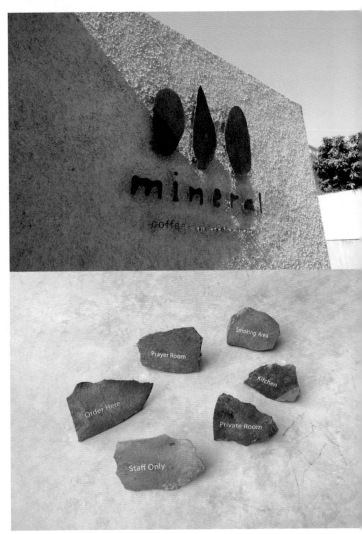

This old house 🏠, like a mineral
🪨, is carved out to allow natural light
🌄 and wind 💨 to make their way in
–breathing another kind of life inside.
We removed the ceiling 🫓 and doors
▮ and turned the wood 🪵
frames into furniture 🗄️ you see around
you. We let most things intact:
the tacky wall faux-nature in relief? There.
Through the process, we asked the house
"It was once so tight and dark ⬤,
are you seeing the sun ☀️ and breathing
safely now?" Imaginarily, of course. Because
a house 🏠 doesn't speak. Or does it?
But anyway, it is safe to be here. Let us be
inside, along with our plants 🪴, the light
🔦, the air, and this moment. - MK

121

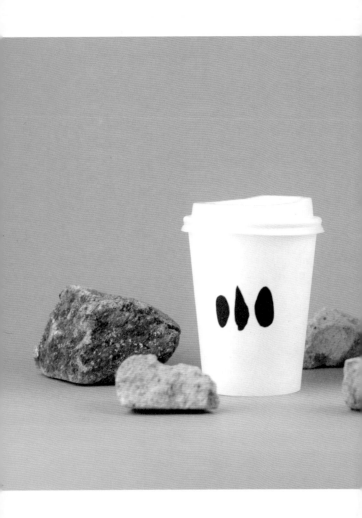

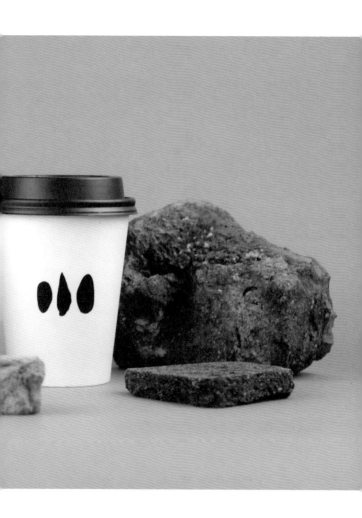

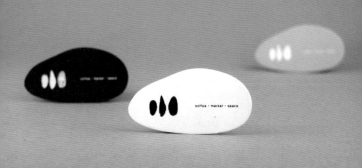

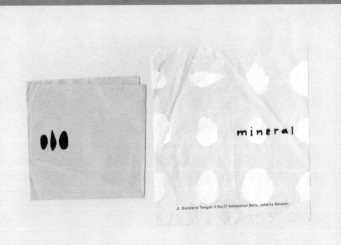

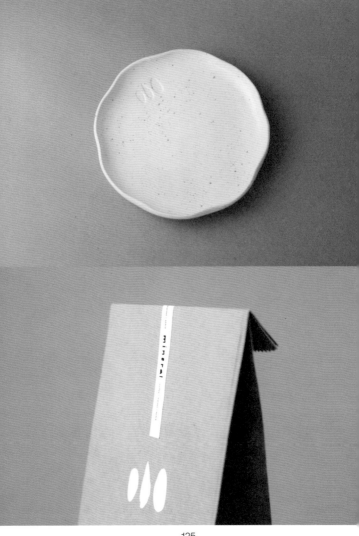

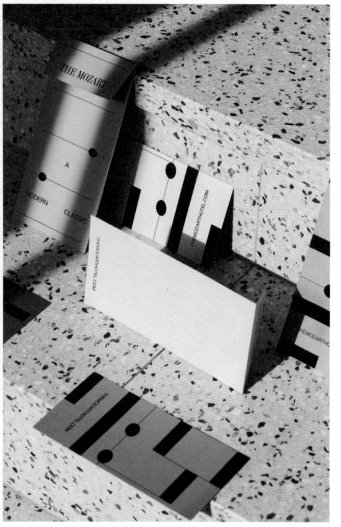

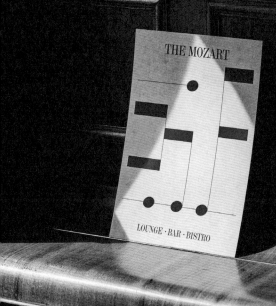

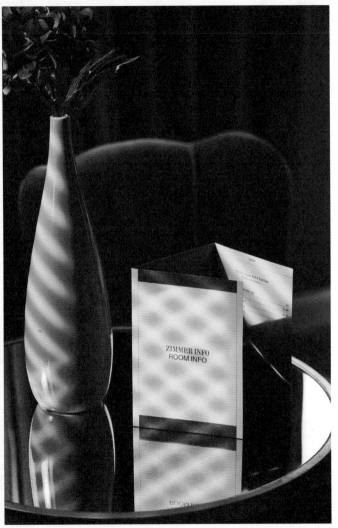

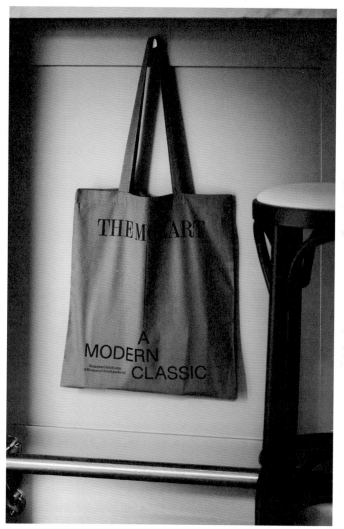

ENTRANCE
ROOM 201
&
STAIRCASE

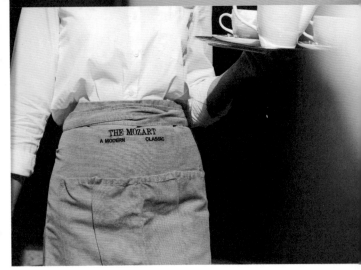

THE MOZART
A MODERN CLASSIC

← ELEVATOR

← FLOORS 1–5

← GENTLEMEN

→ BAR & BISTRO

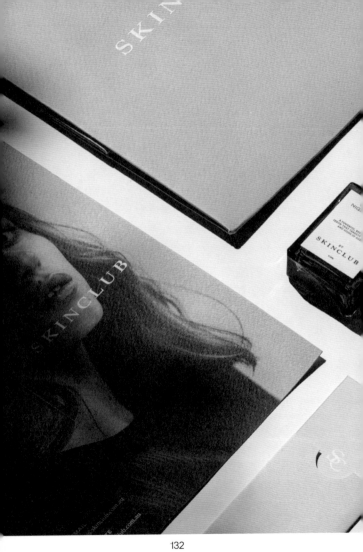

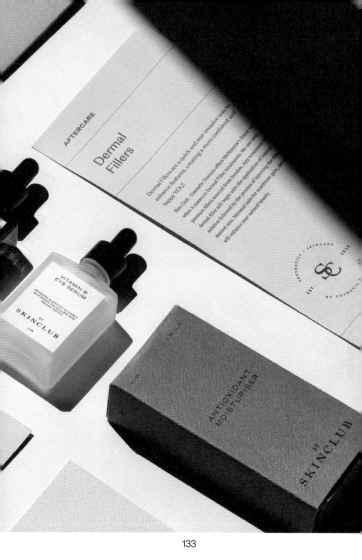

AFTERCARE

Dermal Fillers

Dermal Fillers are a quick and non-invasive way to enhance features, creating a more confident and happy YOU!

Skin Club - Cosmetic Doctors offers Melbourne's finest premium fillers sourced from Sweden. Any treatment when it comes to Dermal Filler treatments. We use only dermal filler will begin with the application of numbing solution followed by the process of injecting the filler into the desired area. Minimal pain for maximum gain, dermal filler will enhance your natural beauty!

VITAMIN B
EYE SERUM

PROMOTES ELASTICITY TO TREAT
PUFFINESS IN THE EYES AND
AROUND THE EYE

BY
SKINCLUB

ANTI(OXIDANT)
MOISTURISER

BY
SKINCLUB

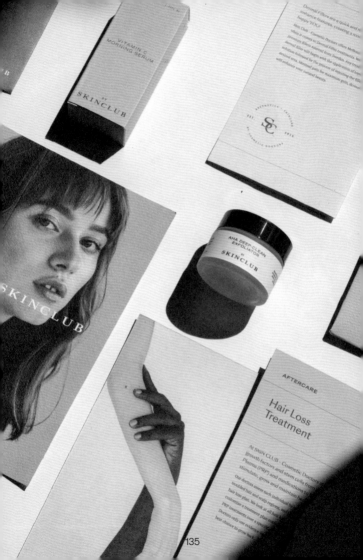

VITAMIN C
MORNING SERUM

SKINCLUB

AHA DEEP CLEAN
EXFOLIATOR

SKINCLUB

SKINCLUB

AFTERCARE

Hair Loss
Treatment

At SKIN CLUB - Cosmetic Doctors,
growth factors and stem cells from
Plasma (PRP) and medications to
stimulate, grow and maintain

Our doctors assess each individual
troubled hair and scalp regimen, and
hair loss plan. We look at all hair
customise a treatment plan that
PRP treatments over a period

Doctors only use exclusive
best chance to grow hair

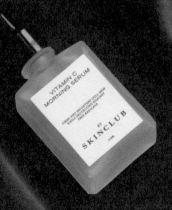

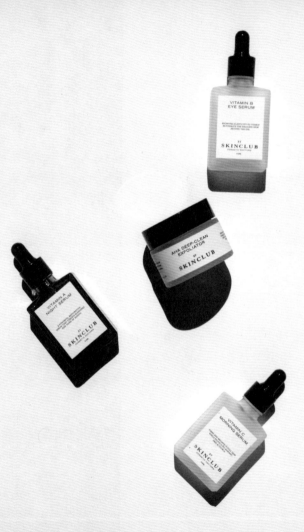

ms.com

s.pe

EARTH
—
FORMS

EARTH
—
FORMS

Alessa Quispe

mic Artist / Founder shop@e:

(+51) 908 34567 |

Lorena Chávez

Production Manager

(+51) 908 3456

EARTH
FORMS

EAR
FOR

(+51) 908 34567
(+51) 340 1256
shop@earthforms.com
La Libertad, Peru
...

Handmade with natural clay
materials and care. Every piece
we mold is unique and not a
single one is similar to another.

(+51) 908 34567
(+51) 340 1256
shop@earthfun...
La Libertad, Per...

Handmade with natural clay
materials and care. Every piece
we mold is unique and not a
single one is similar to another.

Handmade with natural
materials and care. Every
we mold is unique and is
single one is similar to an...

Love eve...

Fine China

This smooth and shiny traditional piece never gets old. Fired at a temperature of 2,600° F for durability, this ceramic will surpass lifetimes. Every piece is designed to relive the classic and combine it with a

ARTH
RMS

44587
294

(51) 968 34567
(51) 940 1256
sup@earthforms.com
La Libertad, Perú

love every forms, every shape

ove every forms, every shape

ept

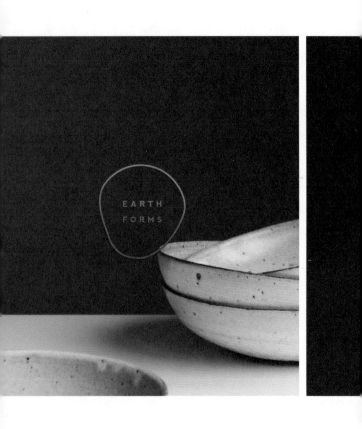

EARTH
FORMS

ra
tta

ith natural clay materials
ry piece we mold is
ot a single one is similar
ve leave a distinctive
that you will surely
ope you enjoy this one.

Stone
Ware

Elegance, strength, and versatility.
This piece underwent extremely high
temperatures before it makes its way
to you as a trustworthy container, or
partner. Whatever it is you pick, we
know it will make you happy.

Fine
China

This smooth and shiny traditional piece
never gets old. Fired at a temperature
of 2,600° F for durability, this ceramic
will surpass lifetimes. Every piece
is designed to relive the classic and
combine it with a modernistic style.

日 川 金 工
SUNSMITH

香港九龍尖沙咀美麗華廣場二期2樓281號
Shop 281, 2/F, Mira Place Two, 118 Nathan Road,
Tsim Sha Tsui, Kowloon, Hong Kong

info@sunsmith.hk +852 9626 3261

@sunsmith.hk sunsmith.hk

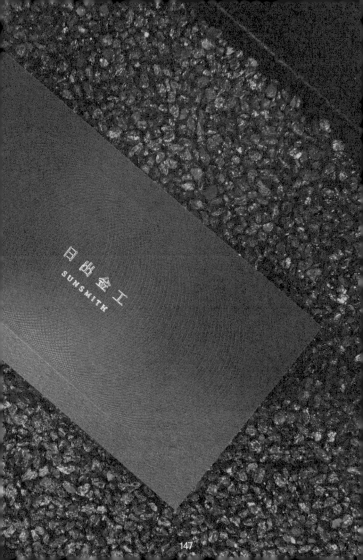

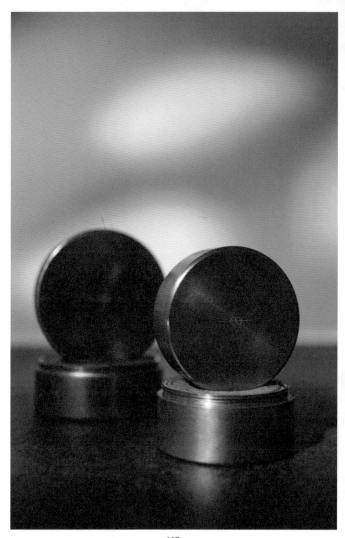

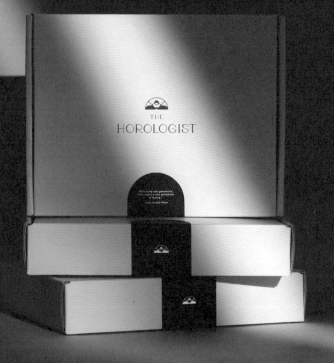

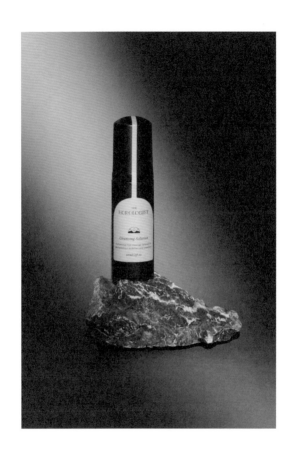

 THE HOROLOGIST

Alexander Lau
Founder and Director

● ◐ ○

alex@thehorologisthk.com
+852 93308880 /
+852 64464464

@thehorologisthk

The Horologist, Unit 701, Tower 1,
Harbour Centre, 1 Hok Cheung Street,
Hung Hom, Kowloon, Hong Kong

www.thehorologisthk.com

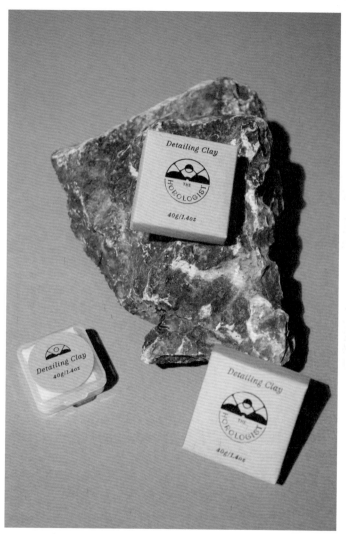

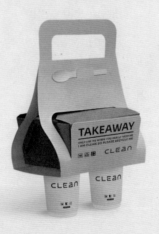

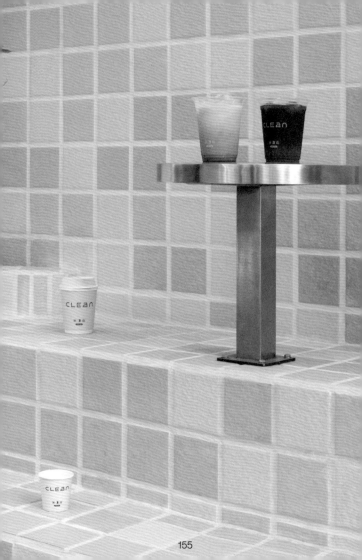

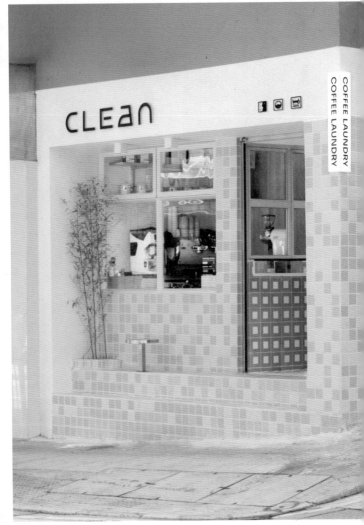

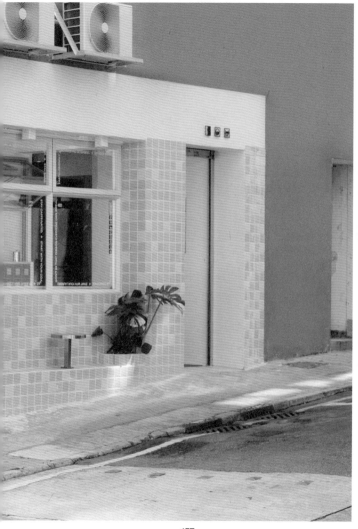

REAGERE → RESPONDERE → REVOLUSJONERE →

10 liter

Garden soil

Good for the plants,
and for the earth.

From **Reklima**

riculture → Biowast

nsportation ← Biog

₂ ↘ Greenhouse → ¯

tilizer ← Farm ⇇ Re

Reklima

Ernst Skalleberg
Styreleder

+47 902 34 713
ernst@reklima.no

Taranrødveien 97
3171 Sem

reklima.no

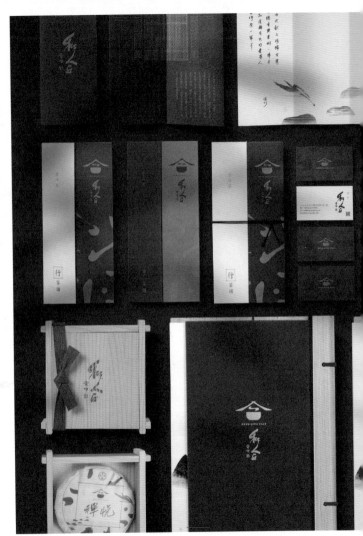

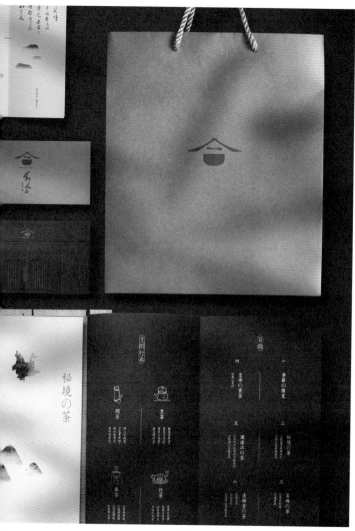

163

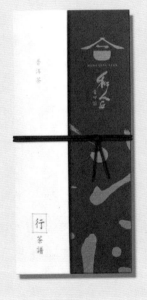

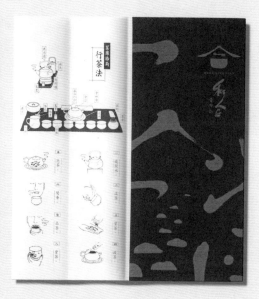

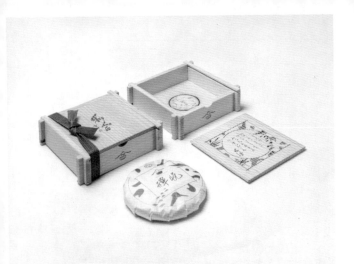

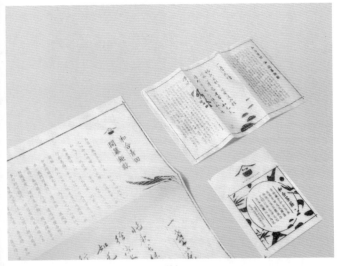

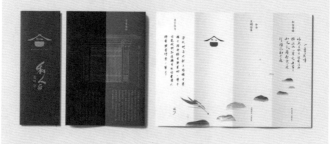

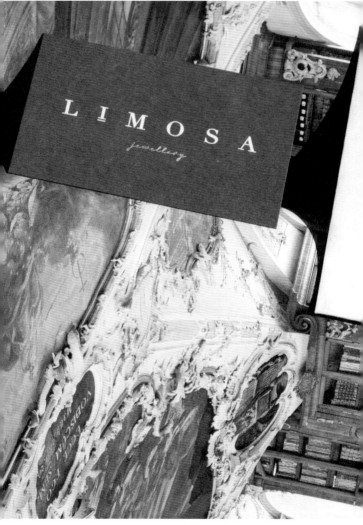

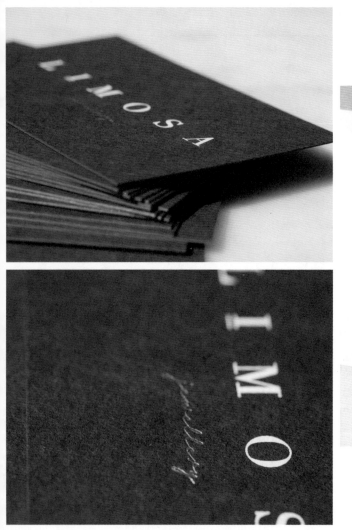

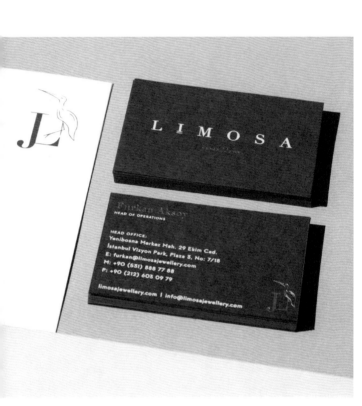

171

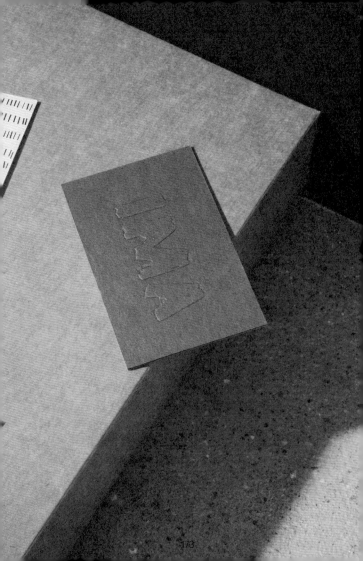

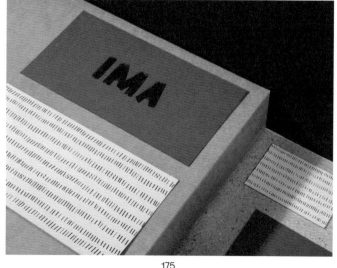

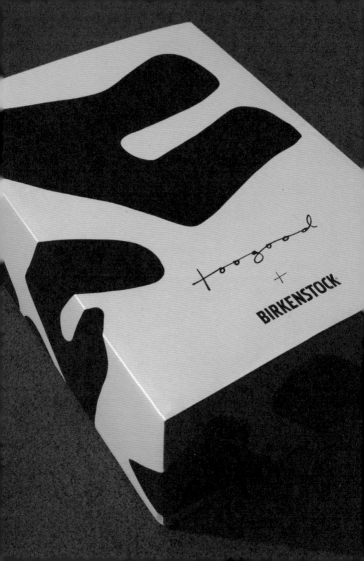

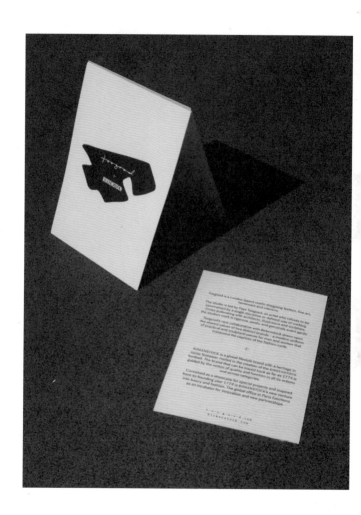

Tangiroit is a London-based crafts designing fashion, fine art, homewares and interiors.

The studio is led by Faye Tangiroit, an artist who refuses to be constrained by a single discipline or defined way of working. Crass pollinating with architects, poets, chefs and perfumers upon the studio's work is rigorous, poetic, and genuinely avant-garde.

Tangiroit's new collaboration with Birkenstock draws upon the shared values of two distinct brands – a modern uniform for practical and sculptural people for men and women that transcend the vagaries of the fashion cycle.

BIRKENSTOCK is a global lifestyle brand with a heritage in iconic footwear, rooted in the creation of the first Birkenstock footbed. The brand that can be traced back as far as 1774 is guided by the notion of quality and function in all its actions and across categories.

Conceived as a showcase for special projects and inspired from its founding year 1774 is Birkenstock's new venture into luxury and fashion. The global office in Paris functions as an incubator for innovation and new partnerships.

t-a-n-g-o-r-o-i-t.com
birkenstock.com

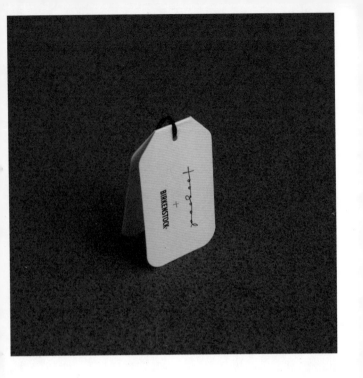

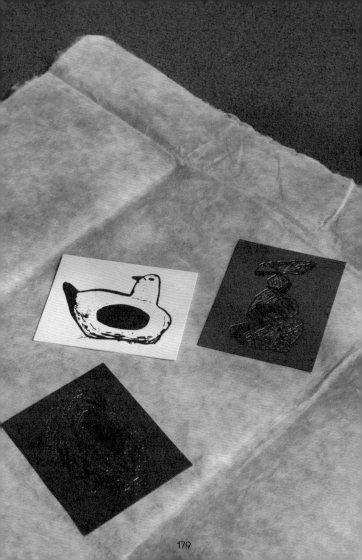

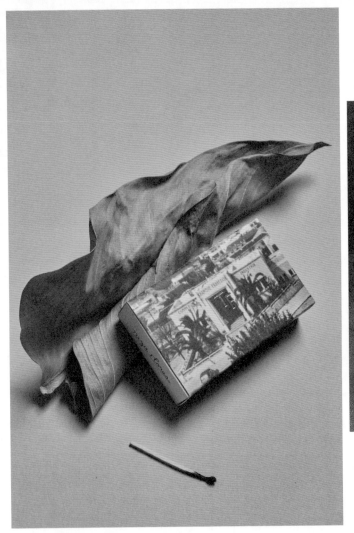

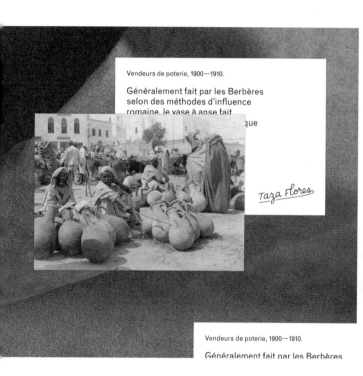

Vendeurs de poterie, 1900—1910.

Généralement fait par les Berbères
selon des méthodes d'influence
romaine, le vase à anse fait
que

Taza Flores

Vendeurs de poterie, 1900—1910.

Généralement fait par les Berbères

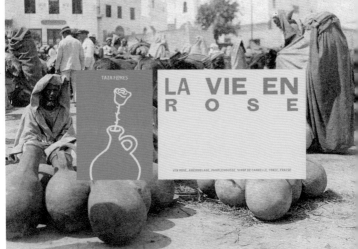

LA VIE EN ROSE

VIN ROSE, AMÉRMELADE, PAMPLEMOUSSE, SIROP DE CANNELLE, TONIC, FRAISE

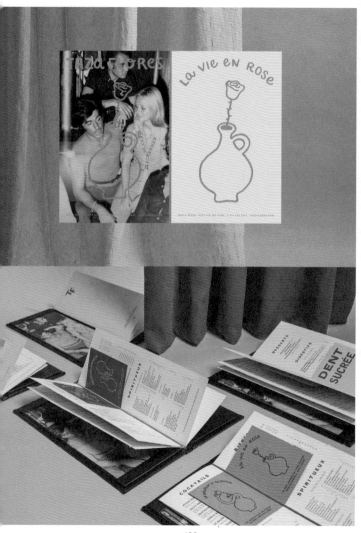

KRAS
FiLME

Rua do Araçás, 558, cj. 32. Jardim Novo,

iVAYA

KRASSiVAYA
FiLMES

+55 11 91234-4567 | prisci.porrie@gmail.com

**KRASSiVAYA
FiLMES**

krassivayafilmes.com.br
@krassivayafilmes

PRISCILLA POMERANTZEFF
priscilla@krassivayafilmes.com.br
+55 11 98558 9822

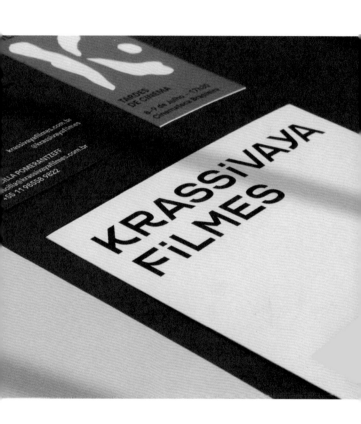

KRASSIVAYA
FILMES

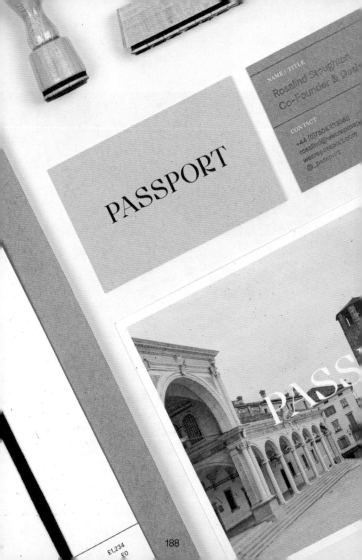

PASSPORT

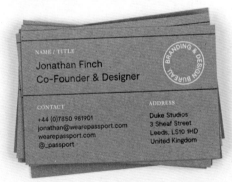

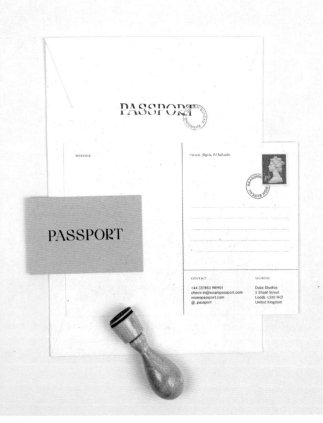

PASSPORT

BRANDING BUREAU

MESSAGE

IMAGE *Algeria, El Salvador*

BRANDING BUREAU

PASSPORT

CONTACT

+44 (0)7850 981901
check-in@wearepassport.com
wearepassport.com
@_passport

ADDRESS

Duke Studios
3 Sheaf Street
Leeds, LS10 1HD
United Kingdom

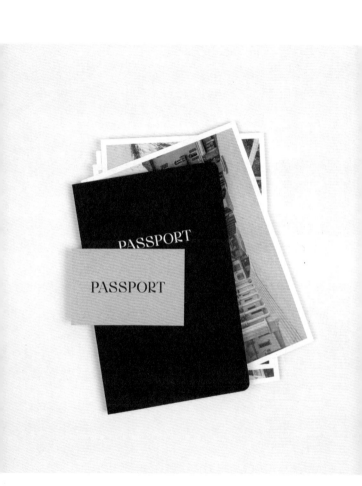

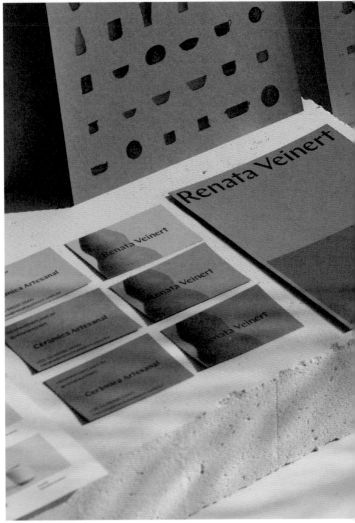

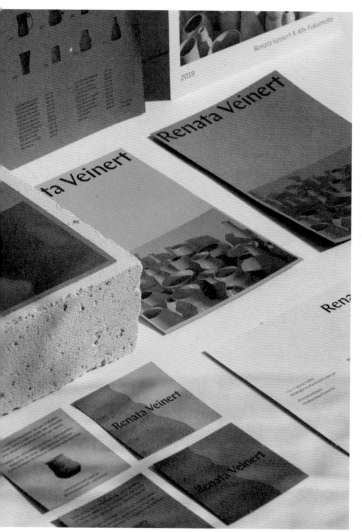

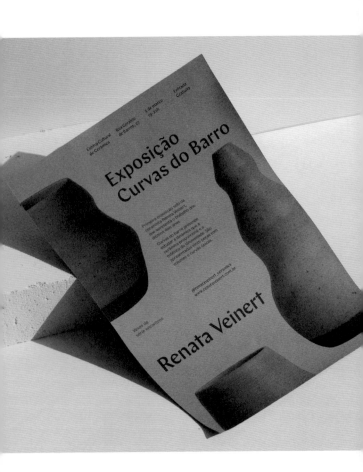

Centro Cultural
de Cerâmica

Rua Geraldo
de Barros, 27

5 de março
19-24h

Entrada
Gratuita

Exposição
Curvas do Barro

Primeira exposição solo da
ceramista Renata Veinert,
que apresenta o trabalho dos
últimos dois anos.

Curvas do Barro pretende
valorizar a beleza que a
cerâmica proporciona. São
peças de diferentes formas,
apresentando vasos junto com
esculturas e curvas sinuosas.

@renataveinert_ceramica
www.renataveinert.com.br

Vasos da
série escultórias

Renata Veinert

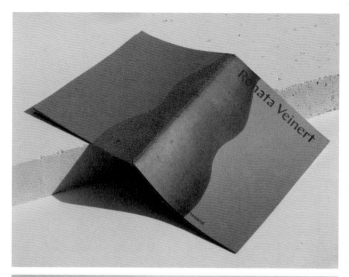

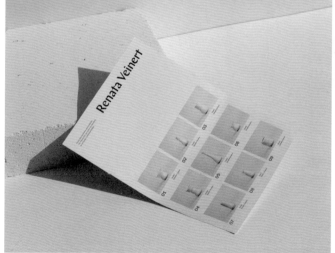

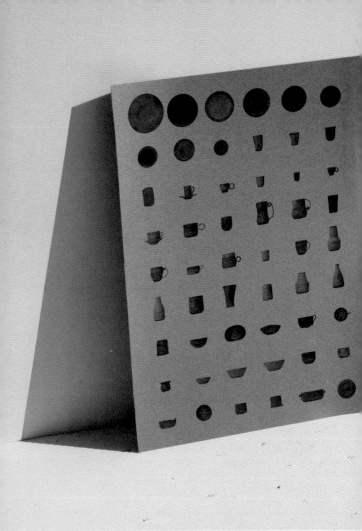

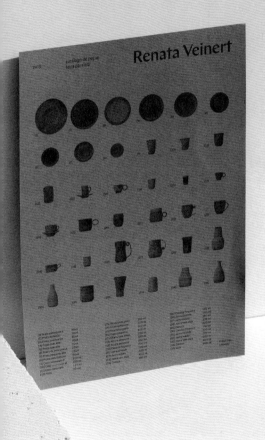

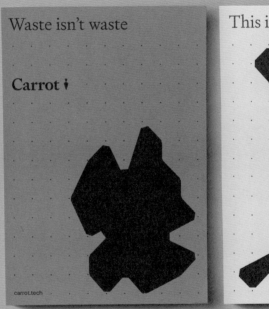

Waste isn't waste

Carrot 🥕

carrot.tech

This is val

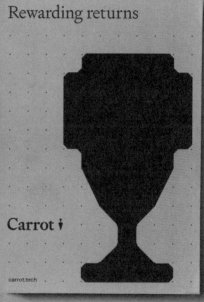

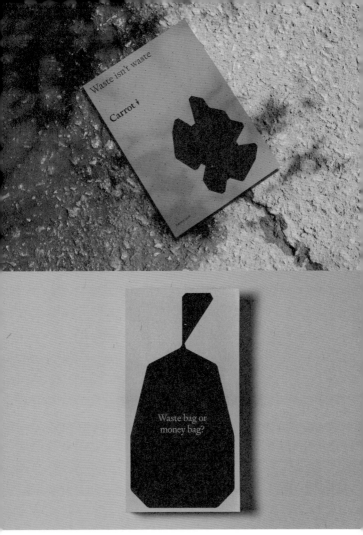

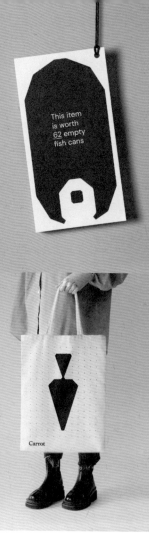

This item
is worth
<u>62</u> empty
fish cans

Carrot

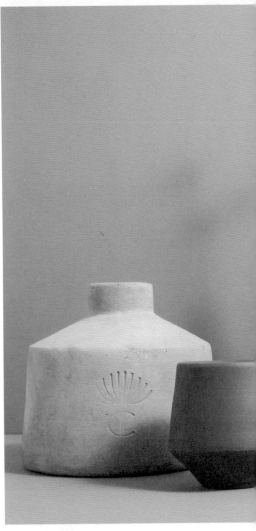

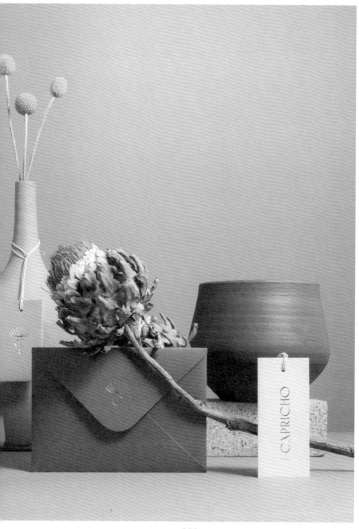

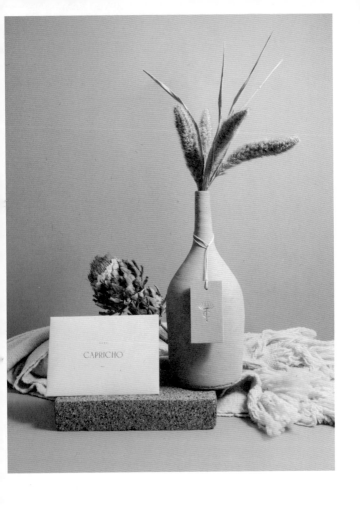

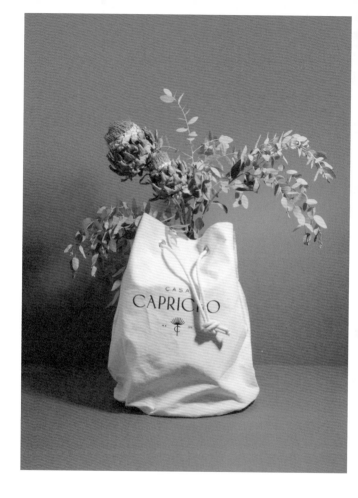

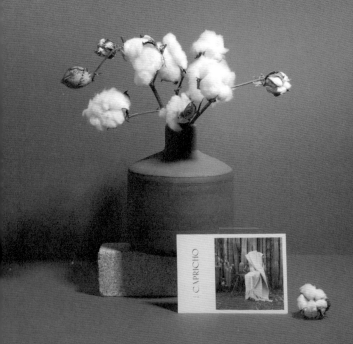

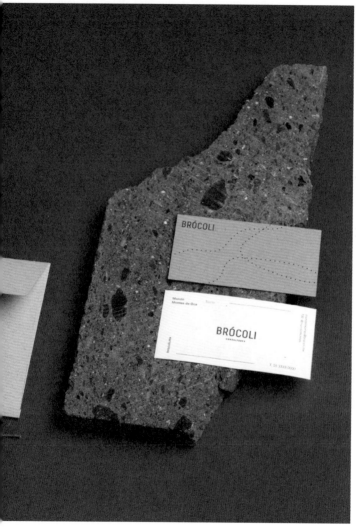

209

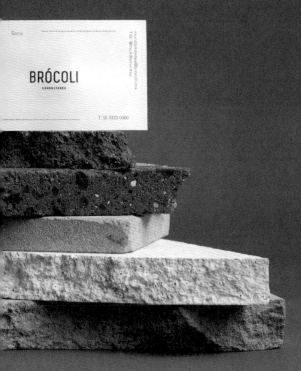

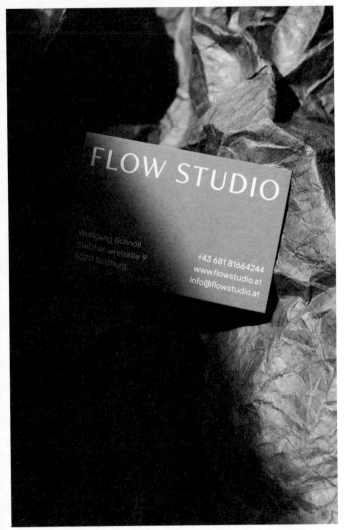

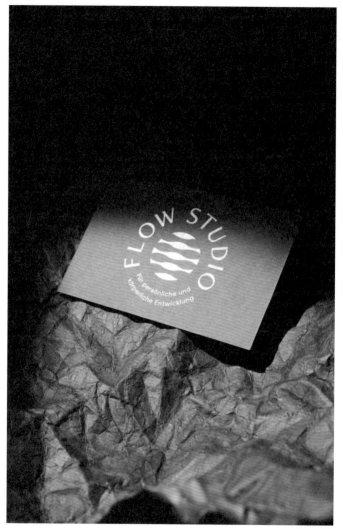

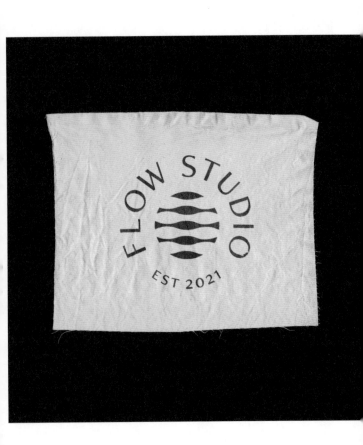

FLOW
STUDIO

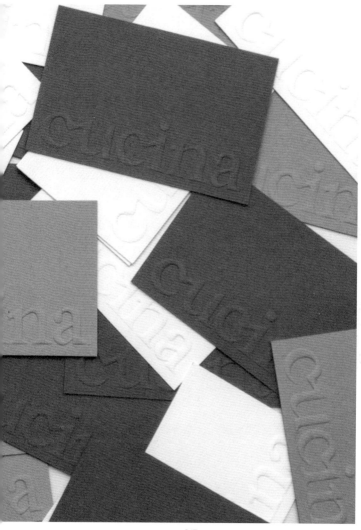

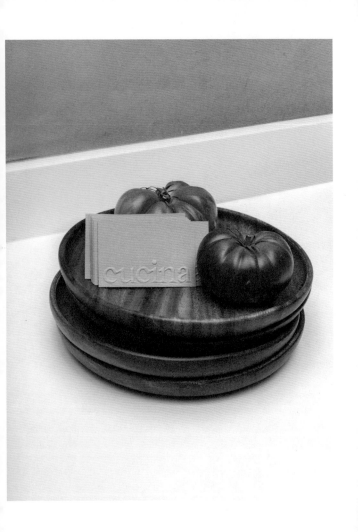

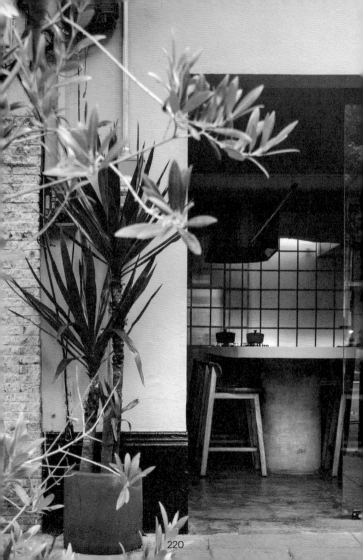

cucina

cucina.mx

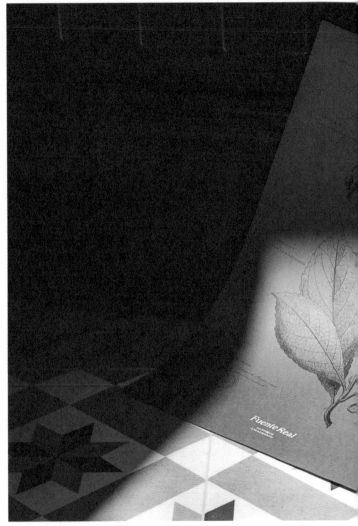

Fuente Real

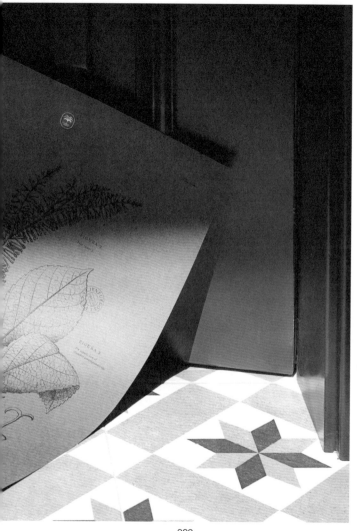

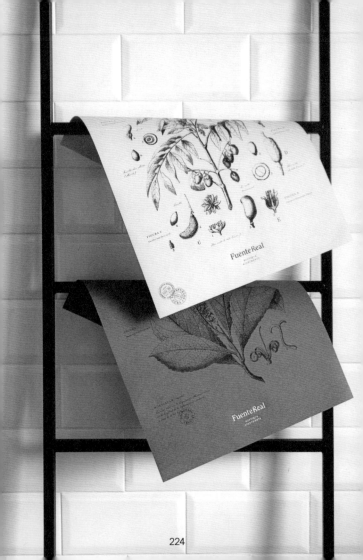

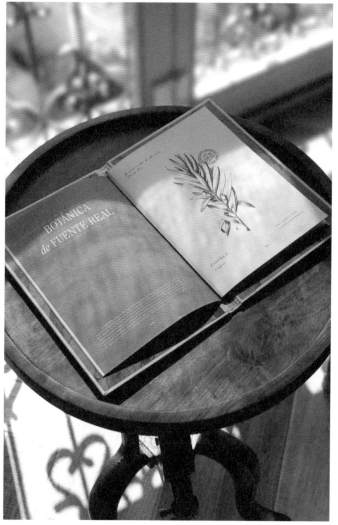

APARTAME

Punta Real es un viaje a los
tentación te ofrecen lo mejor de
que podrás

UN LUG
SOÑAR EN C

PLEASE DO
not DISTURB
POR FAVOR
NO MOLESTAR

Comillas está a apenas 10 kilómetros de Santander. Una coqueta villa a
orillas del Cantábrico que no dejará de sorprenderte; patria chica de taré
pidas refranes, célit balmeario de grandes reyes y sobre todo campo
de pruebas del modernismo de Gaudí.

GARDEN *Jardín*

PARKING

WC

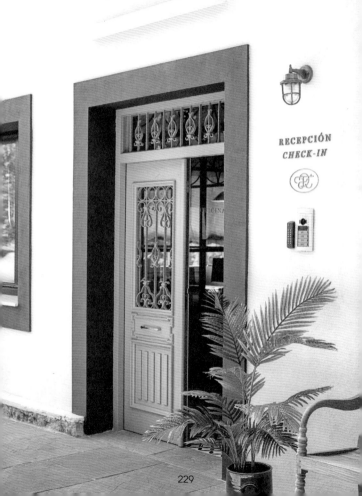

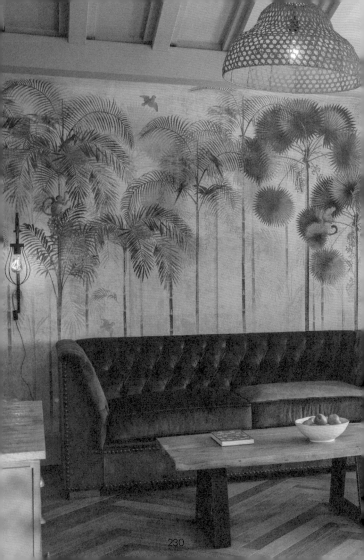

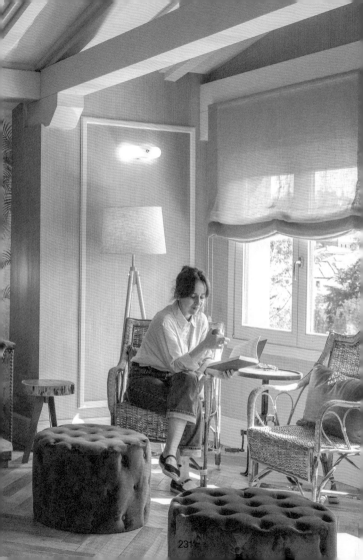

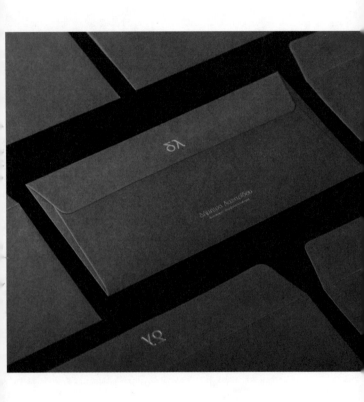

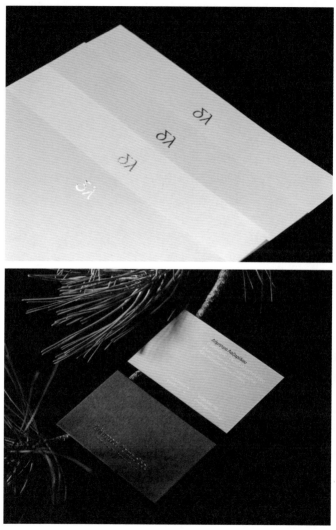

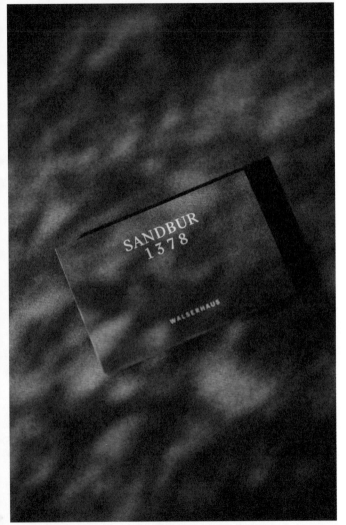

SANDBUR
1 3 7 8

WALSERHAUS

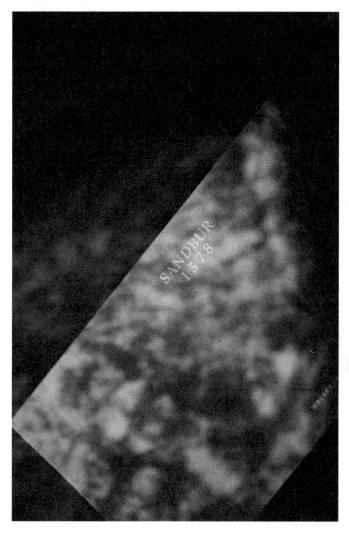

SANDBUR
1 3 7 8

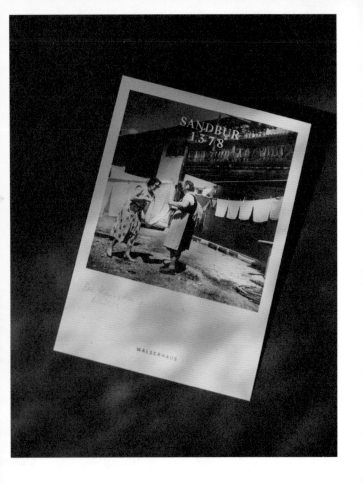

SANDBUR
1 3 7 8

WALSERHAUS

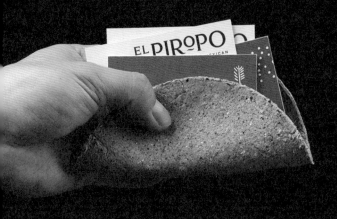

EL PIROPO

REAL ME...
FOO...

RICARDO BARRAZA
214 274 5558 / 972 423 4232
rb@elpiropo.com

www...

1422 K AVE PLANO TX, 75074

EL PIROPO

REAL MEXICAN
FOOD & ART

JOSÉ BARRAZA
214 790 8435 / 972 423 4232
jb@elpiropo.com

www.elpiropo.com

1422 K AVE PLANO TX, 75074

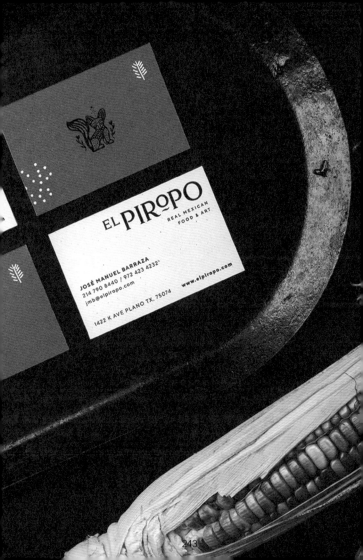

JOSÉ MANUEL BARRAZA
214 790 8840 / 972 423 4232
jmb@elpiropo.com

1422 K AVE PLANO TX, 75074 www.elpiropo.com

EL **PIROPO** REAL MEXICAN
FOOD & ART

972 423 4232
1422 K AVE PLANO TX, 75074 www.elpiropo.com

EL **PIROPO**
REAL MEXICAN
FOOD & ART

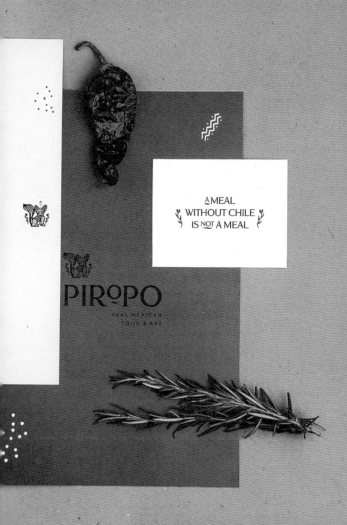

A MEAL
WITHOUT CHILE
IS NOT A MEAL

PIROPO

REAL MEXICAN
FOOD & ART

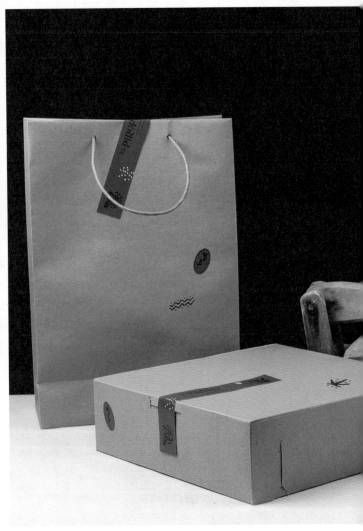

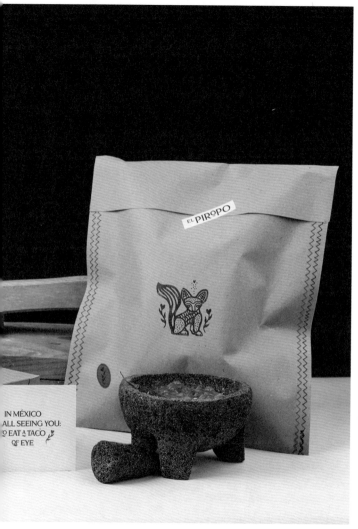

IN MÉXICO
ALL SEEING YOU:
O EAT A TACO
OF EYE

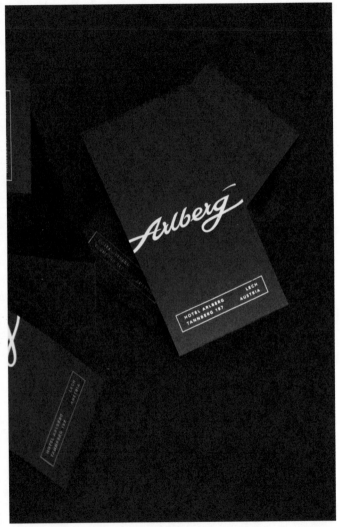

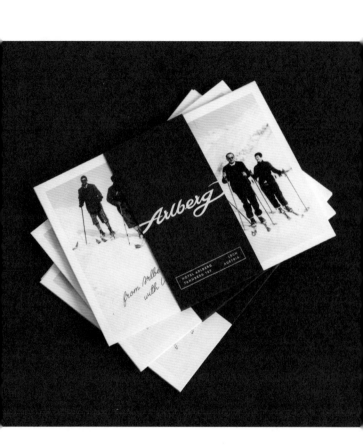

Gone Skiing

PLEASE MAKE UP MY ROOM

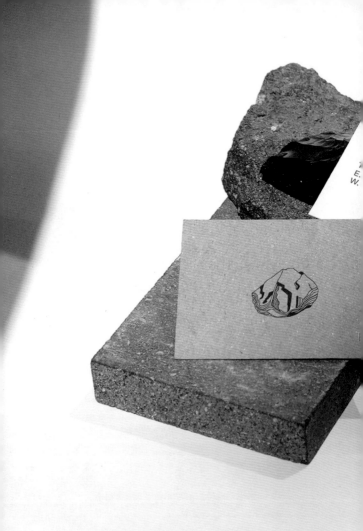

E.
W.

252

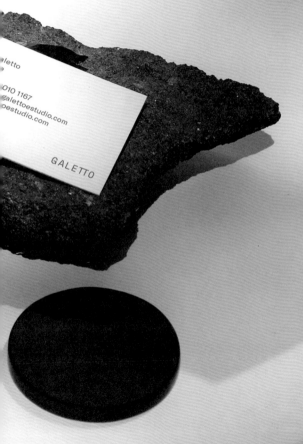

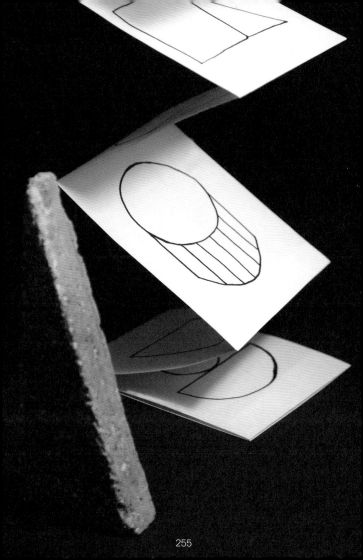

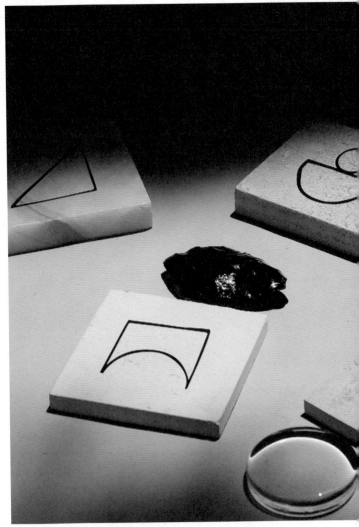

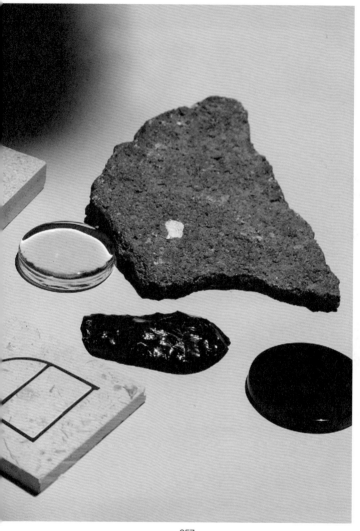

FOR THE

LOVE

OF NATURE

AND

THE CITY

FOR THE LOVE OF NATURE AND THE CITY

FOR THE
LOVE
OF NATURE
AND
THE CITY

FOR THE
LOVE
OF NATURE
AND
THE CITY

FOR THE
LOVE
OF NATURE
AND
THE CITY

FOR THE
LOVE
OF NATURE
AND
THE CITY

FOR THE
LOVE
OF NATURE
AND
THE CITY

FOR THE
LOVE
OF NATURE
AND
THE CITY

FOR THE
LOVE
OF NATURE
AND
THE CITY

FOR THE
LOVE
OF NATURE
AND
THE CITY

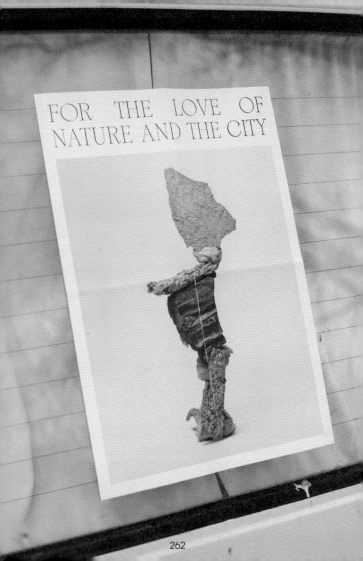

FOR THE LOVE OF
NATURE AND THE CITY

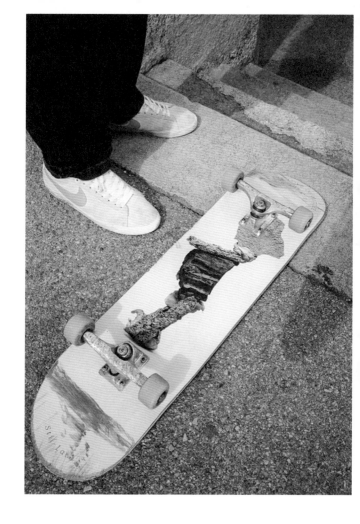

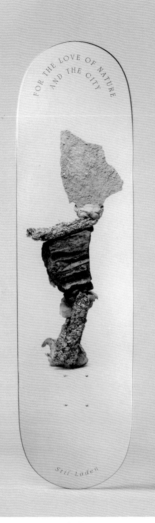

FOR THE LOVE OF NATURE
AND THE CITY

Stil-Laden

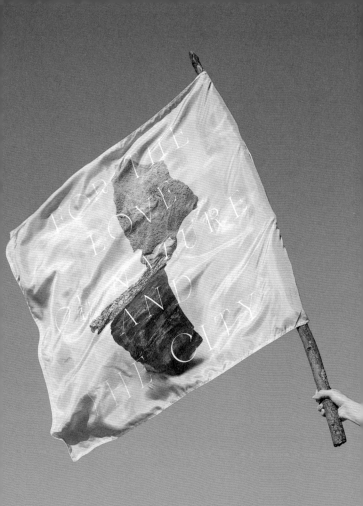

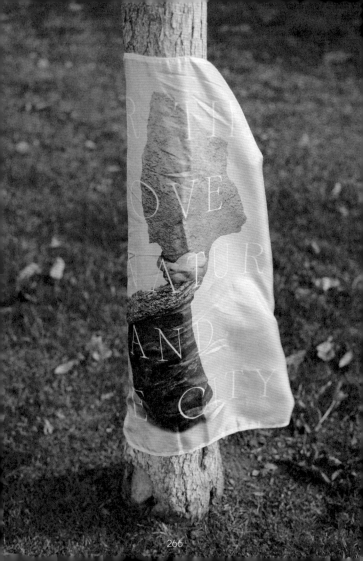

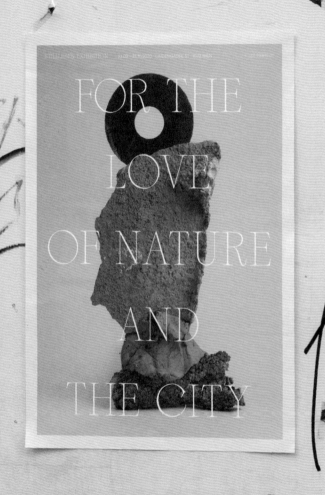

FOR THE
LOVE
OF NATURE
AND
THE CITY

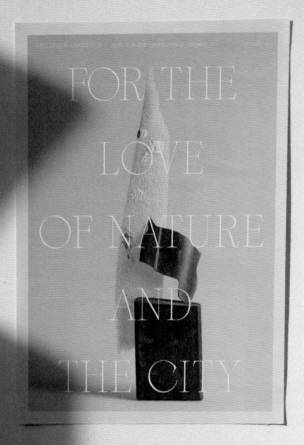

FOR THE
LOVE
OF NATURE
AND
THE CITY

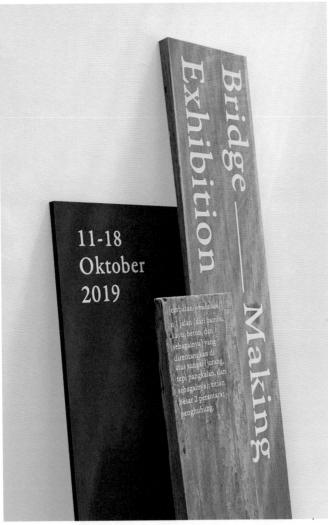

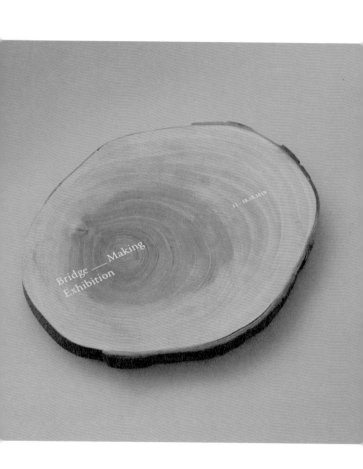

Bridge —— Making
Exhibition

11 - 18.08.2019

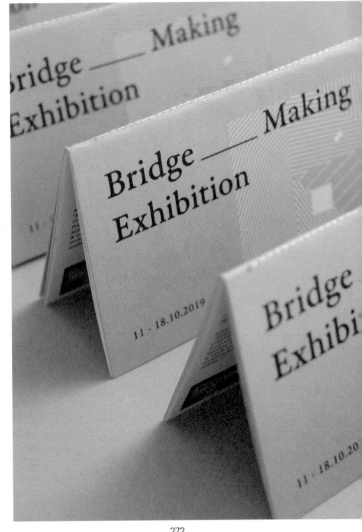

272

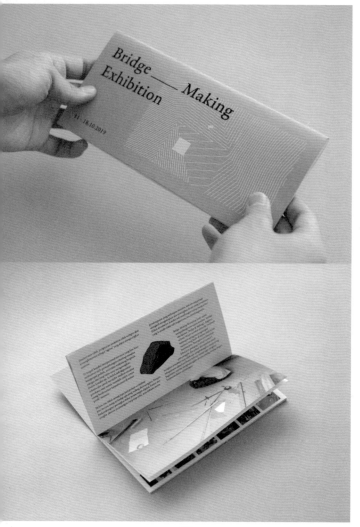

Bridge ____ Making
Exhibition

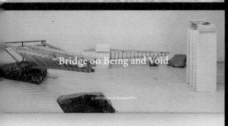

Bridge on Being and Void

by Alf Hafram & Raushan Efari

12

Lokakarya tersebut melibatkan seti
6 pelajar dari 3 perguruan tinggi be
Dikelompokkan ke dalam 3 regu terc
acak, pendekatan ini sengaja dilaku
untuk meredam identitas institusion
menghadirkan wawasan pembelajar
bersama yang menyegarkan. Sebaga
perancangan, jembatan dalam hal in
memberikan pandangan yang baru, ia memiliki ambivalen
menuntut pelajar untuk bertindak secara bijak sebagai ars
insinyur dan perhitungan sekaligus. Menariknya, di luar
jawab utilitarian sebuah jembatan, perancangan jembata
keluar sebagai 3 proposal dari 3 kelompok peserta lokak
dapat mendefinisikan dirinya melalui pendekatan estetis,
moral yang kritis, melepaskan belenggu akan peran jemb
yang semata-mata berkerja sebagai infrastruktur transpor
penyokong kegiatan ekonomi di dunia modern.

"Built to contest and reflect the vanity of
earthly life, the bridge designed as
a one-way cantilever timber structure
with tensile strength optimization."

13

gan roh dan tubuh yang utuh.
n jembatan.

Disadari atau tidak, pengajaran arsitektur tidak terlepas dari kemungkinannya sebagai 'agensi' yang dapat mengasingkan manusia.

Di tengah kondisi interpersonal manusia yang kini kian terdistansi oleh perkembangan teknologi maupun ketegangan politik, arsitektur terkadang bergerak sebagai alat yang turut serta mengasingkan. Dalam kondisi ini, ia boleh jadi digunakan sebatas alat untuk menjadikan struktur-struktur pembatas atau semat untuk meraihi inilah sensasi ruang berdasarkan kenyamanan di antara 'profil' manusia.

Di lain sisi, tidak jarang juga para pelajar arsitektur kini merasa asing terhadap apa yang sedang dirancangnya. Dengan berkembangnya perangkat halus perancangan digital, format dan templat elemen perancangan yang siap salin, atau bahkan sistem

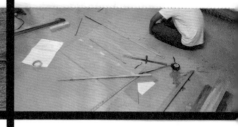

pembangunan yang terlampau otomatis, kini seorang pelajar seringkali mengasingkan dan terasingkan di saat yang bersamaan. Dalam kondisi ini, ia boleh jadi membangun ruang-ruang isolasi yang ia sendiri tidak tahu bagaimana cara membangunnya.

Bridge-Making Workshop hadir untuk mengimbangi arus narasi tersebut. Melalui dua lipatan [Bridge & Making], kegiatan selama 10 hari tersebut mencoba menjawab tantangan mengenai pengasingan manusia yang hadir di dalam teluk beluk bertarsitektur. Berangkat dari bentukan lokakarya pedagogi Critical Context*, para pengajar dan pelajar ditempatkan untuk mengkaji arsitektur yang tidak saja menghubungkan ruang-ruang sebagaimana sebuah jembatan bekerja, namun juga mengenai bagaimana mereka menghubungkan dirinya masing-masing dengan kenyataan dalam membangun.

an tangan, pengaturan material, juga iterasi pembuatan ng ulang pada akhirnya yang menjadi pisau asah dalam tersebut. Tanpa penggunaan perangkat halus perancangan digien, para pelajar distimulasi untuk mengasah kembali berbikir dan menggerakan tangannya dengan lebih medjiari alat-alat dan mesin kembangan kayu dalam tsingkat, membangun model dari skala 1:200 hingga nai pada garis yang tidak sempurna dalam lembaran-rus, membangun dan menyusun apa yang ia rancang

ing Exhibition mencoba merangkum mengenai apa nebuh dari lokakarya tersebut. Sebuah memori kolektif lan orang asing, yang akhirnya mengenal sebuah sa, pertemanan, dan dirinya sendiri dengan lebih dekat.

*alah laboratorium pengembangan pedagogi [free programme] pendidikan arsitektur
distimulasi pada tahun 2017 olek sebelumpeak untuk dan praktik arsitektur

"Bridge the River" Bridge

by Gunha Damorik & Reza Bishoqi

Bridge — Making
Exhibition

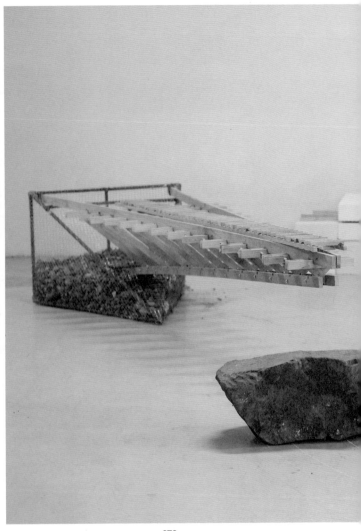

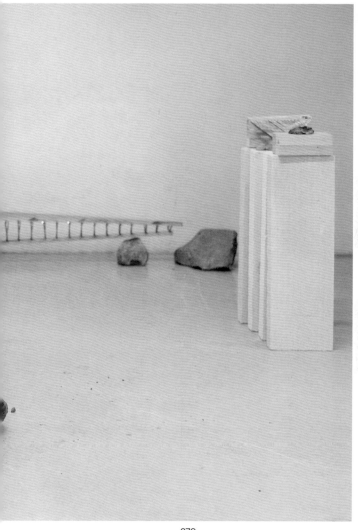

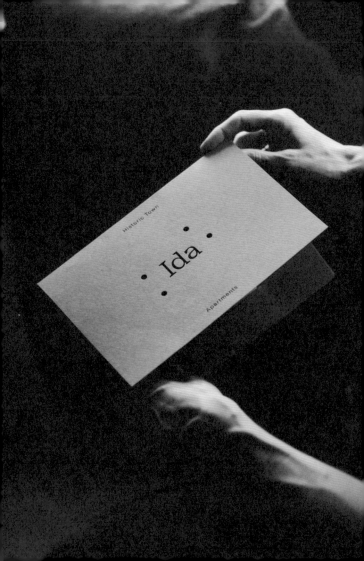

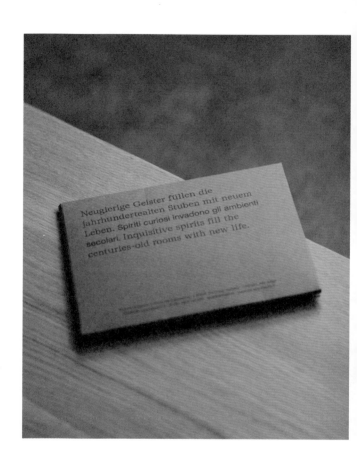

Neugierige Geister füllen die jahrhundertealten Stuben mit neuem Leben. Spiriti curiosi invadono gli ambienti secolari. Inquisitive spirits fill the centuries-old rooms with new life.

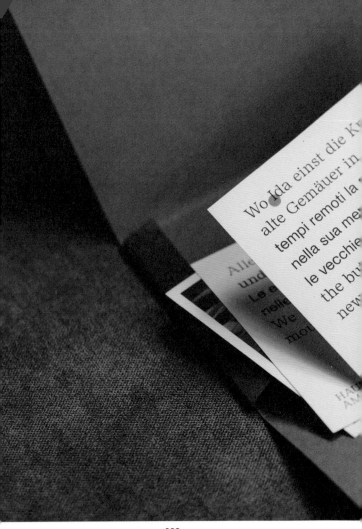

Wo Ida einst die Kr
alte Gemäuer in
tempi remoti la
nella sua me
le vecchie
the bu
new

Alle
und
Le e
riello
We
mou

HA
AM

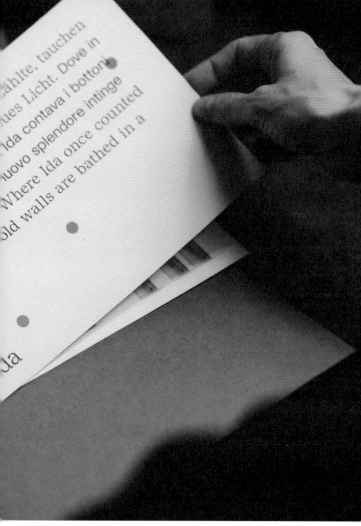

ählte, tauchen
ues Licht. Dove in
Ida contava i bottoni
nuovo splendore intinge
Where Ida once counted
old walls are bathed in a

da

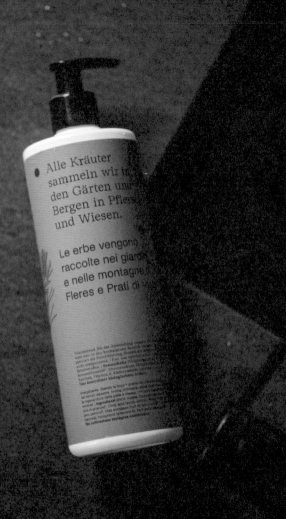

Alle Kräuter
sammeln wir in
den Gärten und
Bergen in Pflers
und Wiesen.

Le erbe vengono
raccolte nei giardini
e nelle montagne di
Fleres e Prati di Vizze.

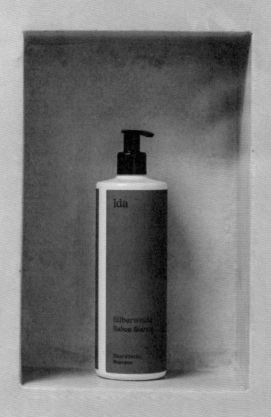

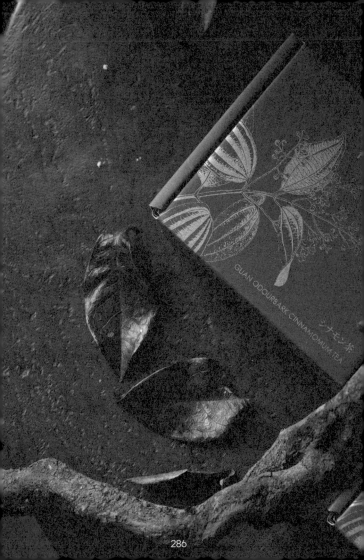

GUAN ODOURBARK CINNAMOMUM TEA

シナモン茶

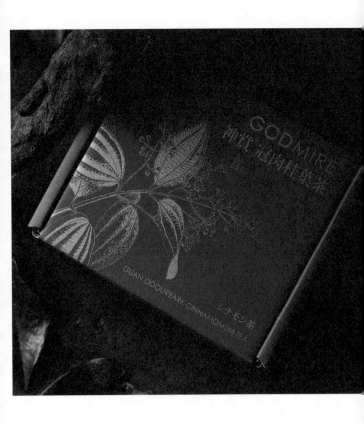

GOD MIRE

桐宜 山肉桂葉茶

GUAN ODOURBARK CINNAMOMUM TEA シナモン茶

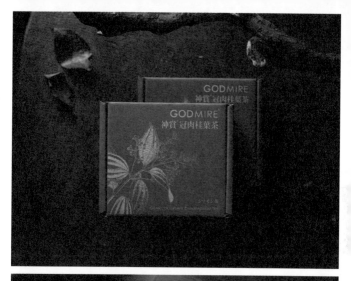

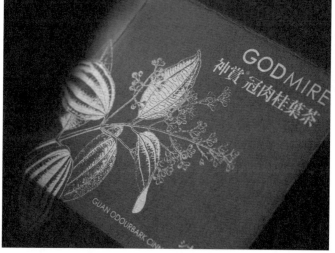

"An earthy colour palette gives people a sense of stability and peace of mind, giving brands a more reassuring appeal."

COCO
MEAL

Dewy Secret cocoa

可可代餐　15 Packets

DEWY
SECRET

Creative Direction

natalieturnbull.com.au

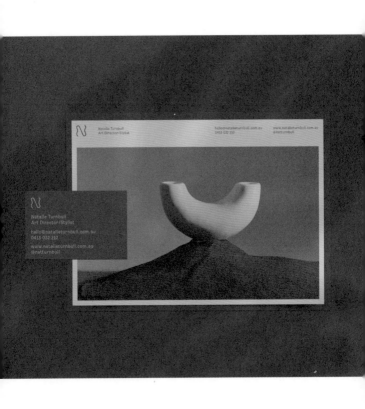

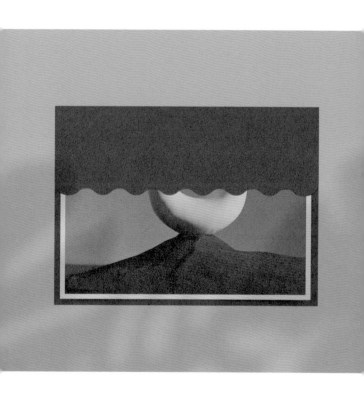

hello@natalieturn
0413 032 212

www.natalieturn
@natturnbull

N

Natalie Turnbull
Art Director/Stylist

hello@natalieturnbull.com.au
0413 032 212

www.natalieturnbull.com.au
@natturnbull

N

N

Natalie Turnbull
Art Director/Sty

hello@natalietur
0413 032 212

www.natalieturn
@natturnbull

N

Natalie Turnbull
Art Director/Stylist

hello@natalieturnbull.com.au
0413 032 212

www.natalieturnbull.com.au
@natturnbull

N

Natalie Turnbull
Art Director/St

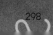

N

Natalie Turnbull
Art Director/Stylist

hello@natalieturnbull.com.au
0413 032 212

www.natalieturnbull.com.au
@natturnbull

N

Natalie Turnbull
Art Director/Stylist

hello@natalieturnbull.com.au
0413 032 212

www.natalieturnbull.com.au
@natturnbull

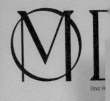

Since 19

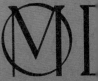

Since 19

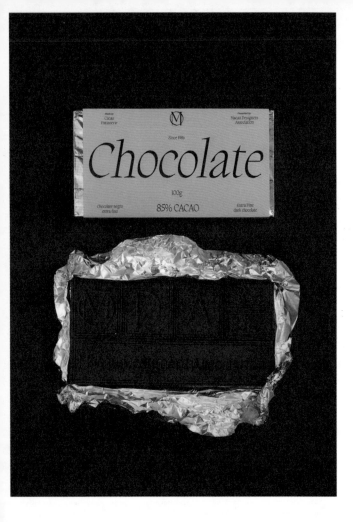

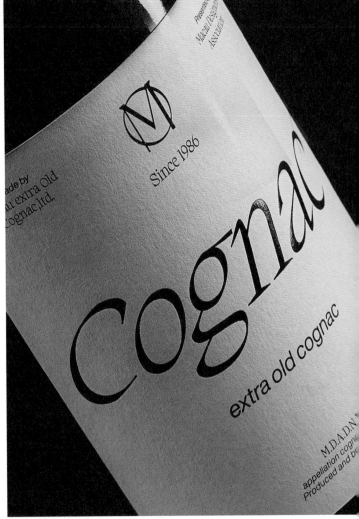

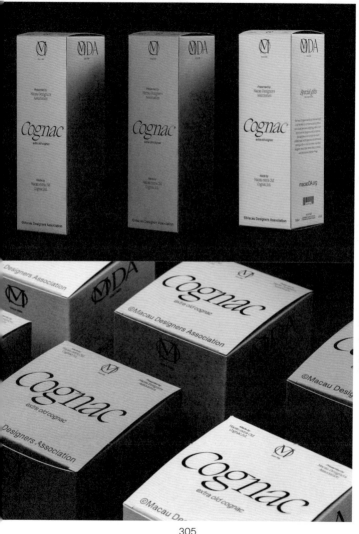

305

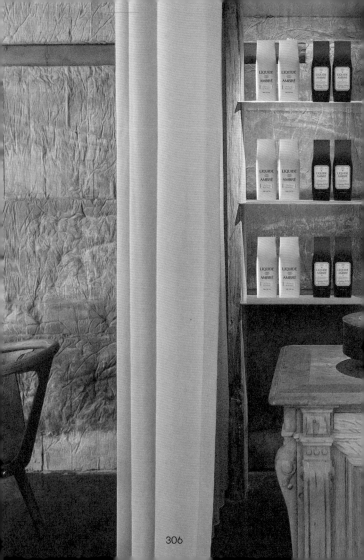

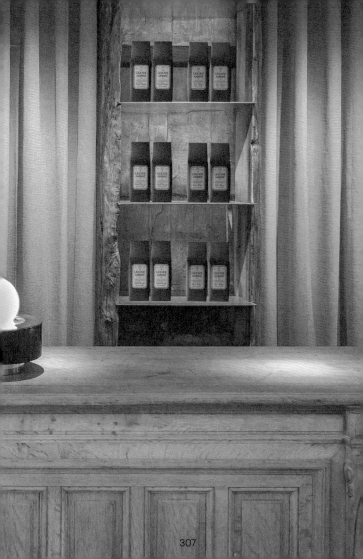

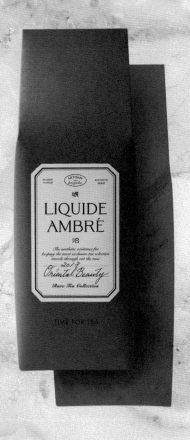

ARTISAN
bespoke

DELICATE AESTHETIC
FLAVOUR SENSE

埌

LIQUIDE
AMBRÉ

泊

*The aesthetic existence for
keeping the most exclusive tea selection
travels through out the time*

2018
Oriental Beauty

Rare Tea Collection

TIME FOR TEA

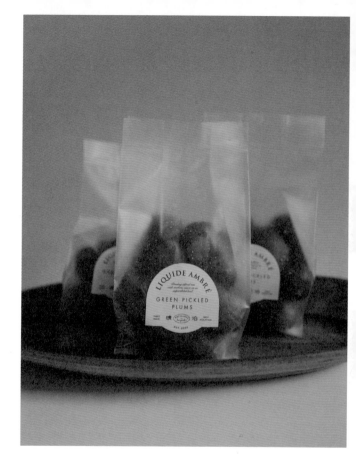

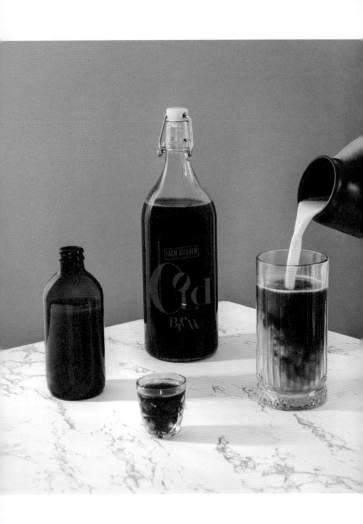

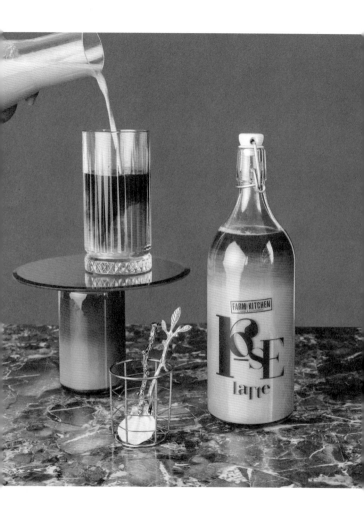

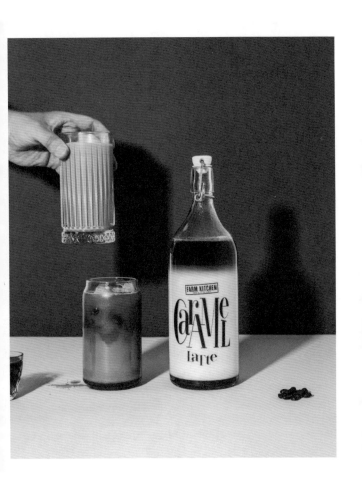

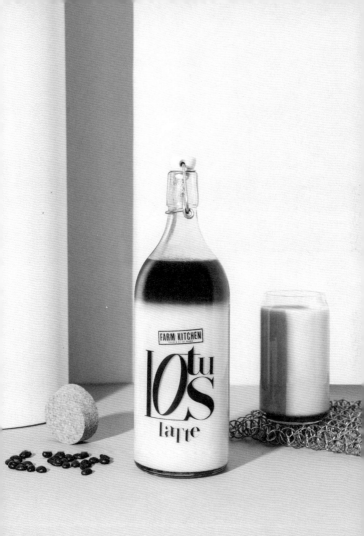

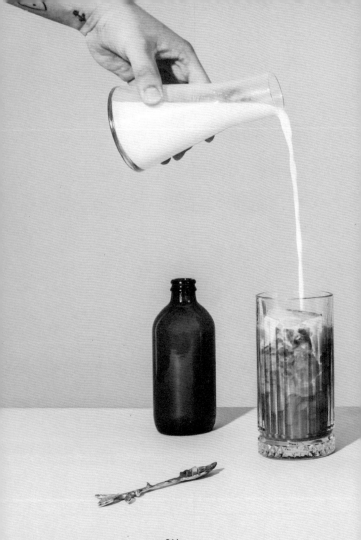

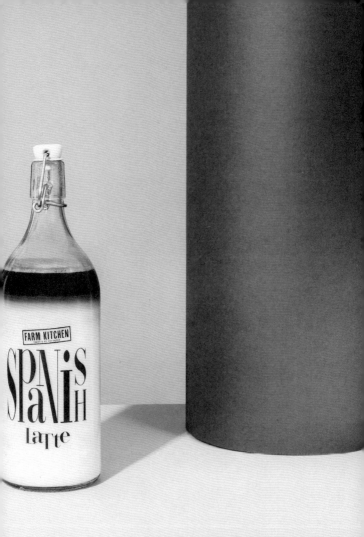

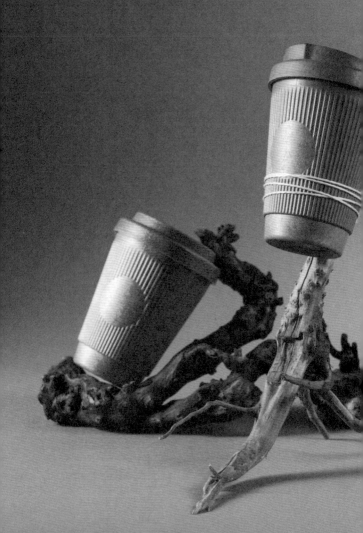

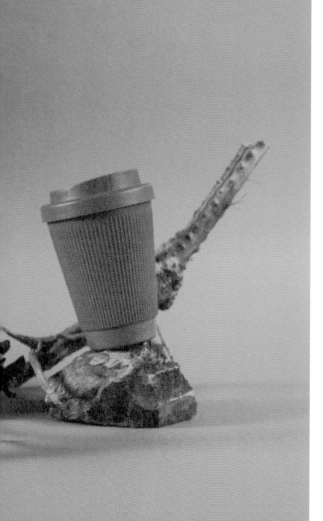

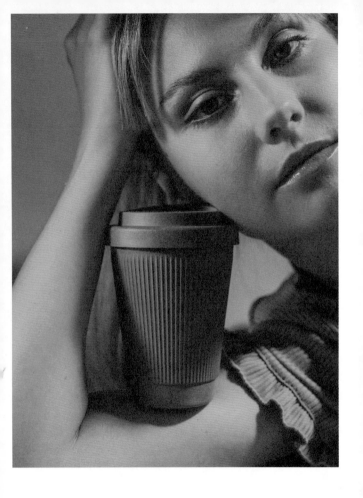

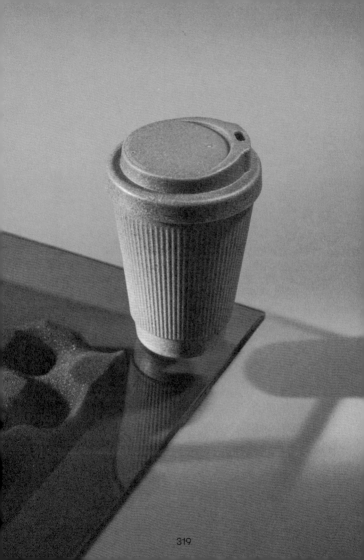

"Natural colours become relevant as they immediately establish an emotional connection with nature and the feelings of wellbeing, prompting viewers to seek reconnection with their bodies."

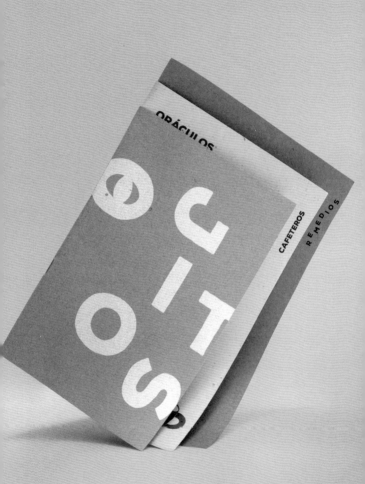

ORÁCULOS

CAFETEROS

REMEDIOS

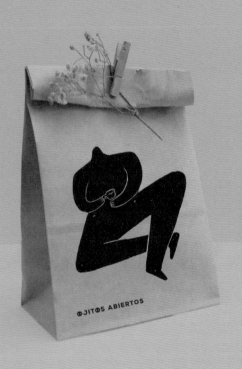

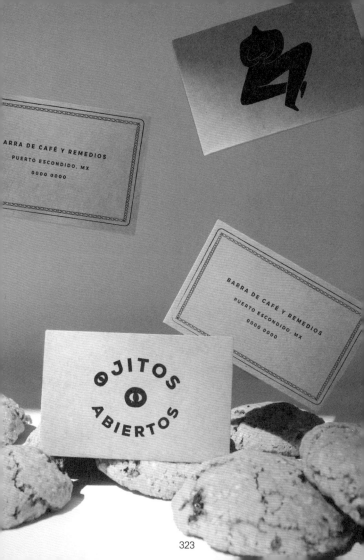

ARRA DE CAFÉ Y REMEDIOS
PUERTO ESCONDIDO, MX
0000 0000

BARRA DE CAFÉ Y REMEDIOS
PUERTO ESCONDIDO, MX
0000 0000

OJITOS
ABIERTOS

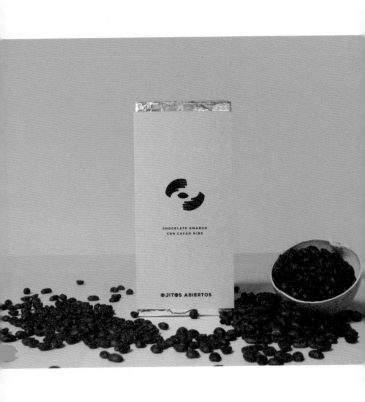

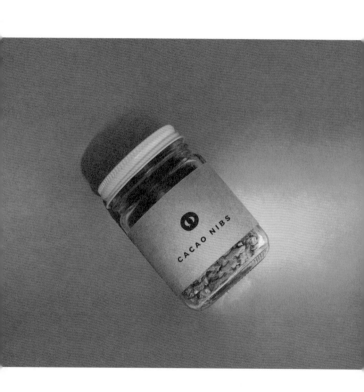

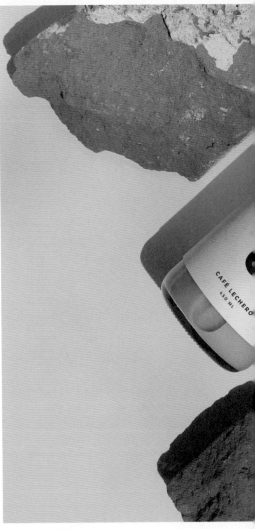

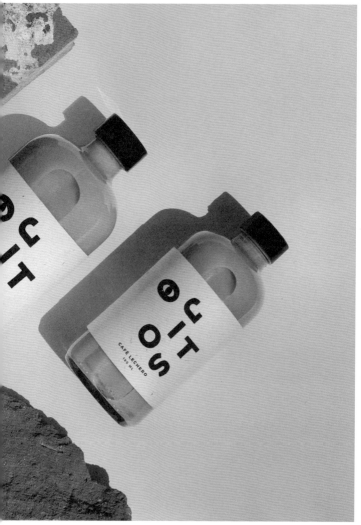

ARCAD

Red Wine
semisweet

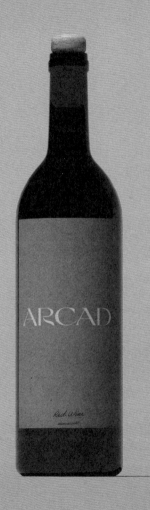

4X c 2x500ml ℮

EXTRA VIRGIN OLIVE OIL

Harvested from the rich hills of Sintra, *Colina™* celebrates heritage, innovation and practicality. Our products are high end and rich in flavour, but affordable.

Like gold, but liquid.

Colina

Colina™

SEASONALLY HAND-SELECTED

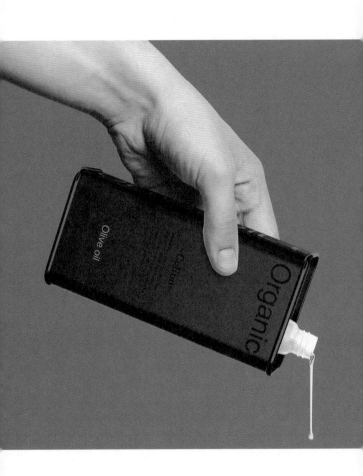

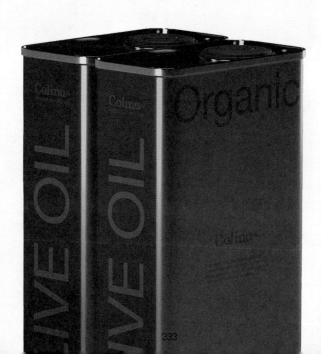

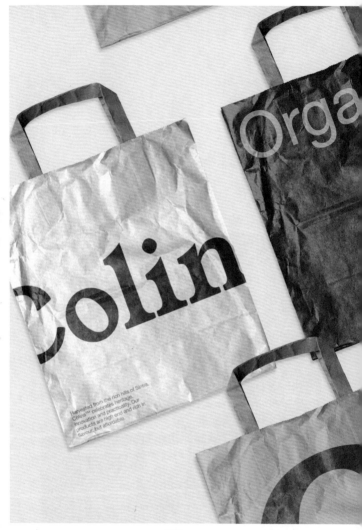

Harvested from the rich hills of Sintra,
Colina™ celebrates heritage,
innovation and practicality. Our
products are high end and rich in
flavour, but affordable.

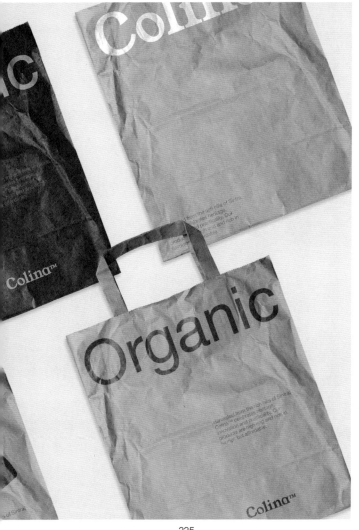

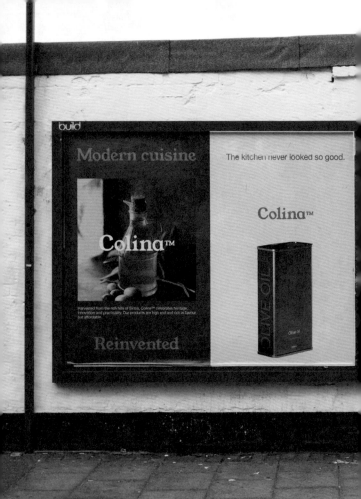

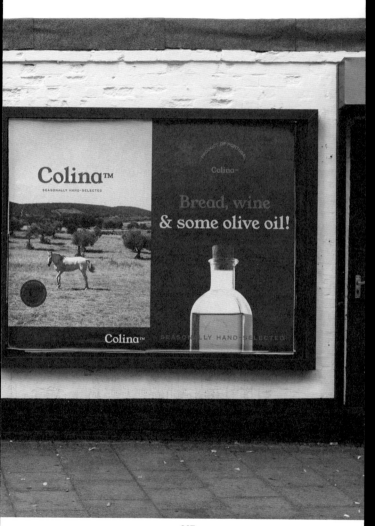

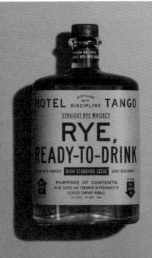

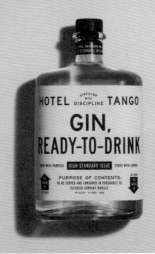

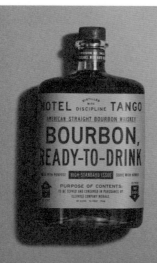

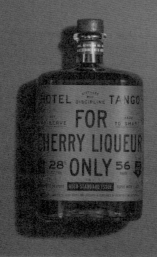

HOTEL ~RELEASE AT ONCE~ TANGO
PRINT ADVERTISEMENT

COMMISSIONED BY: A.N. DSP-IN-21004 CONTAINS: 68 WORDS

FOR THE PERSUASION OF DISCERNING
DRINKERS THAT PRODUCT SHOWN IS
DISTILLED WITH DISCIPLINE AND OF HIGHEST QUALITY

DISPLAY PROMINENTLY ⟵——————⟶ CIRCULATE FREELY

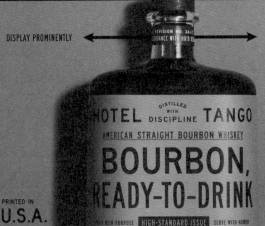

PRINTED IN
U.S.A.

DISTRIBUTED BY:

DEPARTMENT OF
STRATEGIC COMMUNICATION

HOTEL TANGO DISTILLERY
INDIANAPOLIS, IN

THE NATION'S 1ST COMBAT-DISABLED
VETERAN-OWNED DISTILLERY

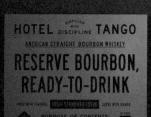
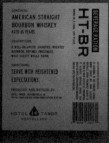
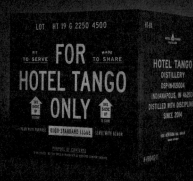

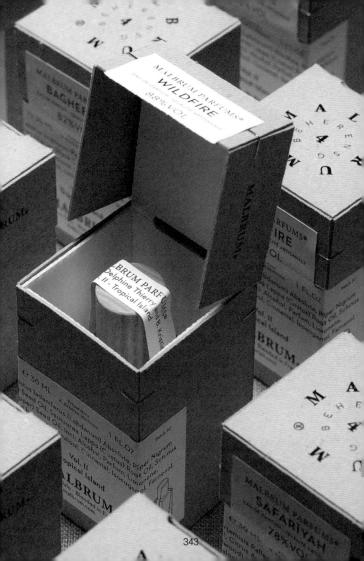

343

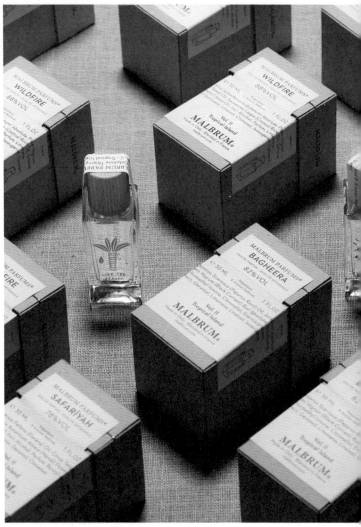

344

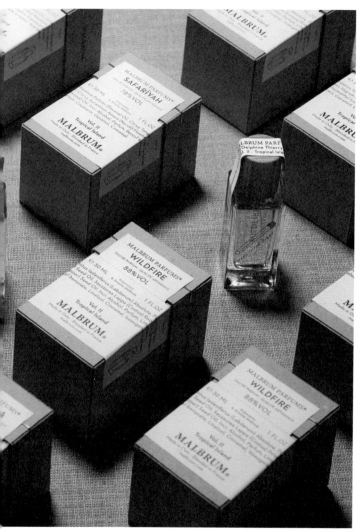

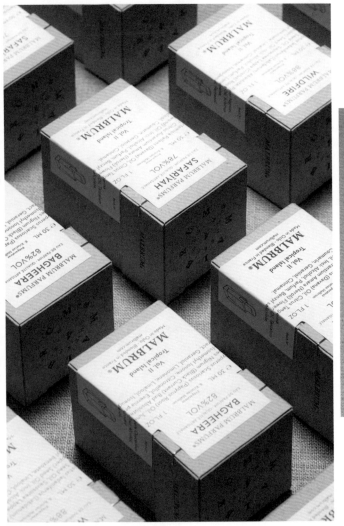

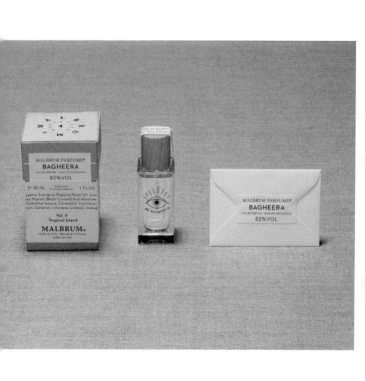

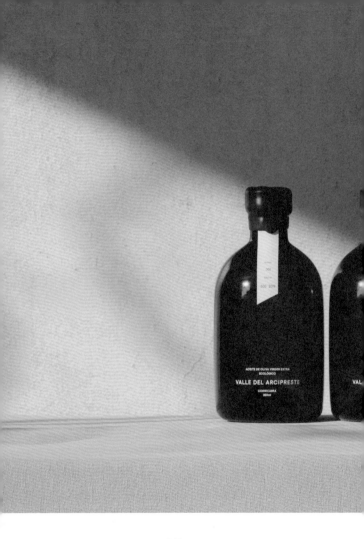

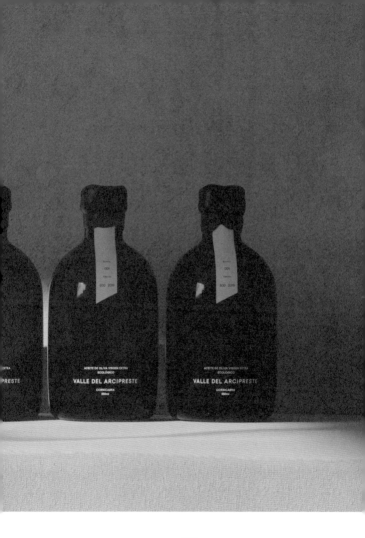

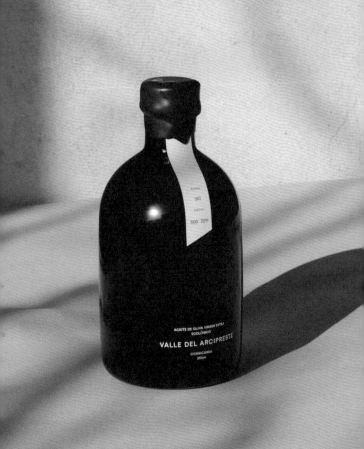

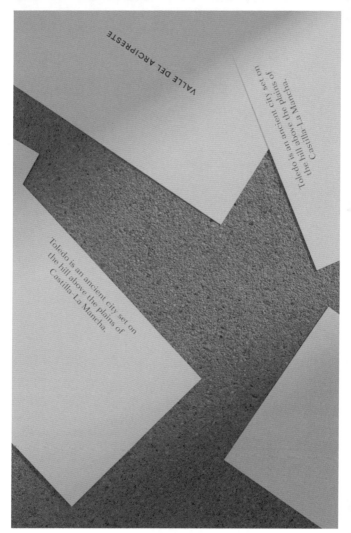

Toledo is an ancient city set on the hill above the plains of Castilla-La Mancha.

Toledo is an ancient city set on the hill above the plains of Castilla-La Mancha.

ACEITE DE OLIVA VIRGEN EXTRA
ECOLÓGICO

VALLE DEL ARCIPRESTE

CORNICABRA

Luis Tassara Fernandez
de Dordova

LUIS.D'VALLE.IT
VALLEDELARCIPRESTE.IT

MOMO
FRESHLY CRUSHED LOCALLY

MOMO

MADE CONSCIOUSLY, CRUSHED WITH INTENTION.

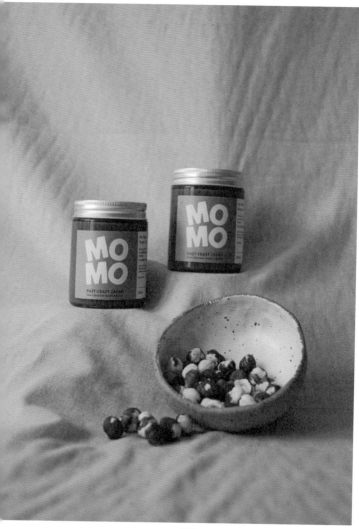

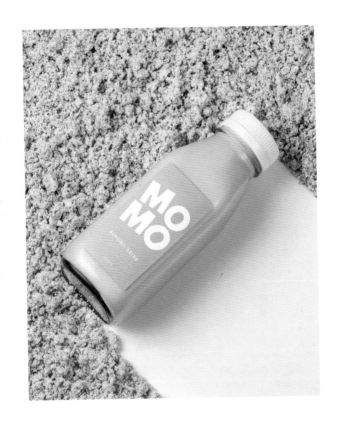

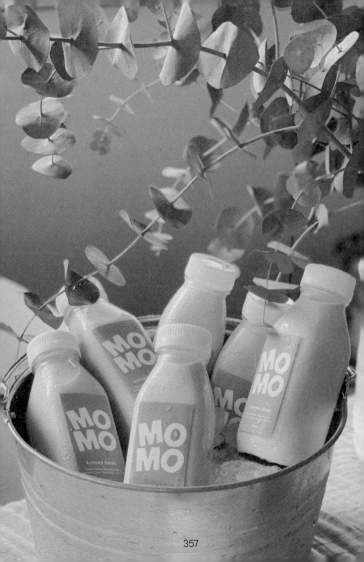

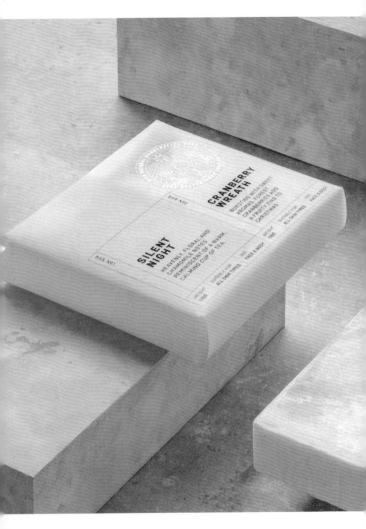

CRANBERRY
WREATH

BURSTING WITH SWEET
AROMAS, FOREST
CRANBERRIES AND
A FRUITY ZING TO
CHRISTMAS

BAR Nº2

WEIGHT
1506

SUITABLE FOR
ALL SKIN TYPES

USE
FACE & BODY

SILENT
NIGHT

HEAVENLY FLORAL AND
CHAMOMILE NOTES
REMINISCENT OF A WARM,
CALMING CUP OF TEA.

BAR Nº1

WEIGHT
1506

SUITABLE FOR
ALL SKIN TYPES

USE
FACE & BODY

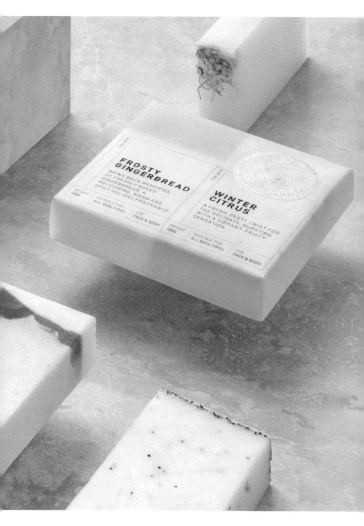

FROSTY
GINGERBREAD

BRING BACK MEMORIES
OF FRESHLY BAKED
GINGERBREAD. WARM AND
SPICY HOLIDAY FRAGRANCE.

WEIGHT
130G

SUITABLE FOR
ALL SKIN TYPES

USE
FACE & BODY

WINTER
CITRUS

A FRESH, ZESTY TWIST FOR
THE HOLIDAYS. BURSTING
WITH A VIBRANT, FRUITY
SENSATION.

WEIGHT
130G

SUITABLE FOR
ALL SKIN TYPES

USE
FACE & BODY

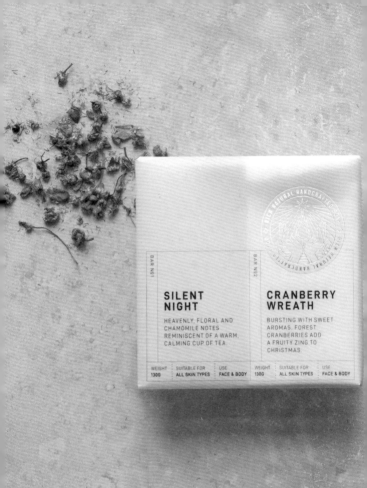

BAR №1

SILENT NIGHT

HEAVENLY, FLORAL AND
CHAMOMILE NOTES
REMINISCENT OF A WARM,
CALMING CUP OF TEA.

WEIGHT	SUITABLE FOR	USE
130G	ALL SKIN TYPES	FACE & BODY

BAR №2

CRANBERRY WREATH

BURSTING WITH SWEET
AROMAS, FOREST
CRANBERRIES ADD
A FRUITY ZING TO
CHRISTMAS

WEIGHT	SUITABLE FOR	USE
130G	ALL SKIN TYPES	FACE & BODY

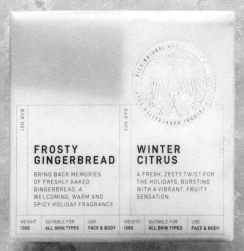

菊糕點

Chu Dessert

om

chudessert

烘焙師

洪菊霜

0937-476-788

嘉義縣民雄鄉東

chudessert.c

chudessert.

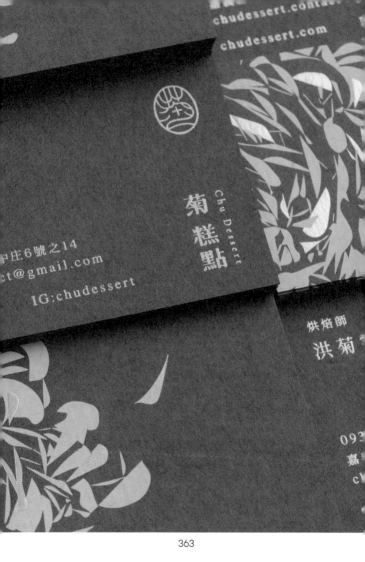

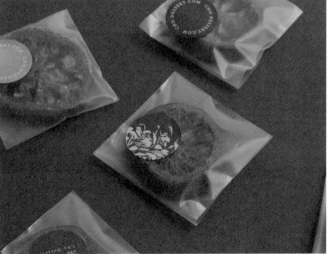

菊
糕
點

Chu Dessert

菊
糕
點

Cha Dessert

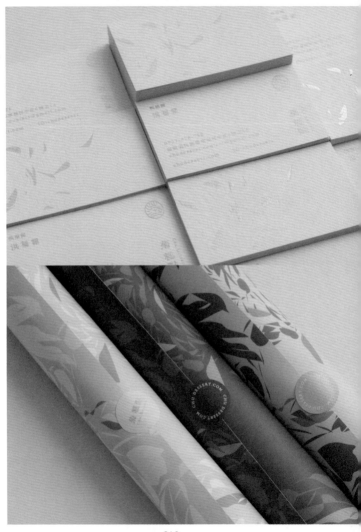

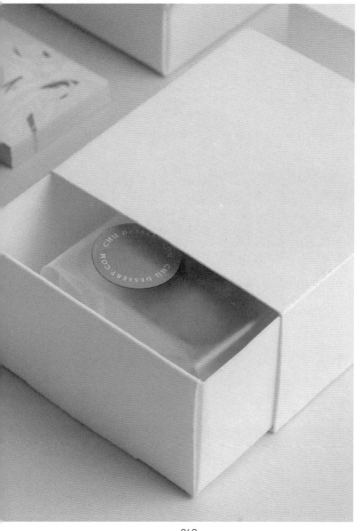

"It is impossible not to find fascinating all the processes that nature takes to achieve certain colours and shapes. Some of them are just phenomenal and inspiring."

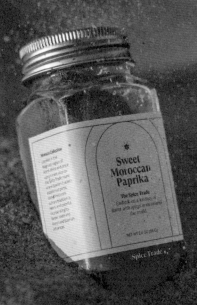

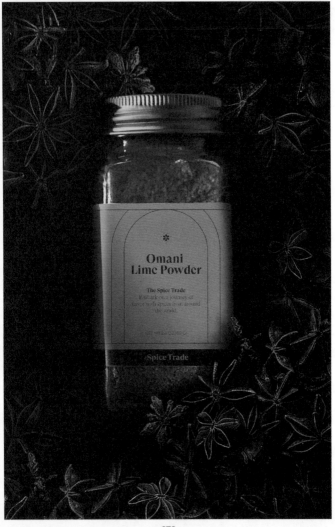

Omani
Lime Powder

The Spice Trade

Embark on a journey of
flavors & spices from around
the world.

NET WT 2.47 OZ/68 G

Spice Trade

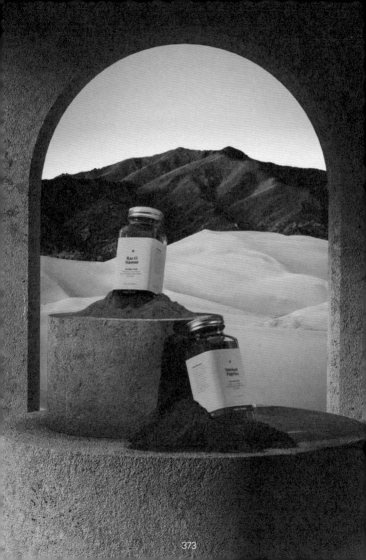

01

Pepp

Oreg

Furi

Cinnamon

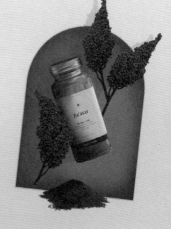

World
Collection

Za'atar

The Spice Trade

o a
'h
vo
rie
ite,
the
ing
this
us.

A WINDOW TO A
WORLD OF FLAVOR

375

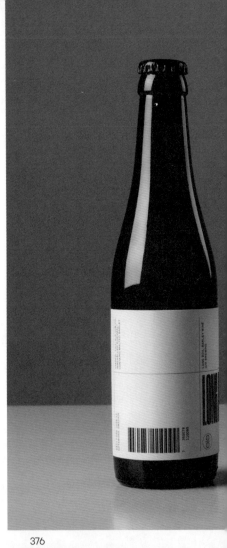

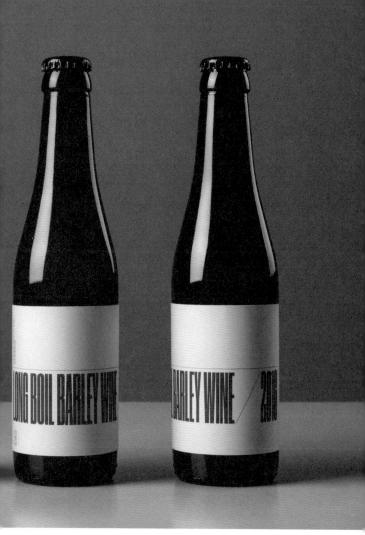

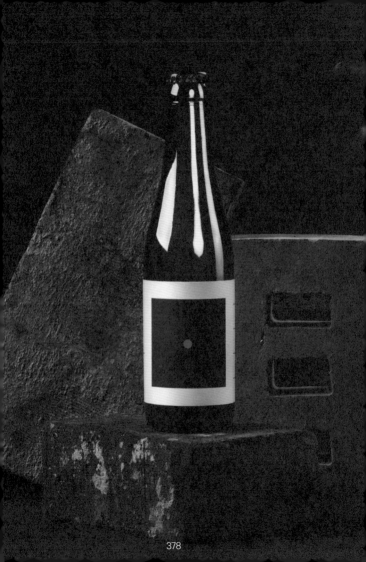

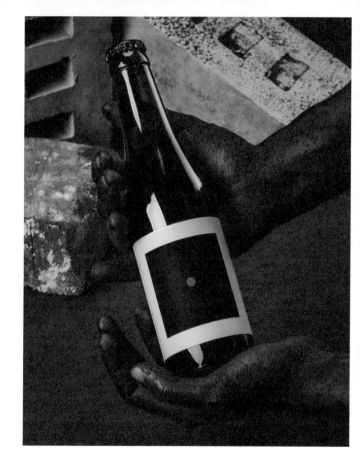

Narangi
0/0 Brewing
33cl. 6.8%

NARANGI IPA: AN IPA MADE WITHOUT ANY FRUIT. ONLY HOPS
UNFILTERED AND UNPASTEURISED. STORE COLD, DARK AND UPRIGHT.
INNEHÅLLER: KORNMALT, VETEMALT, HUMLE, JÄST OCH VATTEN
INGREDIENTS: MALTED BARLEY, WHEAT, HOPS, YEAST AND WATER
STARKÖL. 330ML. ALK. 6.8% VOL.

ART: ORANGE/BINOI. ILLUSTRATION, LUNDGREN/

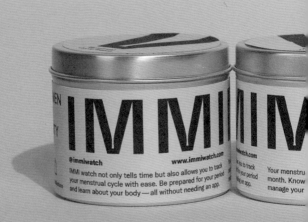

HEN
...TY

@immiwatch www.immiwatch.com

IMMI watch not only tells time but also allows you to track
your menstrual cycle with ease. Be prepared for your period
and learn about your body — all without needing an app.

...watch.com

...u to track
...r your period
...ing an app.

Your menstru...
month. Know...
manage your...

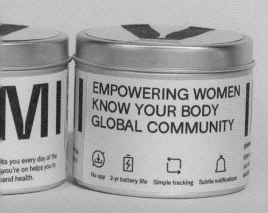

its you every day of the
you're on helps you to
and health.

MI

EMPOWERING WOMEN
KNOW YOUR BODY
GLOBAL COMMUNITY

No app 2-yr battery life Simple tracking Subtle notifications

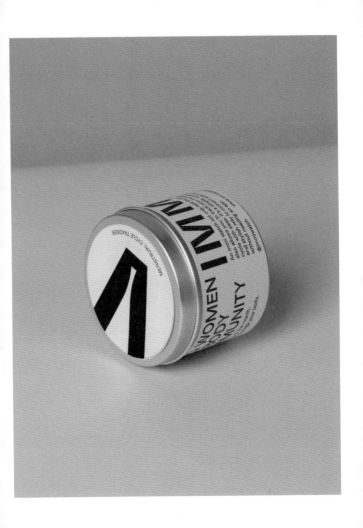

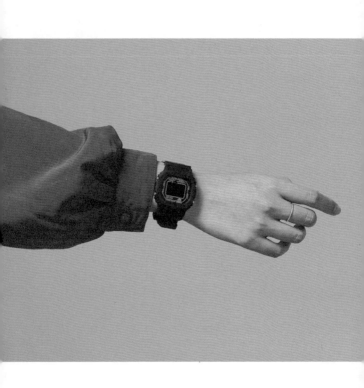

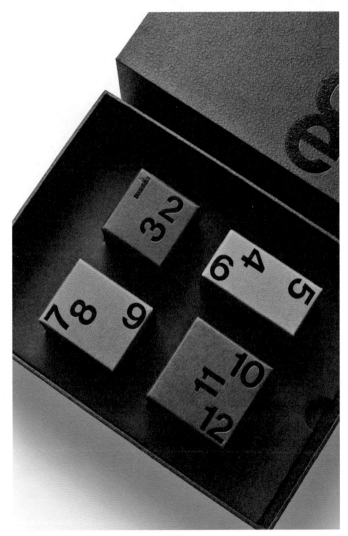

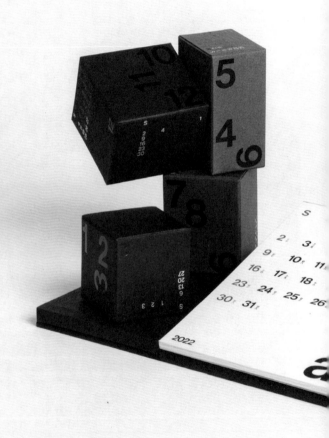

"Natural colours are nature's expression — the wine label's ink was made from the byproduct of pressed grapes, thus Mother Nature has determined the colour, making it both pure and honest."

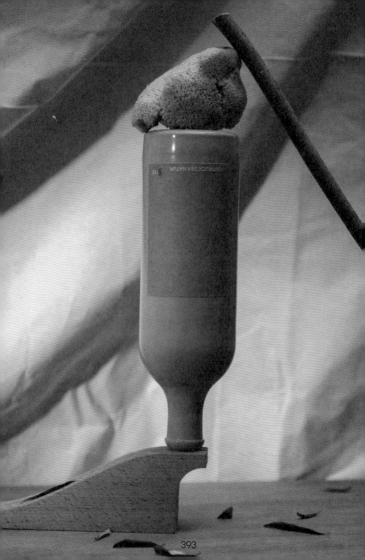

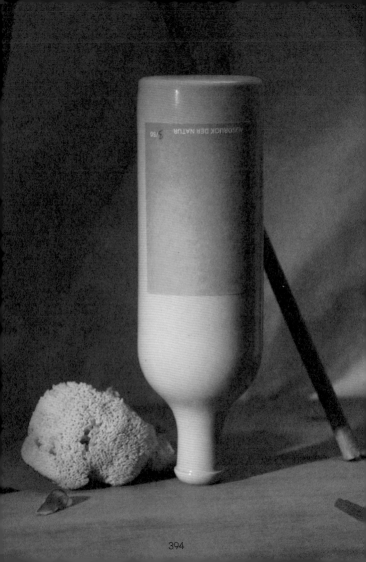

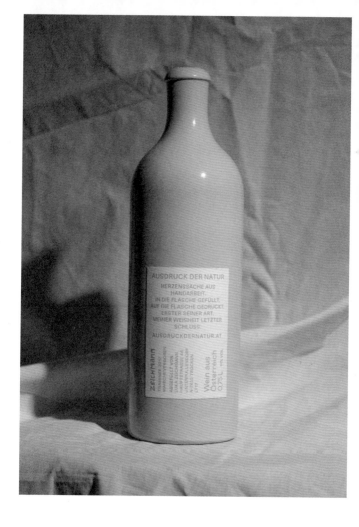

Herzenssache aus
Handarbeit.
Ungeschönt puristisch.
Makellos nativ. Trauben,
der Rebe entsprungen.
Nach Tradition zu Wein kreiert.
Ihr Rest als Druckfarbe aufs
Papier gebracht. Natürlich.
Belassen. Im Einklang.
Innen wie außen. Vollkommen.
Erster seiner Art.
Meiner Weisheit letzter
Schluss.

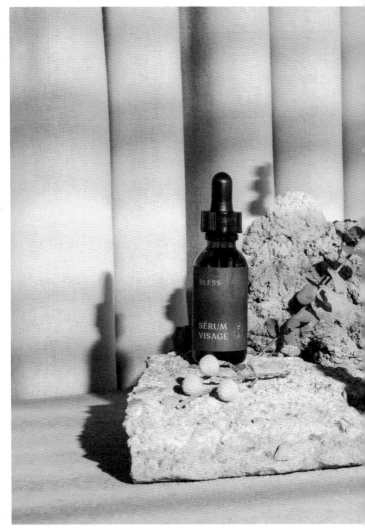

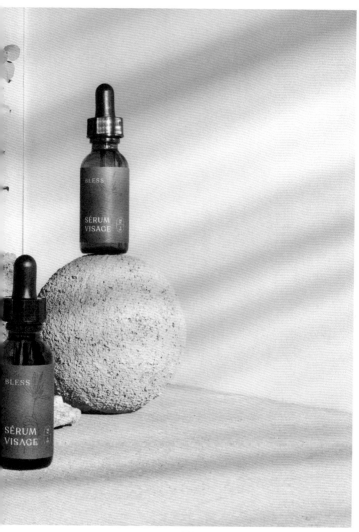

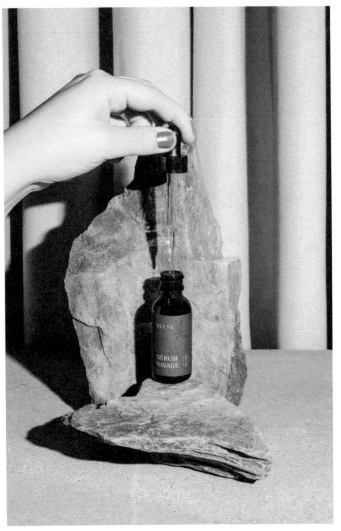

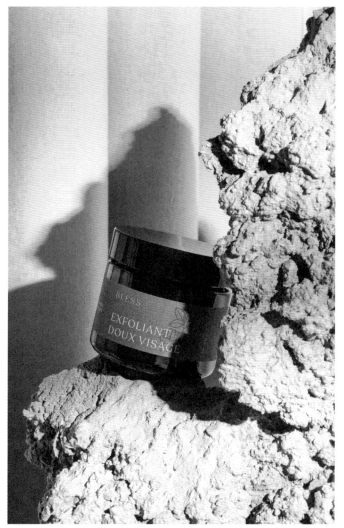

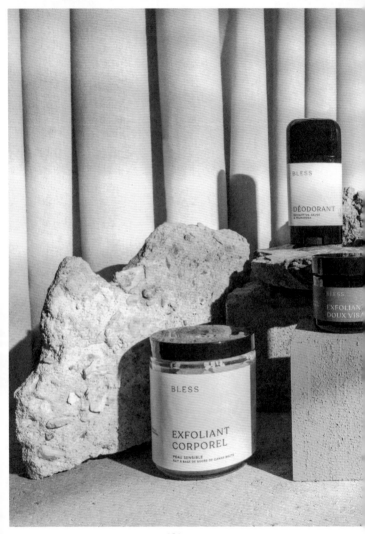

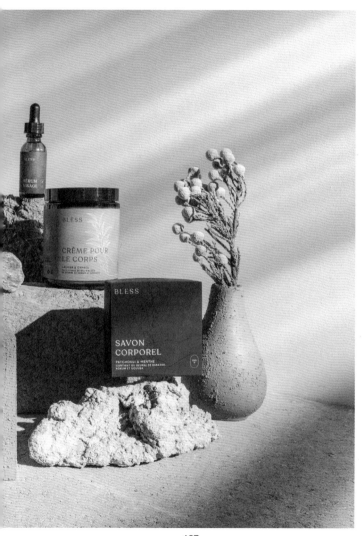

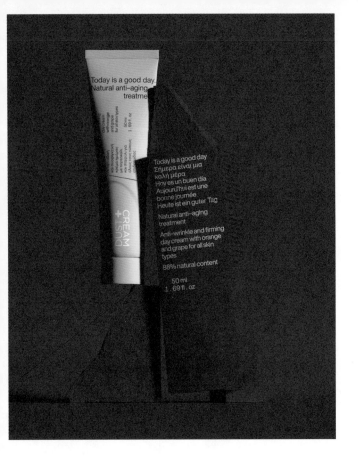

Today is a good day.
Natural anti–aging
treatme

Today is a good day
Σήμερα είναι μια
καλή μέρα
Hoy es un buen día
Aujourd'hui est une
bonne journée
Heute ist ein guter Tag

Natural anti–aging
treatment

Anti–wrinkle and firming
day cream with orange
and grape for all skin
types

88% natural content

50 ml
1. 69 fl. oz

CREAM
DUST +

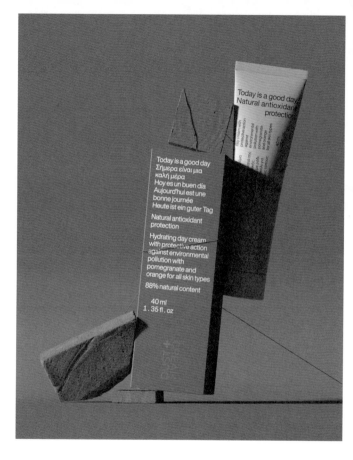

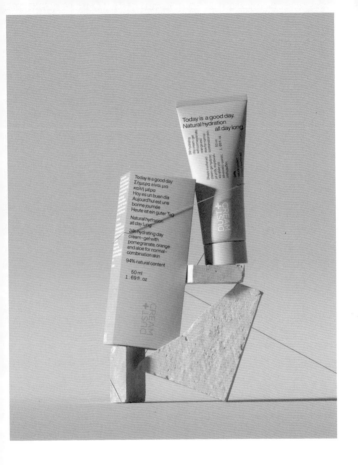

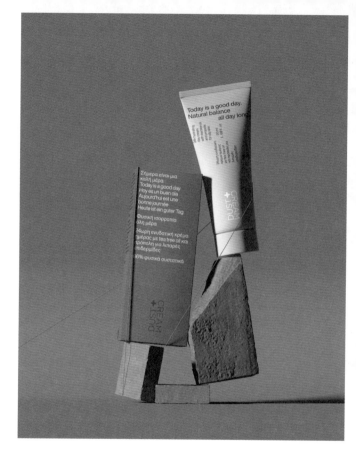

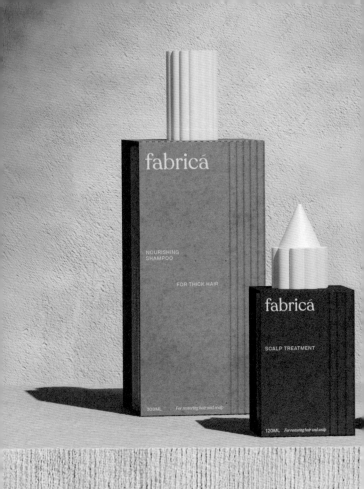

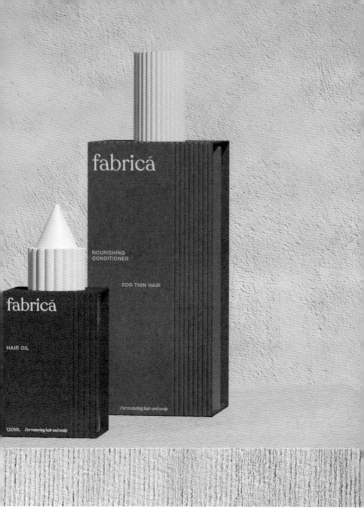

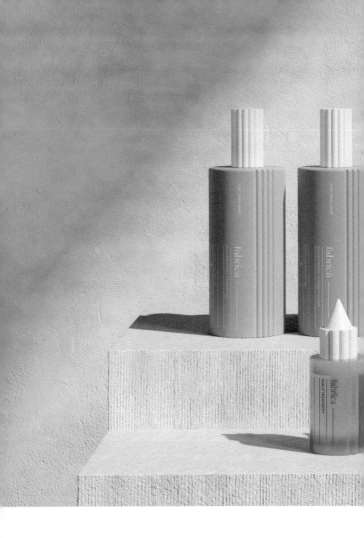

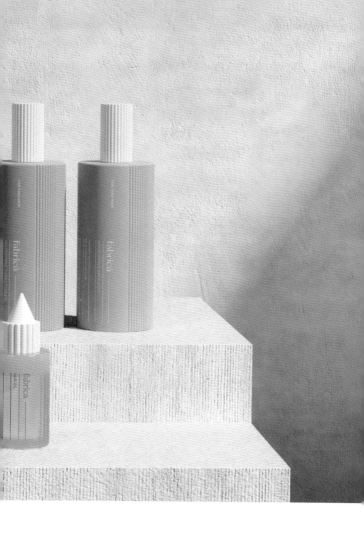

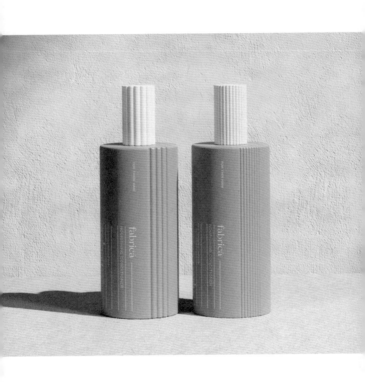

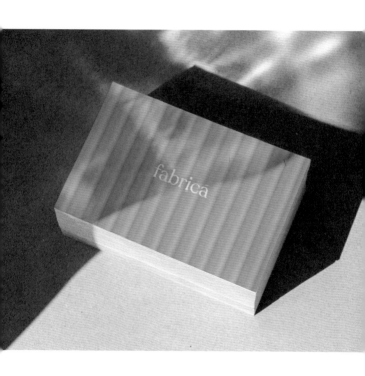

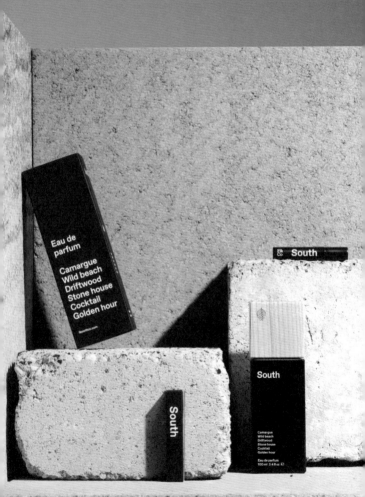

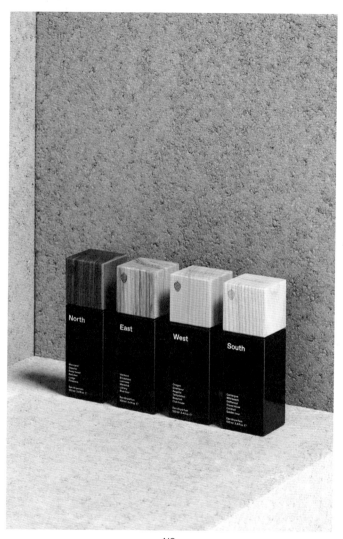

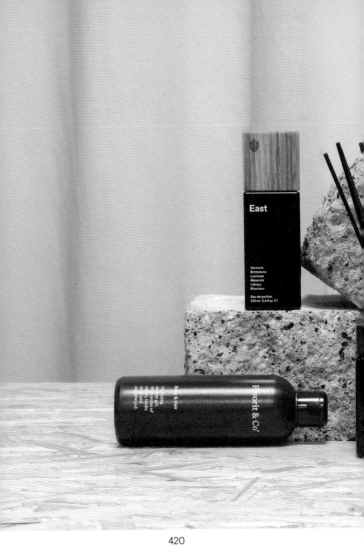

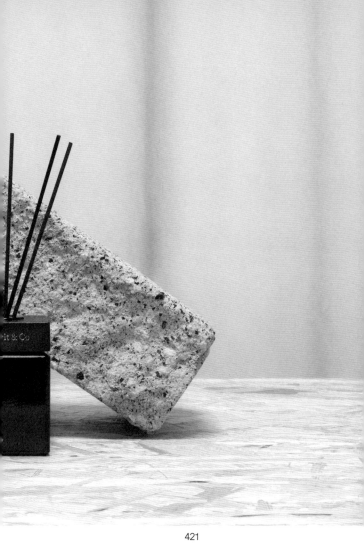

North

Moorland
Disaster
Deep forest
Red deer
Lodge
Fireplace

Eau de parfum
100 ml 3.4 fl oz ℮

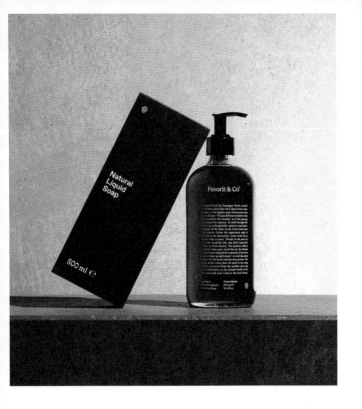

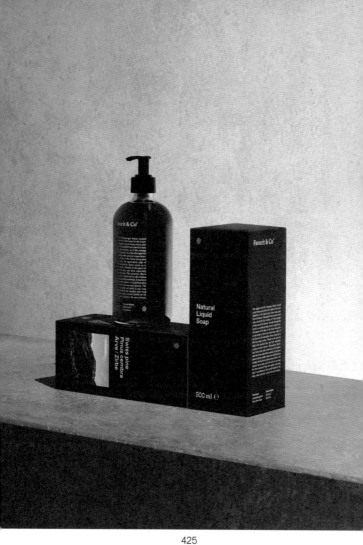

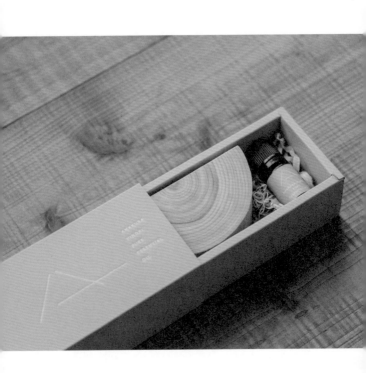

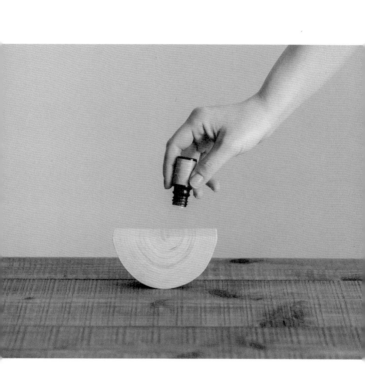

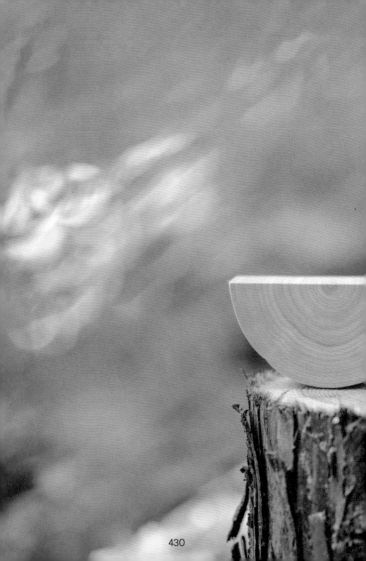

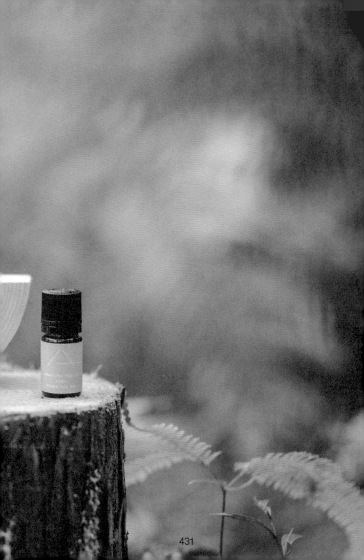

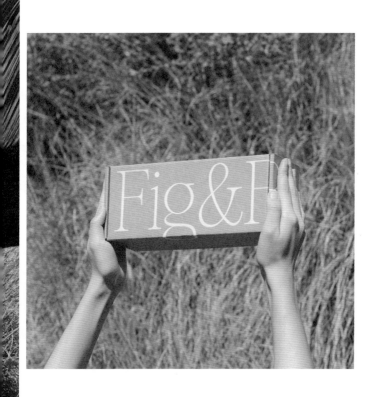

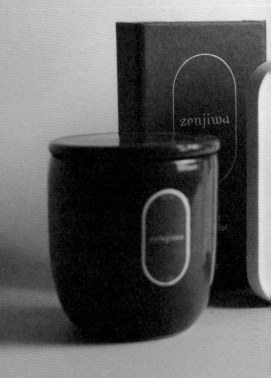

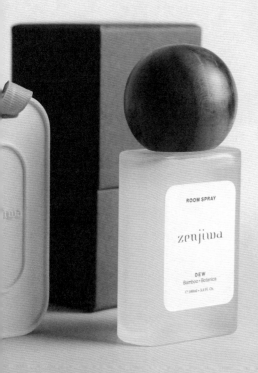

ROOM SPRAY

zenjiwa

DEW
Bamboo • Botanica

℮ 100ml • 3.4 FL Oz.

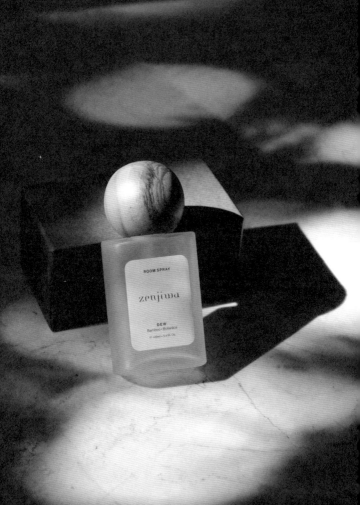

ROOM SPRAY

zenjiwa

DEW
Bamboo · Botanica

441

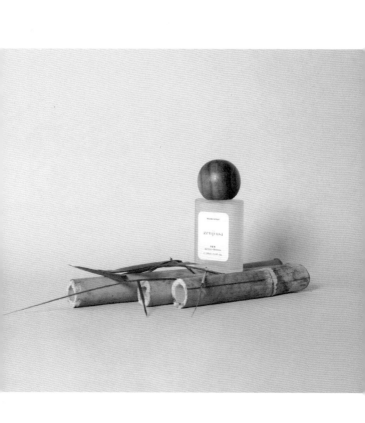

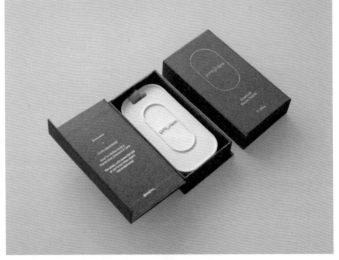

444

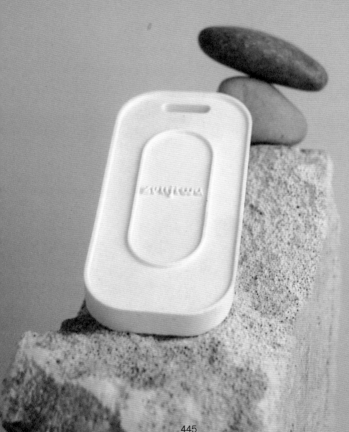

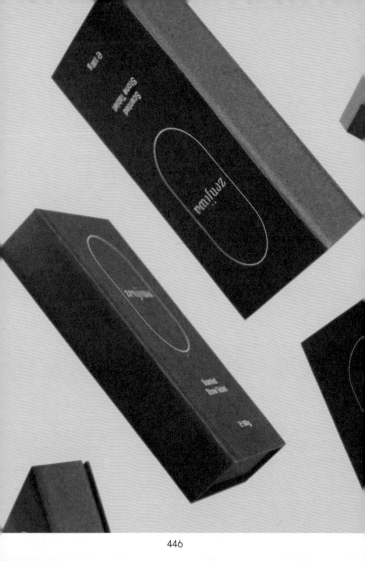

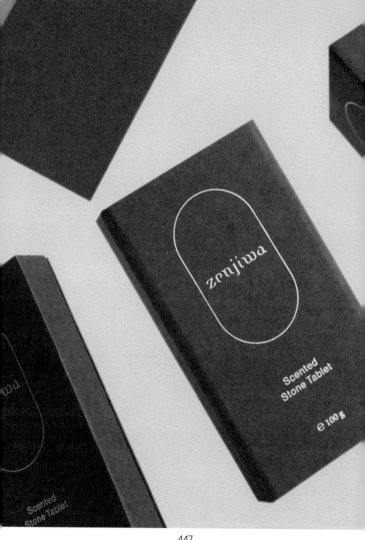

zenjiwa

Scented
Stone Tablet

e 100 g

Scented
Stone Tablet

447

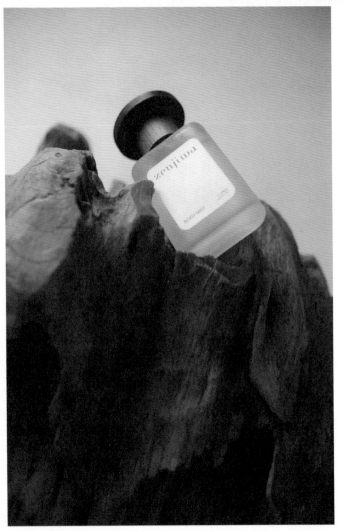

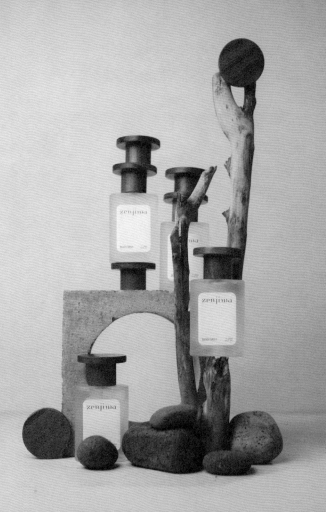

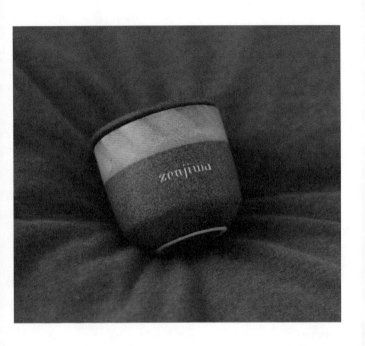

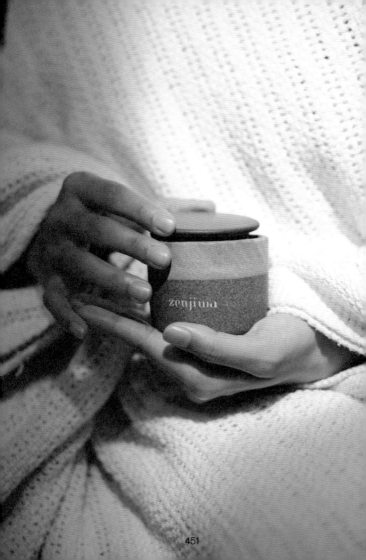

"The sun-kissed, earthy colour palette reflects the product's all-natural ingredients and wears its ethos and home-grown status proudly."

The Kind Sunscreen

50ml

SPF 30

Natural sunscreen
Clear matte finish
Chemical free
Preservative free

Kind for everyone
& the environment

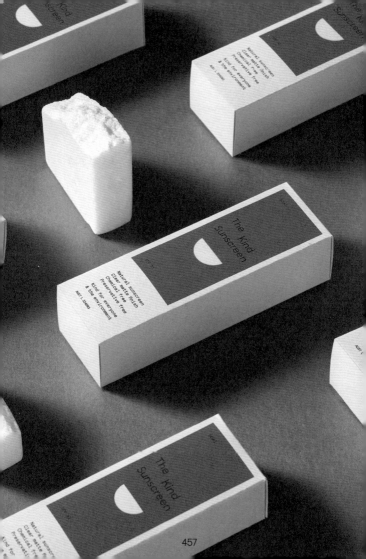

The Kind
Sunscreen

Natural sunscreen
Clear matte finish
Chemical free
Preservative free
Kind for everyone
& the environment

NET 1,5OZ/

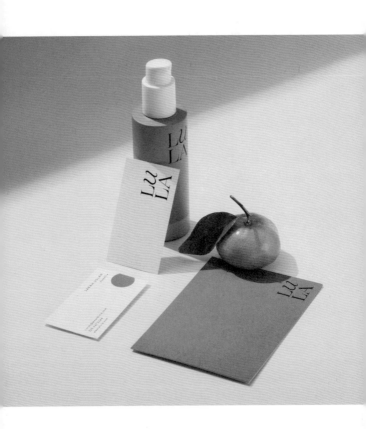

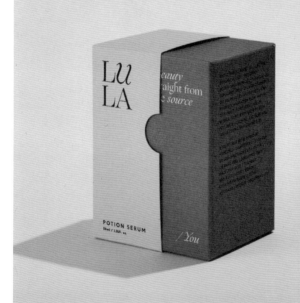

459

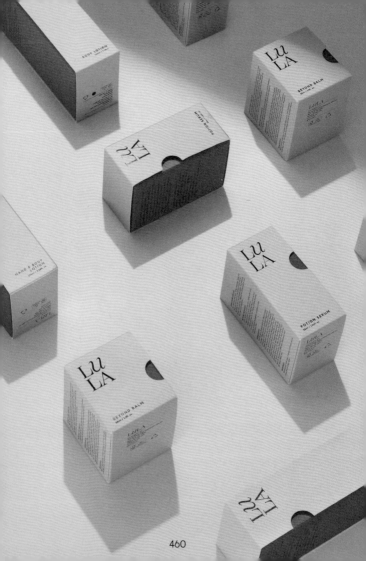

460

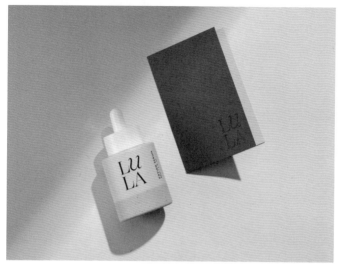

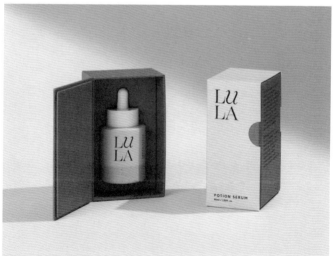

461

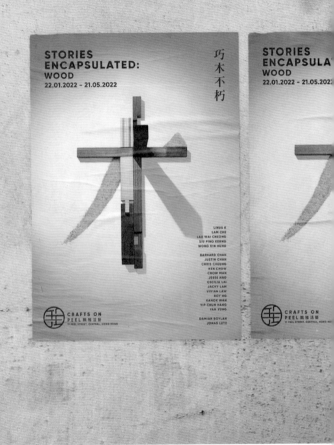

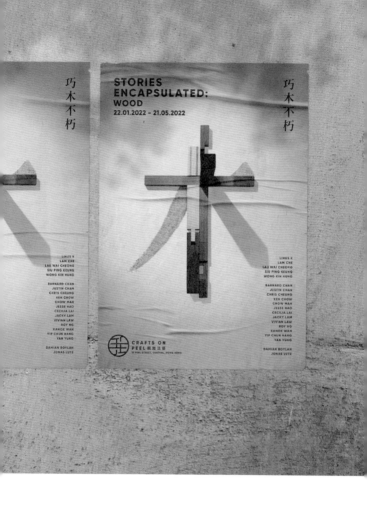

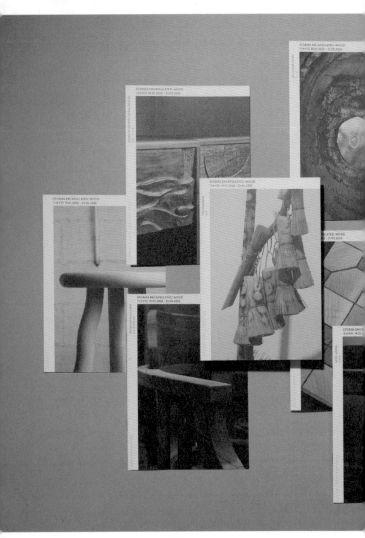

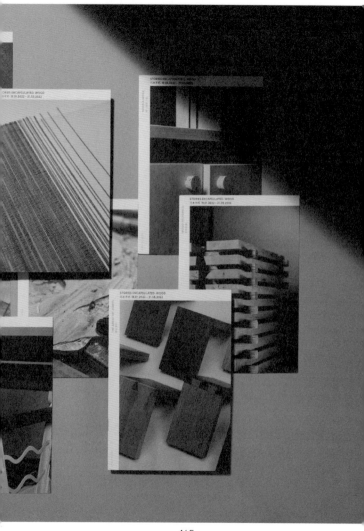

466

467

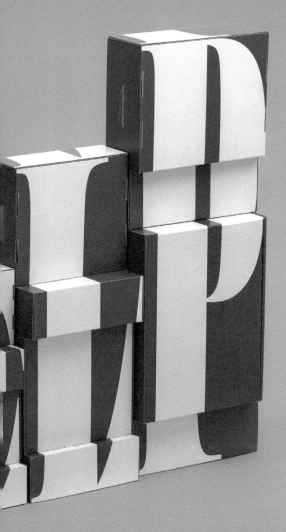

469

Designed by Jens Nilsson. Printed by Packhelp.
We both help ✌️ with 📦 packaging solutions.
jens.nilsson.com ✂️ packhelp.com

470

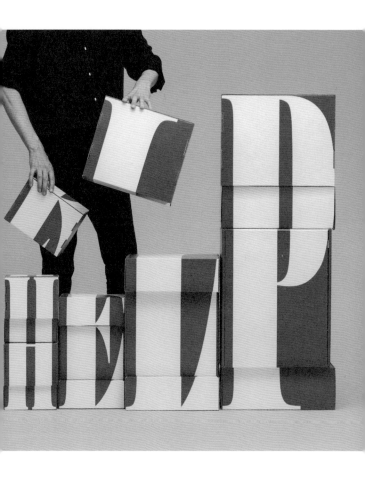

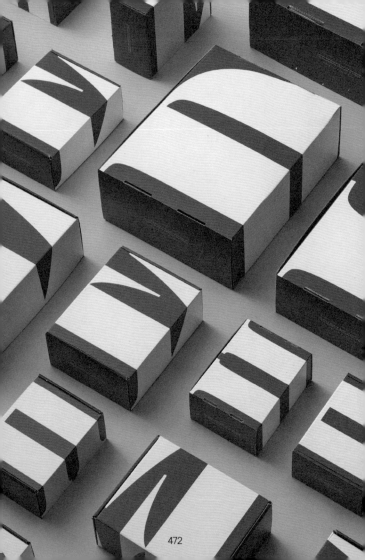

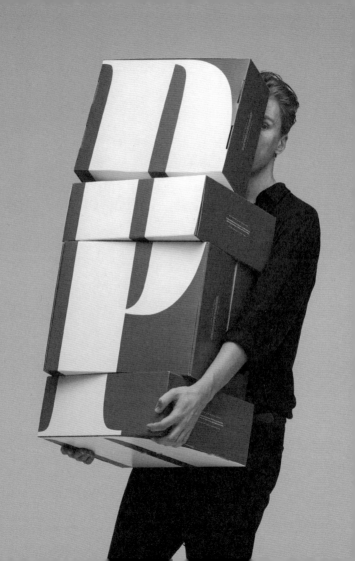

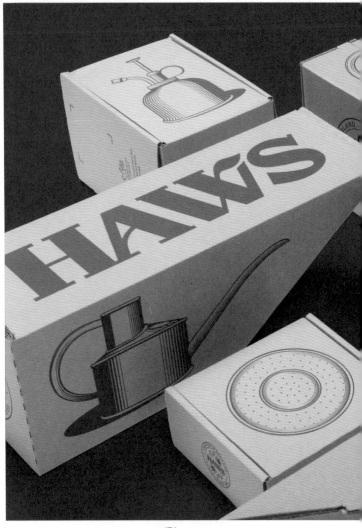

474

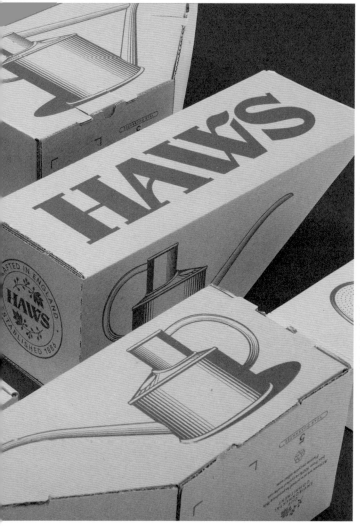

475

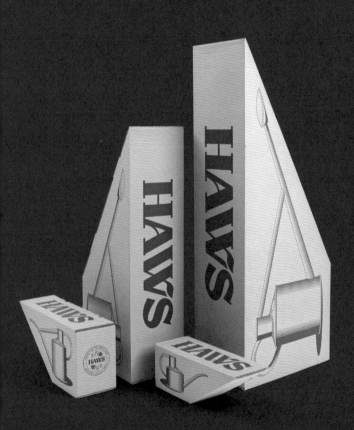

Read me.
Plant me.
Water me.

Printed on herb-seeded paper with vegetable inks. Simply cut this paper up into smaller pieces and cover with about 5mm of soil. Give it a good water and watch your seeds grow!

To learn more about Haws, please visit our website.

haws.co.uk

Just add water!

477

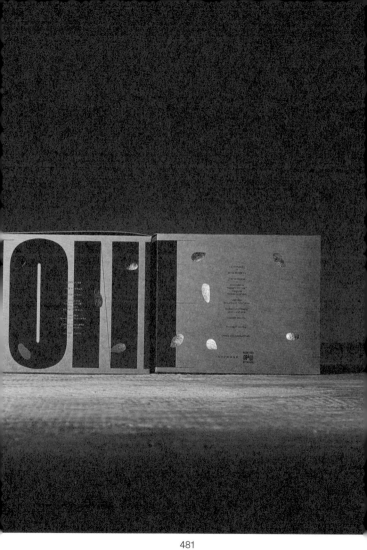

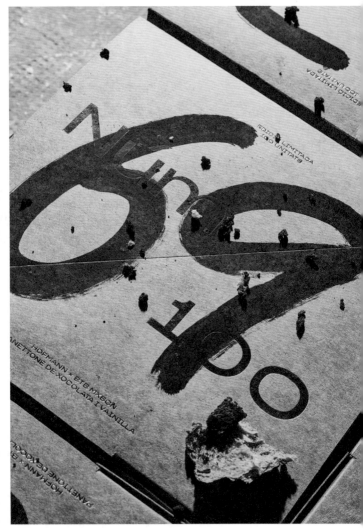

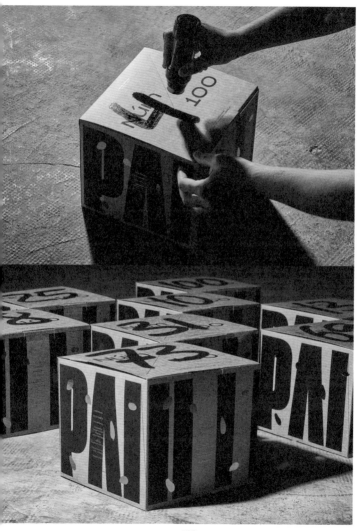

483

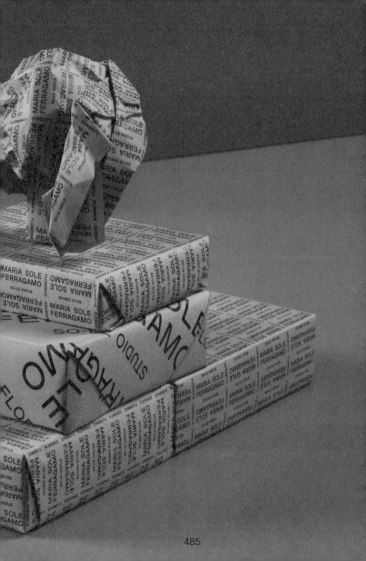

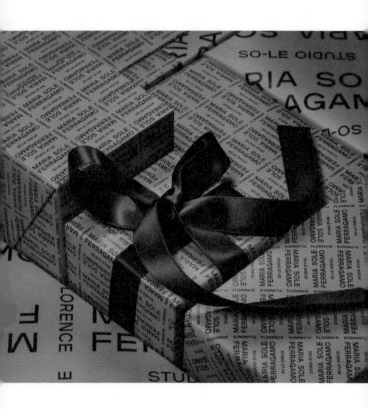

486

12580 ROTT RD.

SUNNY AFTERNOON
STROLL AMONG

ST. LOUIS, MO

ODDLY WONDERFUL
SCULPTURES

an afternoon @

LAUMEIER

SCULPTURE PARK

OUTDOORS, UP-CLOSE AND PERSONAL

ARTISTS

Alexandre Da Cunha
Tony Tasset
Marie Watt
Alexander Liberman
Cosimo Cavallaro
Donald Judd
Robert Chambers
Jessica Stockholder
Jonathan Borofsky
Chris Smentkowski

COLOPHON

Typefaces:
Lýno
(BP)
Gräbenbach Mono
(Camelot),
Cooper
(Oswald Cooper)

Photography & Design:
Jingxi Fan

2019

AN AFTERNOON @ LAUMEIER

An in-situ experience portrayed in 10 sculpture
encounters from the same sunny afternoon at the
Laumeier Sculpture Park in St. Louis, MO.
While most park-goers would see these sculptures
from afar, this collection of cards and park guide
chronicles an experience up-close.

38.551000°N 90.412000°W

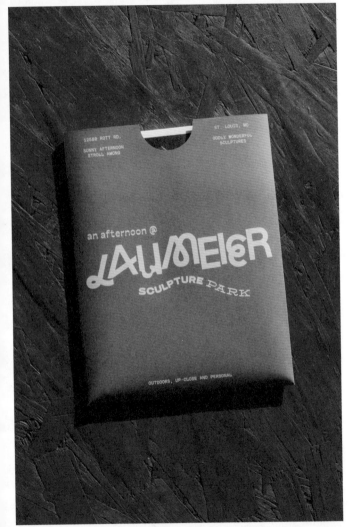

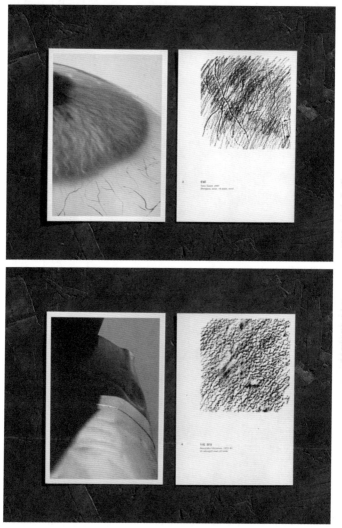

ITINE RARY

and

MAP GUIDE

AN AFTERNOON @
LAUMEIER SCULPTURE PARK

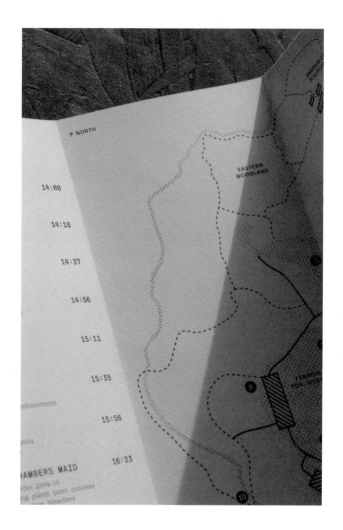

patagonia

↗

Boulder
Guide
Book

↖

FLATIRONS / 7,193 FT.

TABLE OF CONTENTS

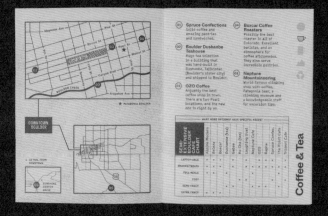

(01) Spruce Confections
Solid coffee and amazing pastries and sandwiches.

(02) Boulder Dushanbe Teahouse
Huge tea selection in a building that was hand-built in Dushanbe, Tajikistan (Boulder's sister city) and shipped to Boulder.

(03) OZO Coffee
Arguably the best coffee shop in town. There are two Pearl locations, and the new one is right by us.

(04) Boxcar Coffee Roasters
Possibly the best roaster in all of Colorado. Excellent baristas and an atmosphere for coffee aficionados. They also serve incredible pastries.

(05) Neptune Mountaineering
World-famous climbing shop with coffee, Patagonia beer, a climbing museum and a knowledgeable staff for vacation tips.

GEAR-EXTENDED BOULDER CAFE CHART	Alpine Modern	Boxcar	Boxcar	Dushanbe (tea)	Galore	Kai Cha (tea)	Laughing Goat	Neptune Cafe	OZO	Raplo	Spruce Confec.	The Violet Cafe	Trident Cafe
LAPTOP-ABLE	•	•				•	•	•	•		•	•	•
SNACKS/TREATS	•	•	•			•	•		•		•	•	•
FULL MEALS	•			•			•				•	•	•
COZY							•						
SEMI-FANCY			•	•					•				
EXTRA FANCY	•	•											

WANT MORE OPTIONS? ALSO MEETING OUR SPECIFIC NEEDS?

Coffee & Tea

DOWNTOWN BOULDER

★ PATAGONIA BOULDER

← 10 MIN. FROM DOWNTOWN

SUNSHINE CANYON DRIVE

A-FL

FÖRSTA JANUARI

FÖRSTA JANUARI
EN BOK (OM FÖRVÄNTAN)
AV A-FL

HUNDÖRAT SMALL PRESS
STOCKHOLM 2021

DA'N FÖRE

DA'N FÖRE

DA'N FÖRE

1.0 SKOTTDAGEN
29 FEBRUARI: S. 70 LÄSES ENBART
VID SKOTTÅR.

KORREKTURLÄST 1-2 OKTOBER 2021.
INGA ANMÄRKNINGAR.

BENGT AF KLINTBERG.

DA'N FÖRE

DA'N FÖRE

DA'N FÖRE

DOPPAREDA'N

© 2021 A-FL (ANDREAS FRIBERG LUNDGREN)
© 2021 HUNDÖRAT SMALL PRESS, STOCKHOLM
TRYCKT AV GÖTEBORGSTRYCKERIET & BUNDEN
AV FLODSTRANDS BOKBINDERI.
FÖRSTA UPPLAGAN, 100 EXEMPLAR.

ISBN 978-91-985508-5-4

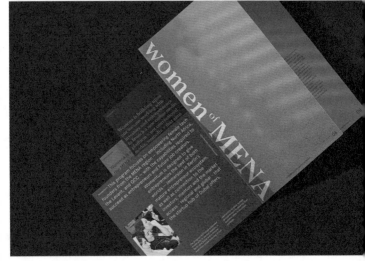

Women of MENA

This program focuses on empowering female tech founders from the MENA region — including North Africa, the Levant, and GCC — with the capabilities required to succeed as entrepreneurs and future job creators.

WomenA is designed to give entrepreneurs the best of both worlds: immersion in the regional entrepreneurship ecosystem, as well as connection to the investors, mentors and the market access — regional and global — that the startup hub of Dubai offers.

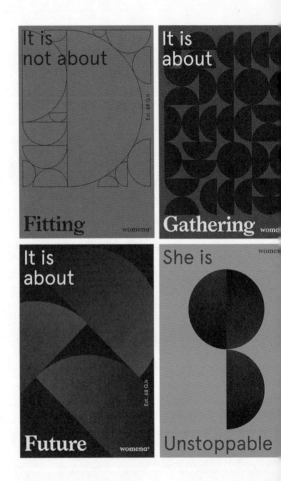

LEPORELLO N° 03

03

FIONA BANNER AKA THE VANITY PRESS

FIONA BANNER AKA THE VANITY PRESS

PUBL. LL'EDITIONS

LEPORELLO N° 03

NNER AKA THE VANITY PRESS

PUBL. LL'EDITIONS

LEPO

FIONA BANNER

PUBL

N° 03

E VANITY PRESS

IONS

Kalle Sanner

Lukas/Markus

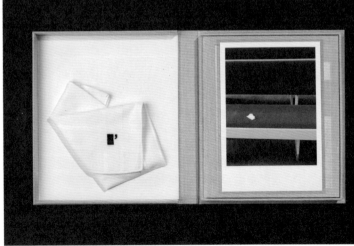

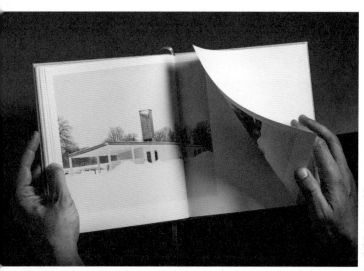

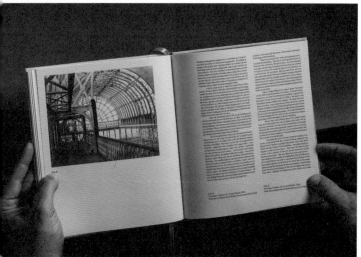

three norfolk

1.01

2.0

three norfolk

3.02

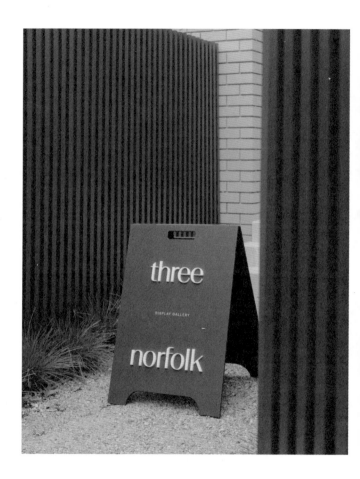

three

DISPLAY GALLERY

norfolk

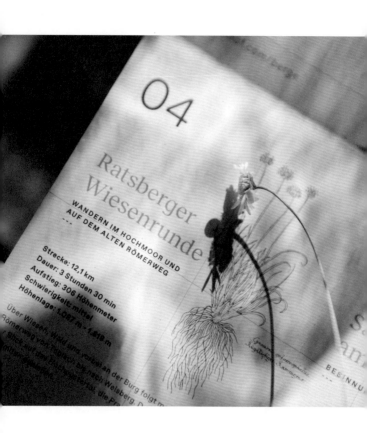

04

Ratsberger Wiesenrunde

WANDERN IM HOCHMOOR UND
AUF DEM ALTEN RÖMERWEG

Strecke: 12,1 km
Dauer: 3 Stunden 30 min
Aufstieg: 306 Höhenmeter
Schwierigkeit: mittel
Höhenlage: 1.087 m – 1.618 m

Über Wiesen, Wald und vorbei an der Burg folgt m
Römerweg vom Ratsberg bis nach Welsberg. D
Blick auf und über die ganze Herbst, die Frei

524

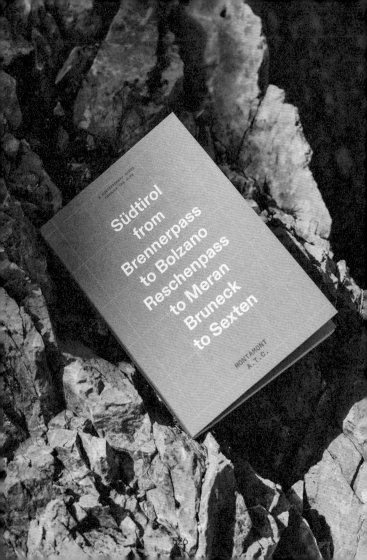

A CONTEMPORARY GUIDE
THROUGH THE ALPS

Südtirol
from
Brennerpass
to Bolzano
Reschenpass
to Meran
Bruneck
to Sexten

MONTAMONT
A . T . C .

Engadin
from
Scuol
to St. Moritz
Pontresina
to Berninapass
Silvaplana
to Malojapass

"Aside from nature-inspired hues, Private Visit also uses natural materials into its skateboards and accessories to strike a balance between artefacts and nature."

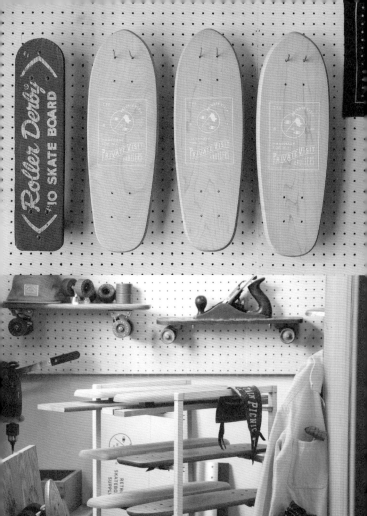

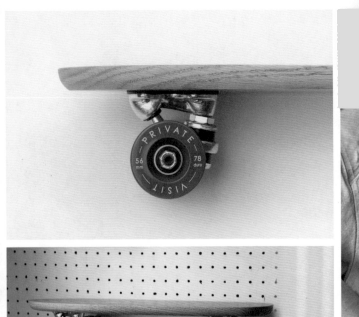

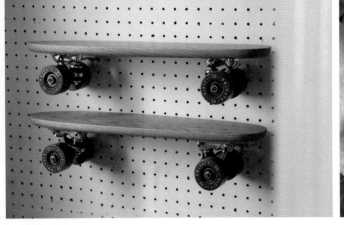

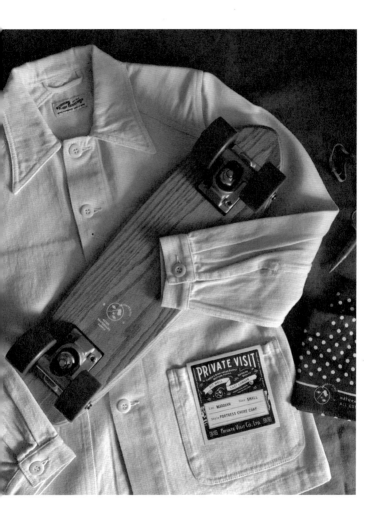

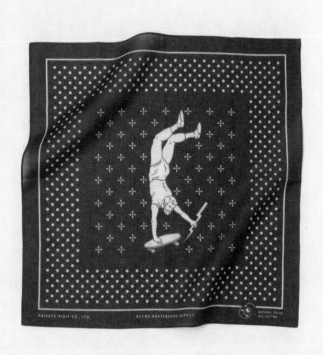

534

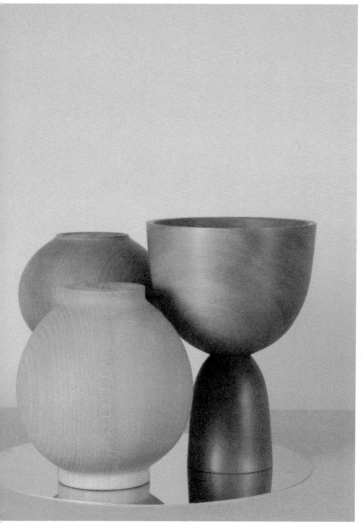

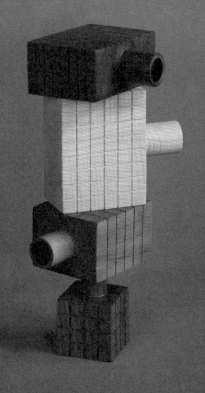

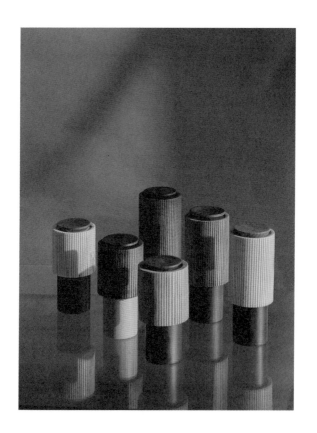

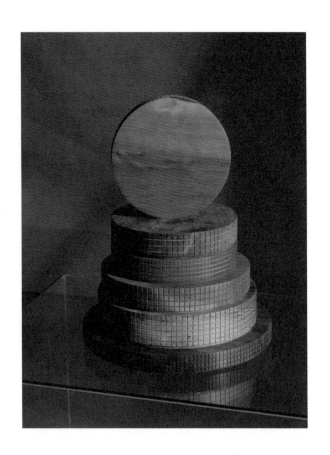

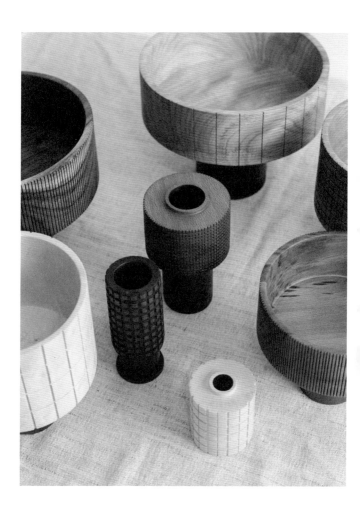

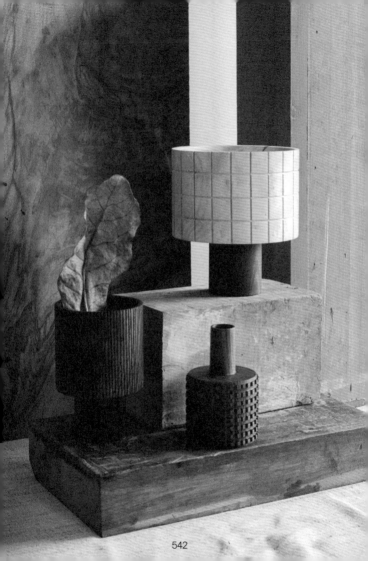

542

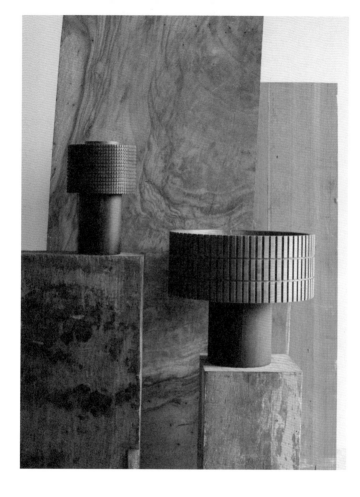

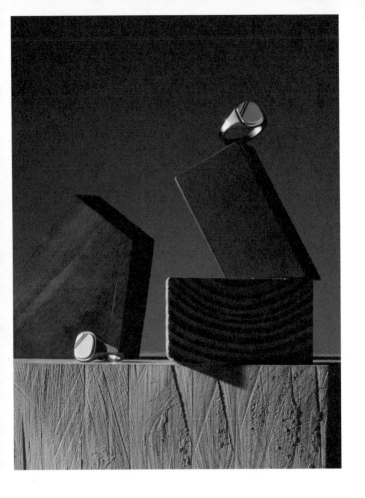

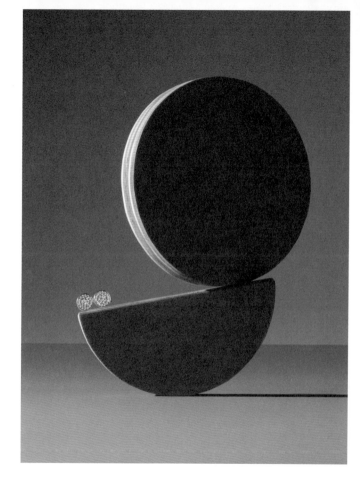

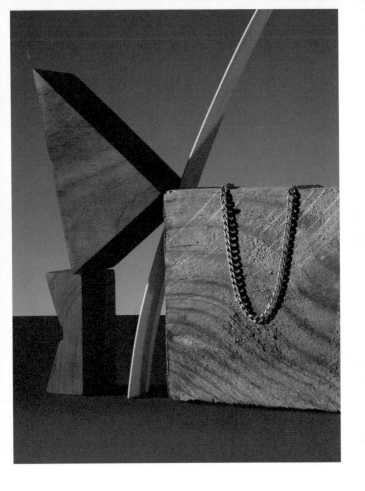

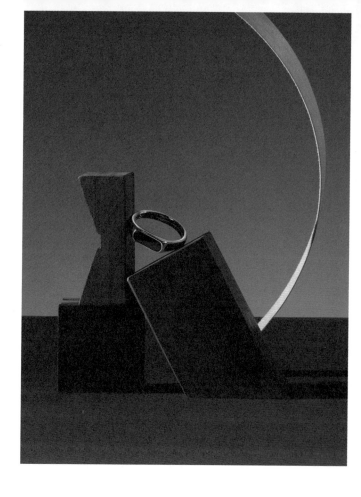

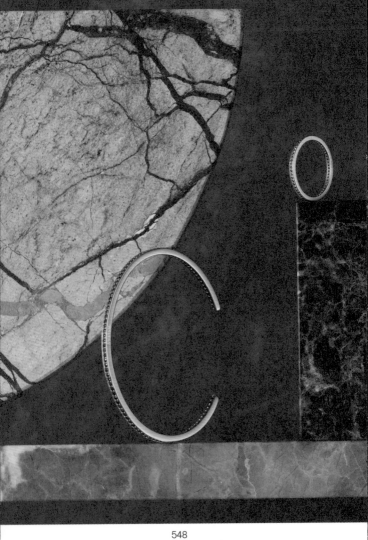

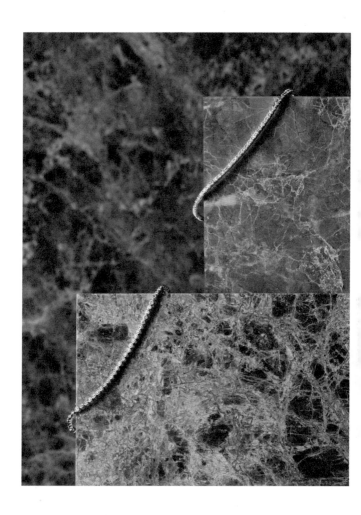

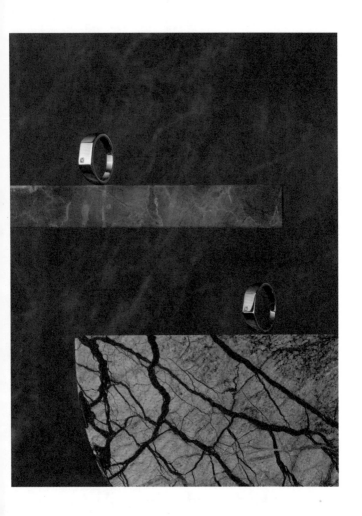

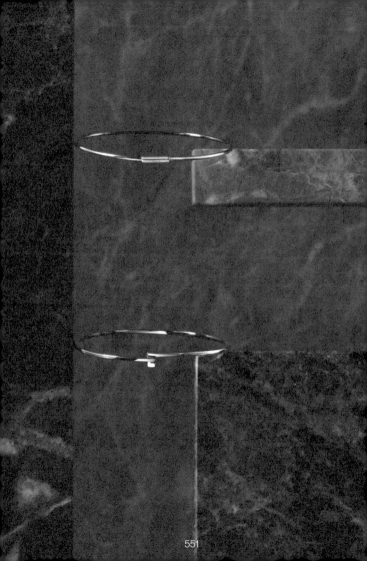

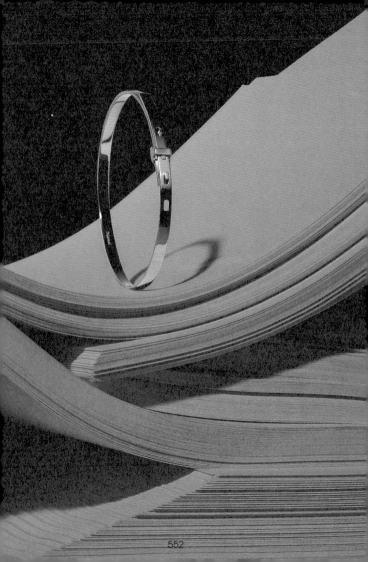

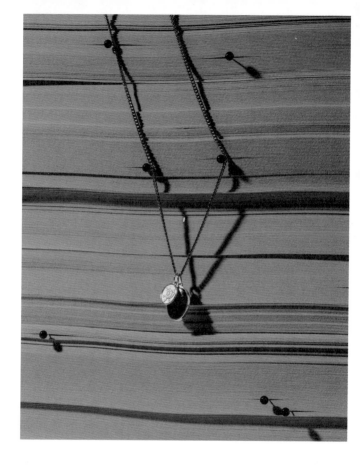

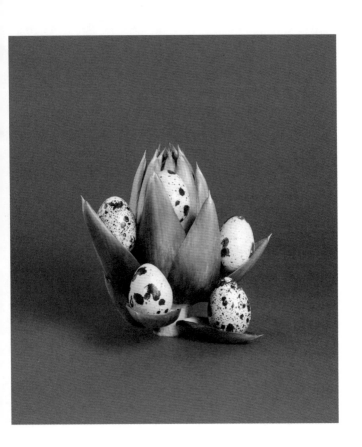

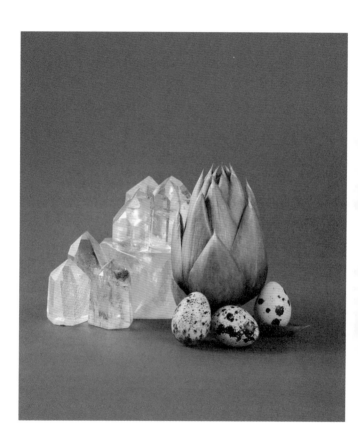

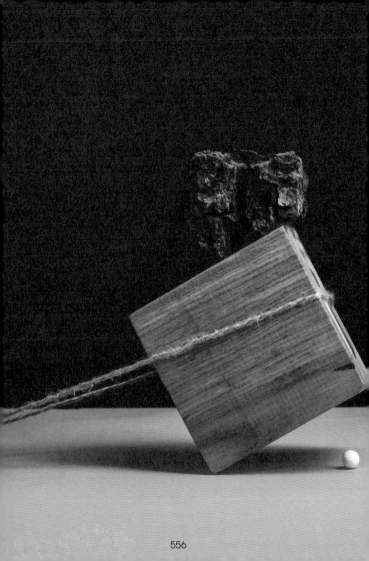

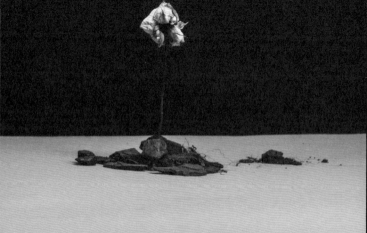

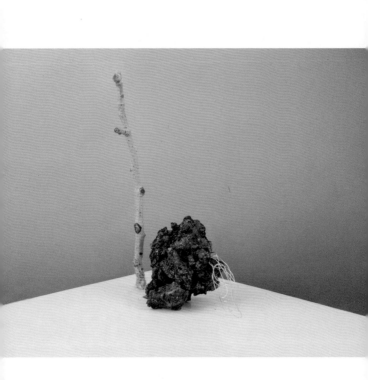

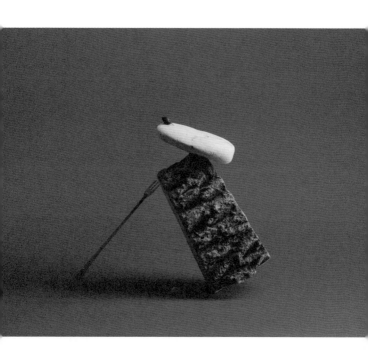

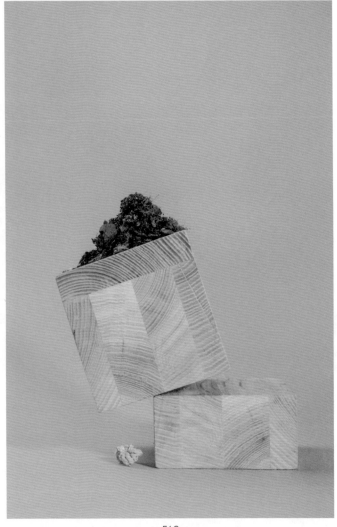

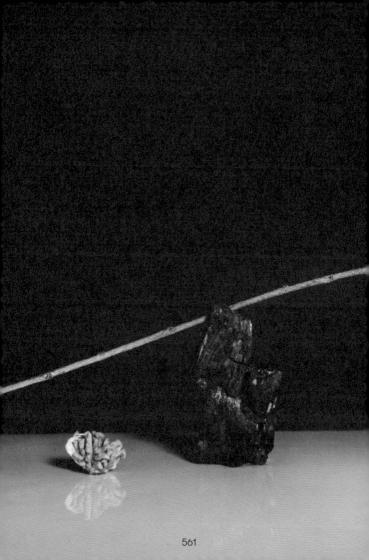

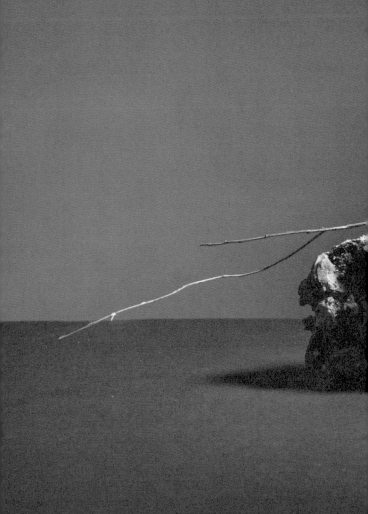

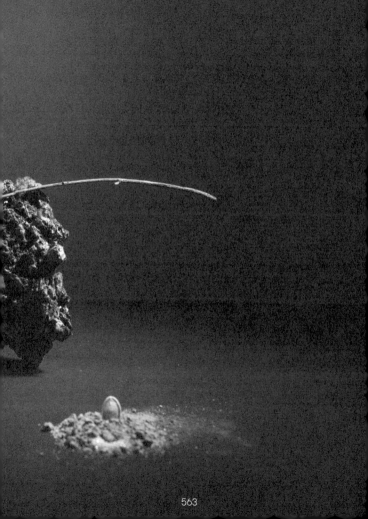

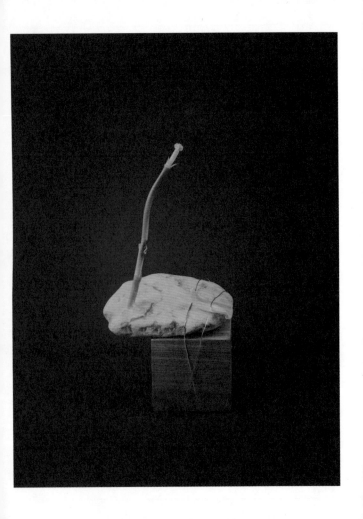

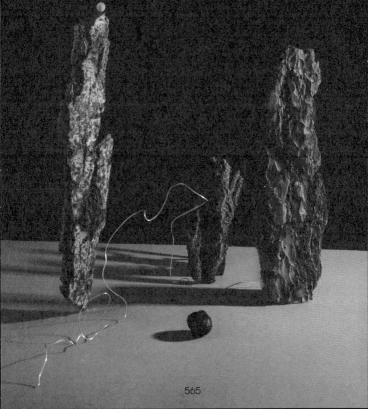

"Natural colours and tones resonate with us because of our deep connection to nature. These tones echo the same sentiment and connect us all with the same sentiment."

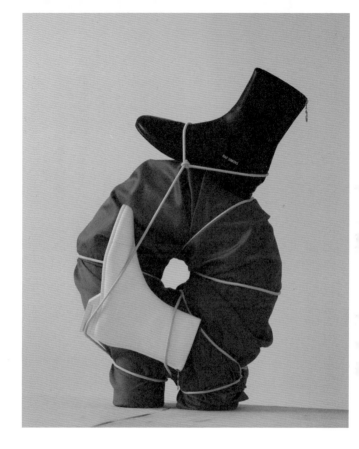

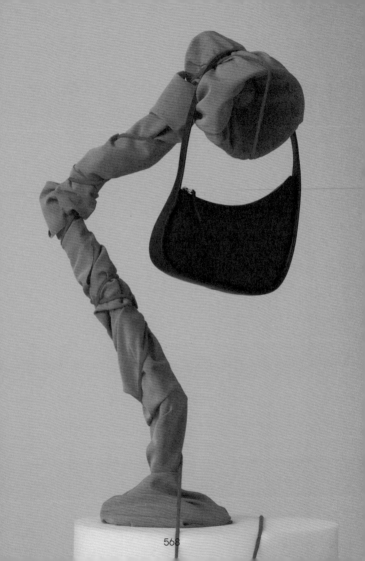

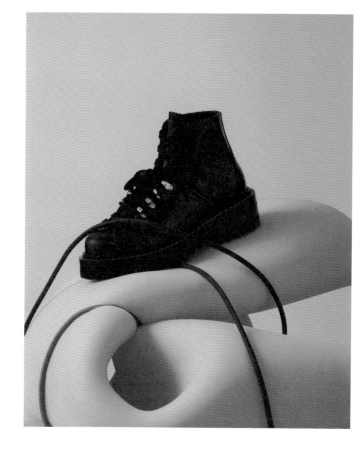

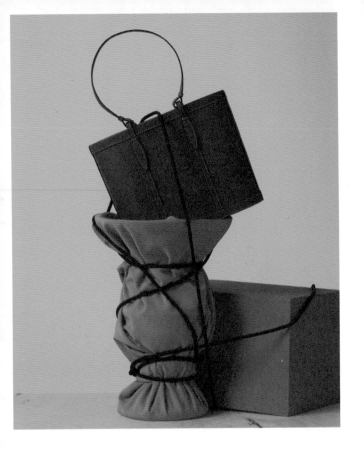

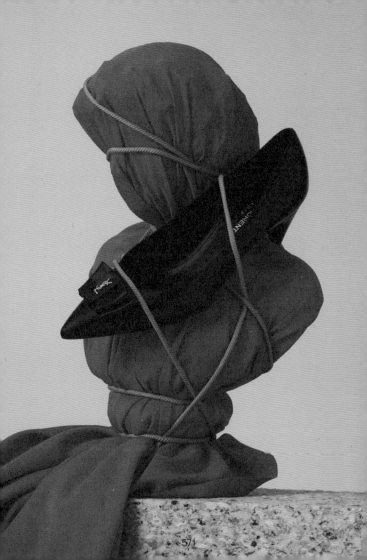

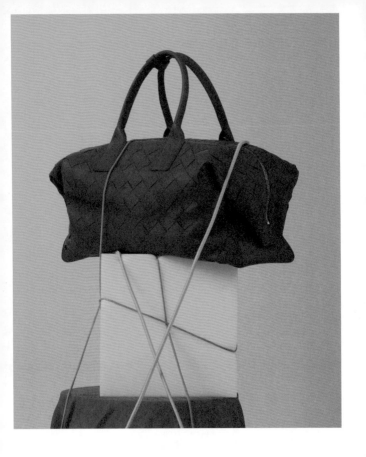

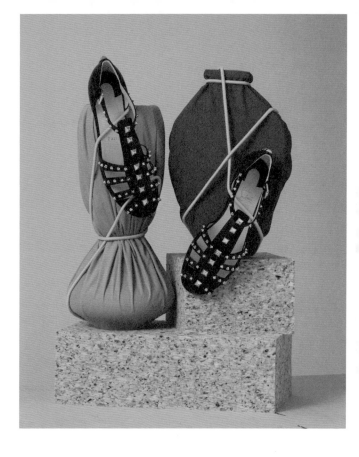

573

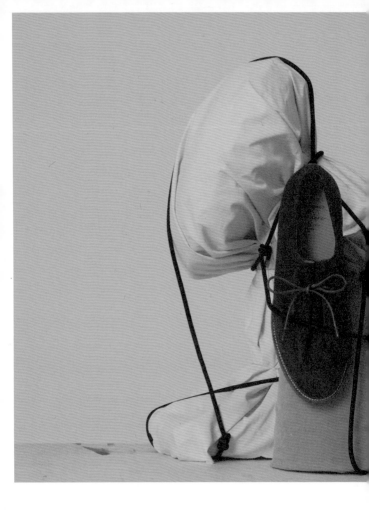

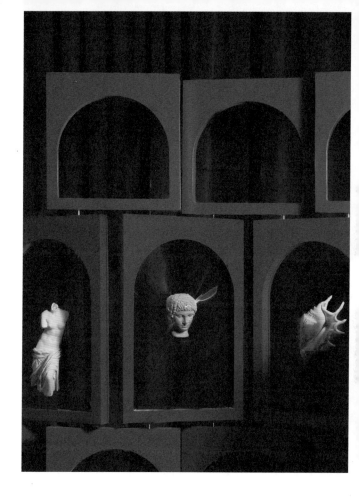

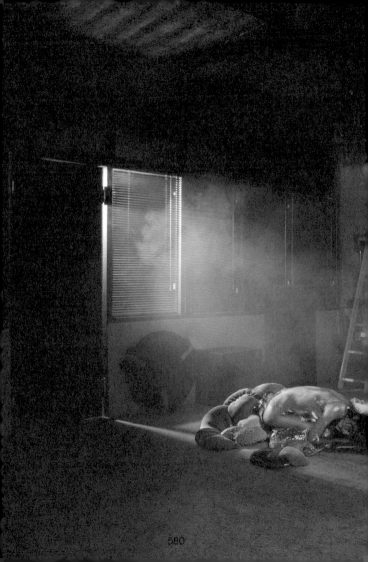

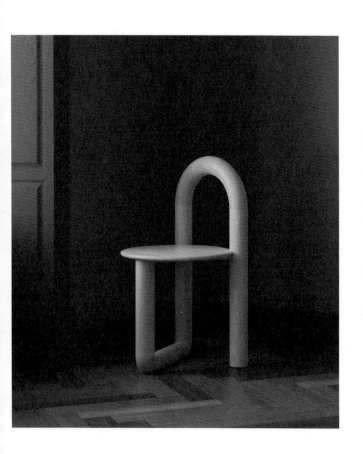

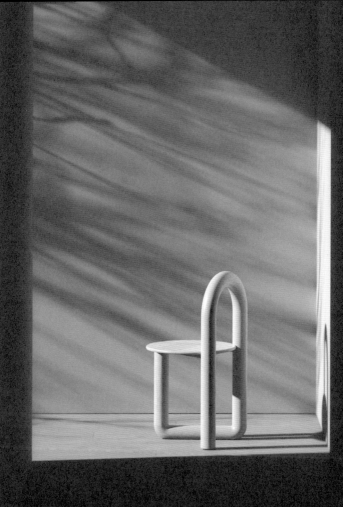

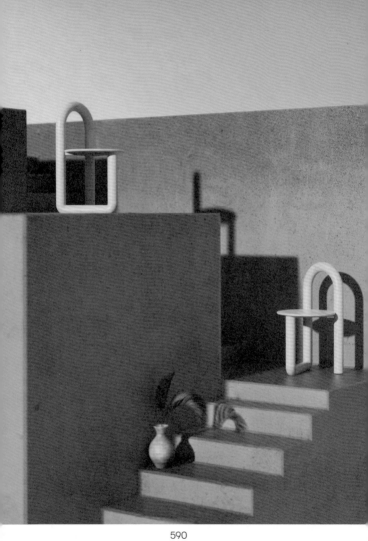

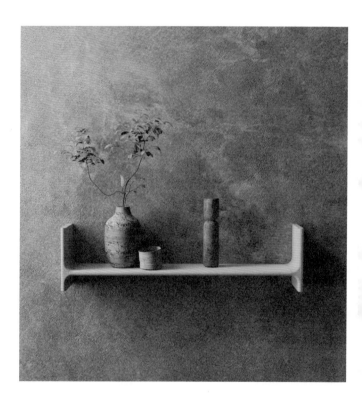

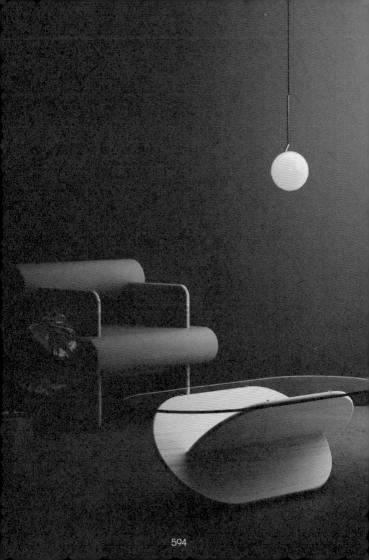

"The furniture is hand-crafted from locally-sourced solid wood, and the natural tone, grain, and imperfections of the material are integral to the unique voice of each piece."

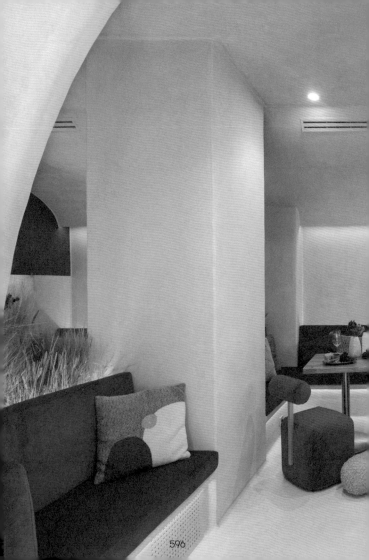

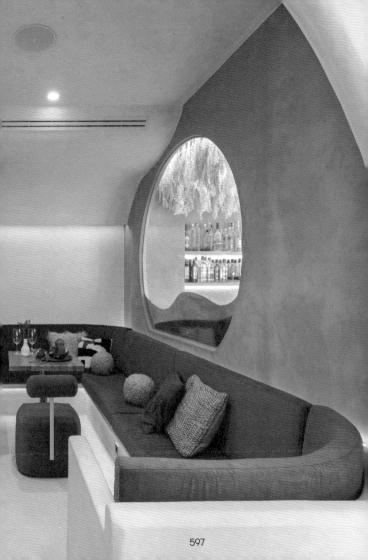

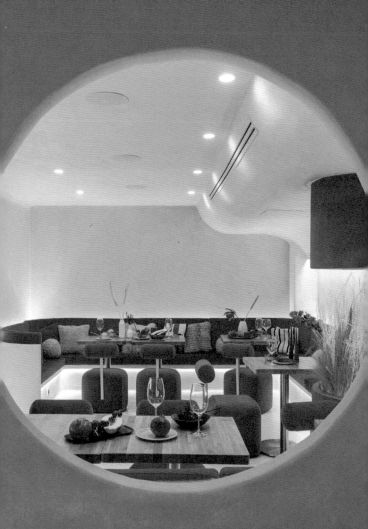

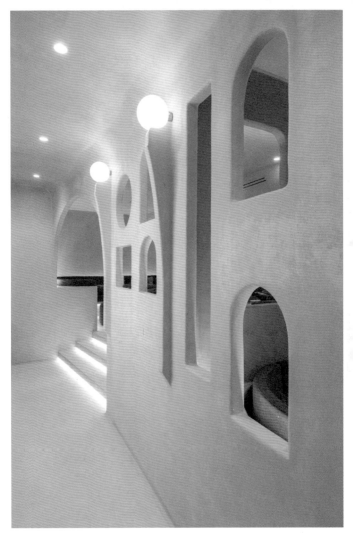

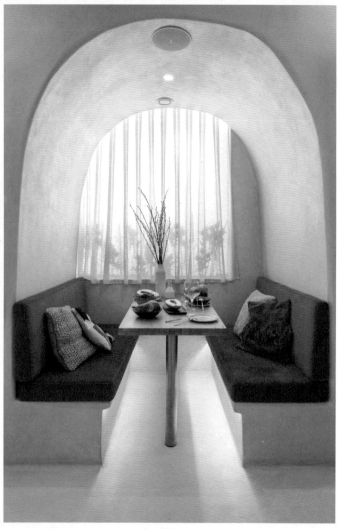

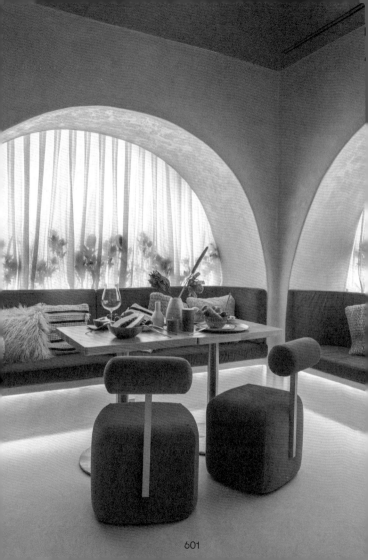

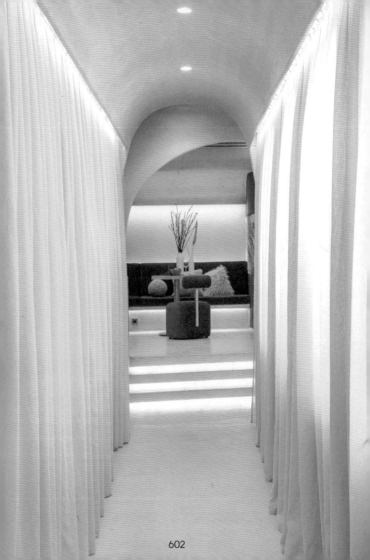

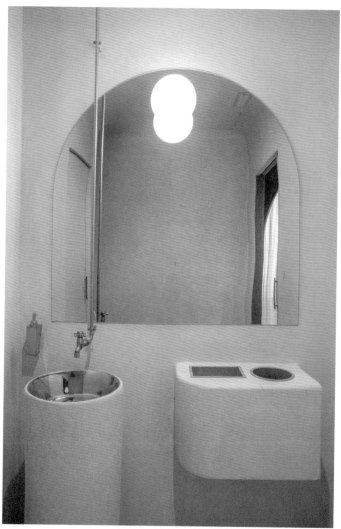

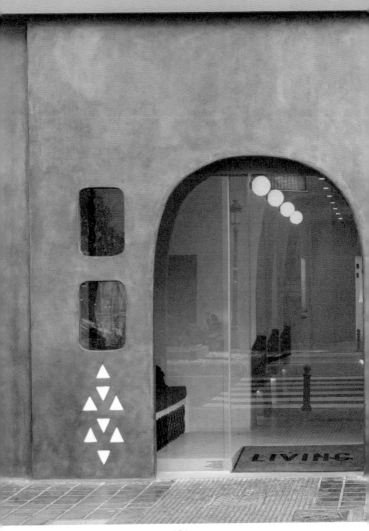

İVİNG
BAKKALI

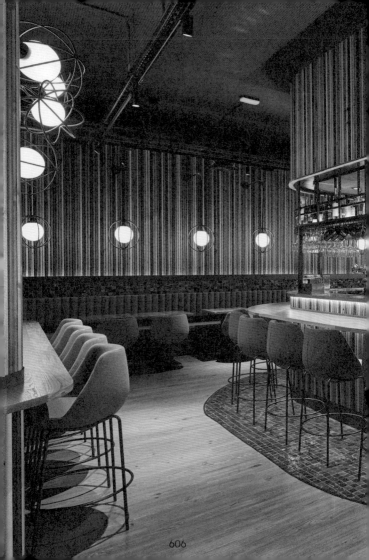

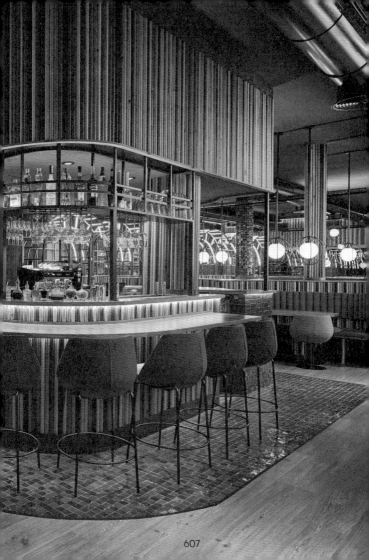

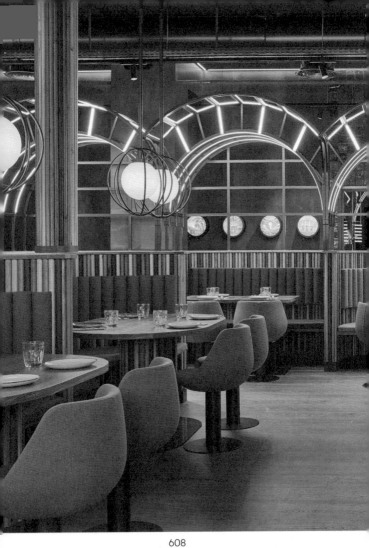

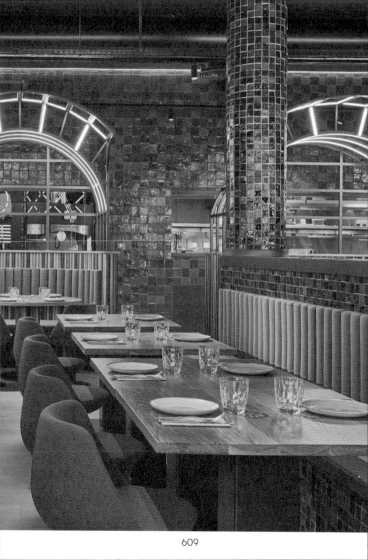

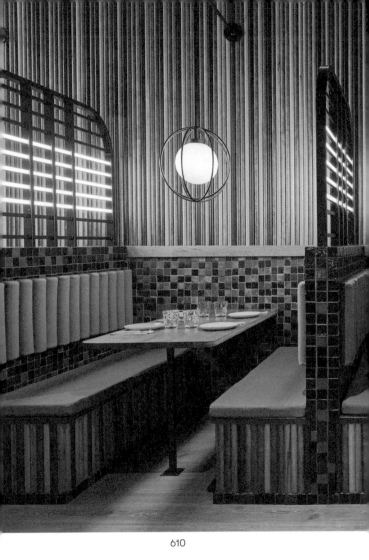

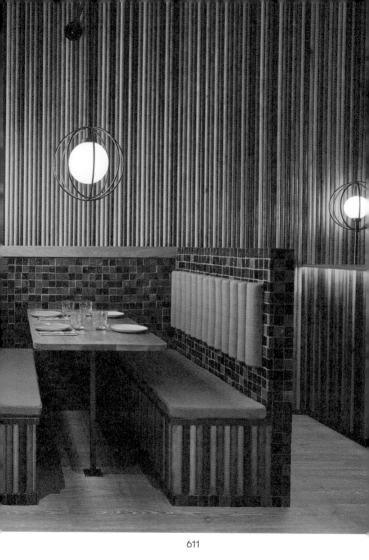

ALVARO OBREGON
N°228

TLECAN

MEZCALERIA

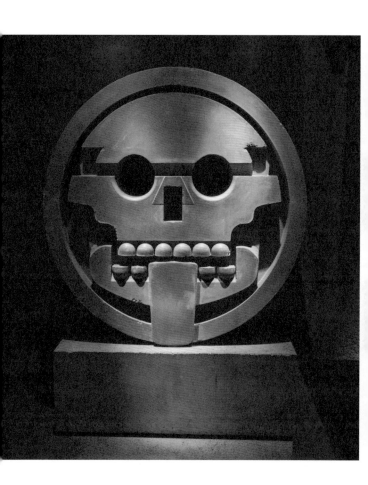

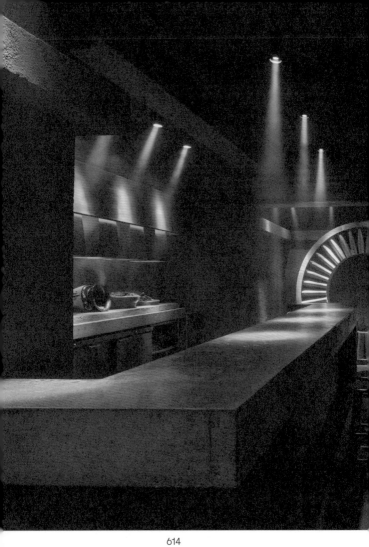

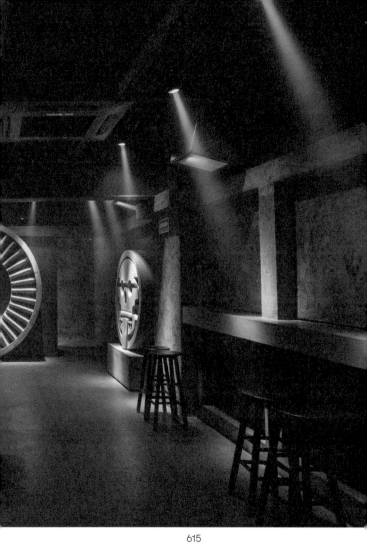

栖 ハビタット ⑦

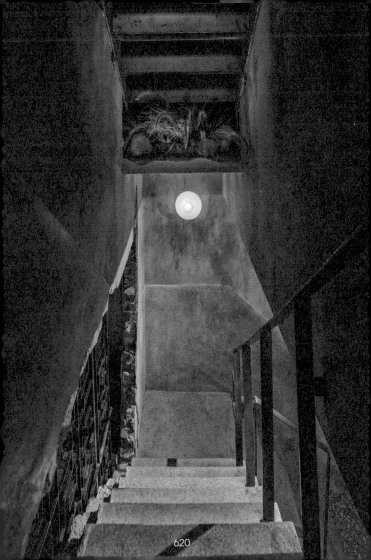

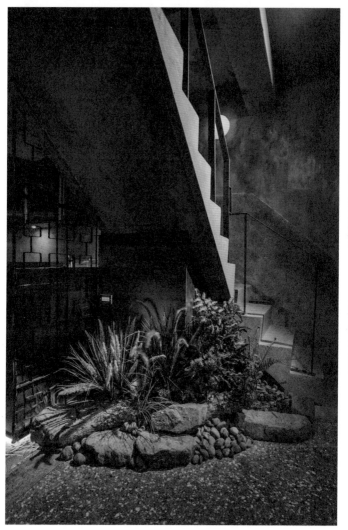

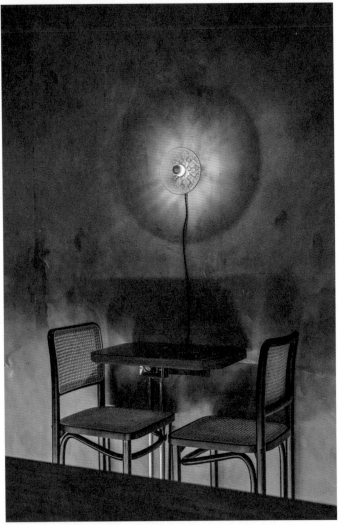

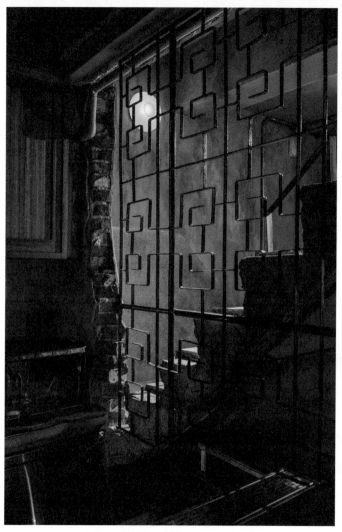

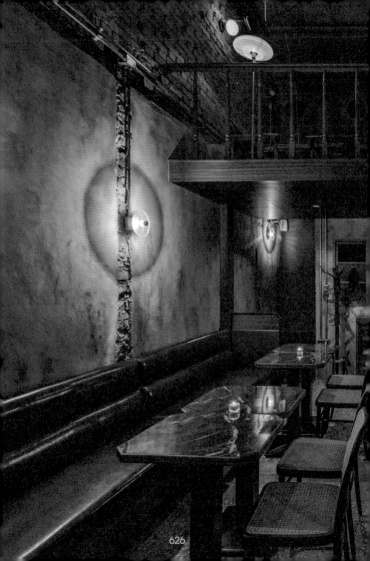

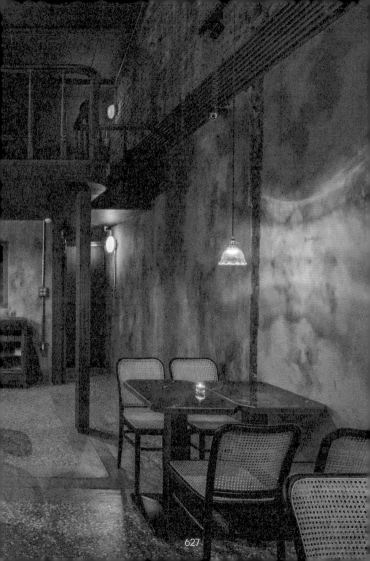

INDEX

BIOGRAPHY

Adam Goodison

adamgoodisonphotography.com

Adam Goodison is a still-life photographer based in London. Working with clients such as British Vogue, Martini, The Telegraph and Net-A-Porter, his lens brings a bold, playful approach to studio photography, using long shadows, layers and depth to tread the line between lived-in scenarios and composed set-ups.

PP. 566–575

Adam Lowe

adamlowedesign.com

Adam Lowe is a Brooklyn-based designer and art director focused on brand identity. He enjoys building complex systems that carry weight and feel worked, all while appearing simple in application.

PP. 074–081

ADC Studio

adcstudio.com.tw

Founded in 2001, ADC STUDIO has established strong and steady client relationships with a focus on branding and visual design in international fashion, beauty, F&B and retail. With design experience around the globe, the studio specialises in strategic planning, visual communications and marketing management.

PP. 306–309

Adn Studio
adnstudioo.com

Adn Studio was founded by Amr Elwan, a freelance art director and graphic designer working with startups, brands, and design agencies to bring new products to life and improve existing ones. Amr loves to create engaging experiences that are memorable for customers/users, leading to growth and profitability for clients.

PP. 328–329

Ana Patron Toffano
behance.net/AnaPatron

Ana Patron Toffano has been dedicating her work in branding and illustration for the past 6 years with a focus on the food and beverage industry. She is passionate about typography design, the outdoors and nature. Ana is also a Merit Award winner in the HOW International Design Awards in the branding category.

PP. 320–327

Anagrama
anagrama.com

Anagrama is an international branding firm specialising in the design of brands, objects, spaces, software, and multimedia. It thrives on breaking the traditional creative agency scheme by integrating multidisciplinary teams of creative and business experts.

PP. 612–617

ARCHIGRAPHIX DESIGN STUDIO

archigraphix.co

Archigraphix is an independent design studio specialising in branding, packaging, and graphic design founded by Gökçe Yiğit. She is a creative director, designer, and architect based in Istanbul. An admirer of modernism and simplicity, she desires to experiment these notions into her creations, always looking for new ideas and eager to create.

PP. 168–171

Ava Victoria

behance.net/avavictoria

Ava is a Dubai-based visual communicator who specialises in brand identity. She often integrates storytelling through-out her body of work spanning across corporate identities, print design and illustration.

PP. 138–143

B126Workshop

behance.net/b126worksh3fb7

B126Workshop designs with the aim to find the perfect balance between aesthetics and the needs of the people they work with.

PP. 286–289

Both

both.studio

Both is a branding and visual communication studio that
was co-founded by Sigiriya Brown and Dan Smith in Mel-
bourne. Its simple approach is driven by a genuine interest
in the people and companies with which it chooses to work,
leading to thoughtful and relevant design outcomes.

Bruch—Idee&Form

studiobruch.com

Bruch—Idee&Form is a nationally and internationally
awarded design studio based in Graz. They develop visual
design concepts and appropriate strategies for the fields
of branding, editorial design, packing and signage. In their
endeavors, they strive for flexible solutions, new approaches,
differentiation and authenticity.

Bureau Rabensteiner

bureaurabensteiner.at

Bureau Rabensteiner is a branding and graphic design
studio based in Innsbruck. They design everything from
brands to packaging for clients big and small. With strategic
thinking and meaningful designs, the studio has built an
international reputation for high-quality solutions.

by Futura

byfutura.com

by Futura is an internationally renowned creative studio characterised by its disruptive approach to design. Specialising in branding, art direction, and photography, the studio's vision consistently blurs the lines between different disciplines, paving the way to new forms of creativity.

PP. 580–587

Carmen Mitrotta

mitrottacarmen.com

Based in Milan, Carmen Mitrotta has always been attracted to the visual arts and devoted herself to painting at art school in Lecce. She then left painting behind to focus on photography. It was through studies of self-portraits and darkroom experiments that she was inspired to incorporate peculiar shapes and colours in her work.

PP. 554–555

Commission Studio

commission.studio

Commission is a London-based design and branding consultancy led by David McFarline and Christopher Moorby. Aiming to create beautiful and intelligent design, they work in print, packaging, editorial, advertising, and digital media, creating brand identity, graphic design, and art direction for the industries of fashion, art, culture, and commerce.

PP. 042–047

Darling Visual Communications
darling.sg

Darling is an interdisciplinary design consultancy firm based in Singapore established across the domains of branding, print, typography, website design, and spatial installations.

PP. 052–055, 082–087

Dialogue
haveadialogue.gr

Founded by Angelos Ntinas in 2018, Dialogue provides custom design solutions and communication consultancy to clients looking for work that goes beyond their expectations. Dialogue values intelligent and informed perspectives, which is supported through an intensive process of research, strategy development and collaboration networks.

PP. 232–235

Diogo Ferreira & Diogo Rosa
behance.net/DiogoCFerreira / behance.net/odiogoasrosa

Diogo Ferreira and Diogo Rosa are designers and art directors focused on art direction, brand and visual identities with the aim of creating impactful visual language for brands. Their design background allows them to have a general understanding of different design areas without technical or creative limitations.

PP. 370–375

Edith Rose Studio

edithrose.com.au

Edith Rose Studio aims to bring a high fashion aesthetic to the world of wedding and event stationery. Their work focuses on creating thoughtful design solutions that capture the clients' individual personalities. All pieces are handcrafted using letterpress and hot foil printing techniques.

PP. 110–113

Estudio Albino

estudioalbino.com

Estudio Albino is a creative studio specialising in the development of distinctive and strategic branding, strong graphic identity systems, compelling packaging experiences and visual communication consultancy. Estudio Albino is a concept of possibilities, just like a blank page from where ideas come to life.

PP. 202–207

FAENA Studio

faena-studio.org

FAENA is a graphic design studio specialising in communication and branding. Distinguished by linking brands with their audience, their work materialises concepts in projects with a solid and trascendent language. Their design approach is defined by a strategic development, an aesthetic and a deep understanding of language and communication.

PP. 216–221

Favorit&Co

stefanjandl.com

Favorit&Co is a small label for body and mind products in Zurich. A creative haven, full of people brimming with ideas and working with the best in the business to make them a reality. With their minimalist, pure and calm design language, the products are about moving out of the fast lane.

PP. 418–425

Fugitiva

fugitiva.co

Fugitiva is a design studio with a mission to design sustainabe and timeless brand identities that go beyond visual imagery. Composed of a small team of talented and passionate creatives, Fugitiva focuses on providing solutions for clients across sectors, while sharing unique stories that endure over time.

PP. 208–211

googoods design

googoodslife.com

googoods design was founded in 2012 with the belief that good things should be close to our daily lives. Their services range from product, graphics, brand image, exhibition planning, space design to large-scaled art installations. googoods is committed to building and advocating the right designs and providing the most suitable services for brands.

PP. 618–627

Gustavo Schlindwein Botelho / Estúdio Ally Fukumoto

gustavoschlindwein.com / allyfukumoto.com

Ally Fukumoto and Gustavo Schlindwein are designers and art directors based in São Paulo. Working mainly on visual identity and editorial projects for the fashion and culture industry, the designers aim to create authentic solutions, and provide opportunities for new talents.

PP. 184–187, 192–197

Henriquez Lara Estudio

henriquezlara.com

Henriquez Lara Estudio specialises on building brands from scratch through a combination of strategies, such as building emotional connections with the consumers of each project by aligning its positioning and personality traits. With that in mind, the studio uses various graphic techniques to develop powerful, coherent, and timeless brands.

PP. 240–247

Heydays

heydays.no

Heydays is a design studio aiming to remodel how technology and its aesthetics blend into our lives.

PP. 158–161, 198–201

House of Forme

houseofforme.com

House of Forme is a full service design and creative agency supporting the evolution of brands from initial concept to end user experience, through a narrative based holistic approach, designing compelling stories, systematic identities, immersive environments, and considered objects.

PP. 144-157, 462–467

Jens Nilsson

jens-nilsson.com

Jens Nilsson is a Stockholm-based, award-winning graphic designer, art director, and branding expert with over 10 years industry experience. He is the former art director at the Snask design agency and a 2004 Hyper Island alumnus.

PP. 468–473

Jingqi Fan

jingqi.work

Jingqi Fan is a graphic designer based in New York. Her work spans identity systems, art direction, and interactive design. She currently designs with COLLINS. Past experiences include Apple, Square, and Nikolas Type.

PP. 488–493

K9 Design

k9designstudio.com

Established by Kevin Lin, K9 Design's services span across brand identity, graphic packaging, and photography planning. The team is committed in providing clients with professional advice on the brand aesthetics, and creating design works that coexist with market trends.

PP. 290–293

Kaffeeform GmbH

kaffeeform.com

The German independently-owned brand transforms trash into beautiful and durable everyday objects. The company's journey started back in 2015 with a game-changing material using recycled coffee grounds. Committed to local and ethical production, Kaffeeform unwastes and reshapes with the environment in mind.

PP. 316–319

Karla Heredia design

karlaheredia.com

Karla Heredia is a designer who believes that design is a universal means of communication, and loves creating functional and attractive designs. She is always trying to find the best solution for every project by incorporating mixed techniques and looking for inspiration in culture, music, history, architecture and nature.

PP. 252–257

Kevin Nowak

kevinnowak.xxx

Kevin Nowak is an independent graphic designer and art director based in Vienna. Kevin's focus lies in creating clear designs and unusual brand experiences which he bases on research, practice, and collaborations with creatives from various other backgrounds.

PP. 258–269

LMNOP Creative

lmnopcreative.com

Founded by creative director Leigh Nelson, LMNOP is a woman-run and operated design studio that's all about merging strategy and magic. With rich experience in industry ops and attention to detail, every touchpoint is designed to impact the overall experience and the client's brand story.

PP 034–041, 458–461

Local Remote

localremote.co

Cofounded by Brian Liu, Local Remote is a design agency based in Taiwan creating the future of brand experience through innovative, immersive, experiential, and multi-sensory storytelling across virtual and physical platforms.

PP. 432–437

Lundgren+Lindqvist

lundgrenlindqvist.se

Lundgren+Lindqvist is a Swedish design studio led by Andreas Friberg Lundgren and Carl-Johan Lindqvist. Using a conceptually-driven approach, it has built an international reputation for crafting high-quality solutions. The duo also runs ll'Editions, a publishing platform and imprint for creative cross-disciplinary collaborations.

PP. 376–381, 484–487, 498–501, 506–515

Lyon & Lyon

lyonandlyon.co.uk

Lyon & Lyon is a design agency that creates extraordinary work for extraordinary people. Built and run by designers, it works closely with clients to craft innovative and engaging brand experiences, with creativity and fun at the heart of everything it does.

PP. 412–417

Masquespacio

masquespacio.com

Masquespacio is an award-winning creative consultancy founded by Ana Milena Hernández Palacios and Christophe Penasse. Combining interior design and marketing, it customises branding and interior solutions through a unique approach that results in fresh and innovative concepts for clients across the world.

PP. 596–611

Menta

menta.is

Menta is a graphic design studio that celebrates simplicity with a sip of nostalgia. Founded in 2008, Menta creates meaningful brand identities that balance classic and contemporary aesthetics. Through clear concept definition and careful craftswomanship, they aim for natural and ethically produced goals, with an ever-present focus on quality.

PP. 104–109

Miguel Moreira Design

miguelmoreira.com

Co-founder and Art Director of IM Collective, Miguel Moreira is a graphic designer with a background in architecture and a postgraduate in graphic and editorial design. Miguel Moreira has worked with clients in retail, editorial, culture, crafts, and sports. Miguel is also a renowned former athlete locally and internationally.

PP. 100–103

Mohamed Samir

behance.net/amado

Mohamed is a multidisciplinary designer and artist. Since 2014, he worked on multi-scale projects with teams in around the world. He has been recognised by several national and international awards varies between branding, typography, poster, and print design.

PP. 502–505

Mubien Brands

mubien.com

Mubien is a full-service branding studio focused on helping companies become fully themselves. It blends simplicity with sophistication to create elegant, powerful and timeless identities.

PP. 222–231

Nastya Didenko

behance.net/nastyadidenko

Nastya Didenko graduated from the National Academy of Fine Arts and Architecture in 2017. She co-founded artist-run space "Hlebzawod" in 2016 and began to work with food and fine art photography. She works with media such as painting, installation, photography and video, and is currently based in Kyiv.

PP. 556–565

Noance Studio

noancestudio.com

Noance Studio is a strategy, design, and brand communication consultancy focused on social impact and innovation. Its portfolio ranges from compelling brand identities, strategic tool kits of brand, and business development, and placemaking projects.

PP. 330–337

Nowak, Hofer und Karall

Kevin Nowak, Sebastian Hofer-Nonveiller and Max Karall
are a collective of 3 friends working in the fields of visual
communication. They are based in Vienna.

PP. 392–401

Objects & Ideas Inc
objectsandideas.com

Di Tao and Bob Dodd founded Objects & Ideas as a Canadian
design practice in 2015 in order to pursue a vision of a trans-
formative design process, one that could turn their unique
ideas and concepts for furniture and homeware into objects
of desire.

PP. 588–595

.Oddity Studio
odditystudio.com

.Oddity Studio are a new-wave team of Hong Kong-based
designers and developers driven by ideas that navigate
the creative process beyond trends and despite standards,
leading to an impactful outcome above all.

PP. 010–015, 056–061, 382–387

OlssønBarbieri
olssonbarbieri.com

Oslo-based independent studio OlssønBarbieri believes that there is a sustainable way to make products while empowering mindful consumers. Founded by Erika Barbieri and Henrik Olssøn, it works with all clients to manifest a unique blend of their Italian and Norwegian cultures with one eye on history and tradition, and the other looking ahead.

PP. 342–347

ōnō studio
onostudio.be

ōnō studio is a graphic design studio composed of Laura, Louise and Antoine. It offers creatively-driven design services focusing on sustainability for local and international projects. They take a human and personal approach for each project in order to help the client in the best way possible.

PP. 070–073

OVAL
oval.work

OVAL was established in 2005 in Kumamoto by freelance designer Takenori Sugimura, and engages in a wide range of graphic design.

PP. 426–431

Passport

wearepassport.com

Founded by Jonathan Finch and Rosalind Stoughton in 2012, Passport is an independent branding and design studio based in Leeds. Collaborating with businesses and individuals both locally and internationally to create thoughtful and effective visual identities, Passport delivers carefully-crafted, well-executed, and unique resolutions.

PP. 188–191, 354–357

Pengguin

pengguin.hk

Pengguin is a multi-disciplinary design studio in Hong Kong that focuses on visual communication, branding, editorial projects, spatial, exhibition, motion, and interactive design. It sets out to share different stories by triggering the chemistry between visual context and the media. The studio's work has been recognised and published internationally.

PP. 388–391

Private Visit

private-visit.com

Private Visit is a studio based in Taiwan making vintage-style skateboards with solid hardwood sourced from North America. It is inspired not only by skateboarding culture but also the philosophy of time, anthropology, history and folk arts.

PP. 530–535

Quatrième Étage

quatrieme-etage.com

Quatrième Étage is the collaborative design practice of Toulouse-based Ophélie Raynaud and Paris-based Valentin Porte. Together they offer creative and art direction, visual identity, graphic design, and website design services. Quatrième Étage is also known to experiment and inspire through self-initiated visual design projects.

PP. 062–069

Rafael Cardoso

rafael-cardoso.com

Rafael Cardoso is an independent graphic designer focused on brand identities and packaging, working with multiple clients worldwide.

PP. 088–093

Ryan Romanes Studio

ryanromanes.studio

Founded in 2016, Ryan Romanes Studio is an independent design and art direction studio based in Melbourne. They specialise in branding, campaign art direction, editorial design, and websites. Ryan's work has been recognised by numerous international award bodies and has been named one of Print Magazine's 15 under 30 "New Visual Artists".

PP. 132–137

Semiotik Design Agency (SDA)

semiotikdesign.com

Semiotik Design Agency was founded by Dimitris Koliadi-
mas in 2014. Dimitris and his team have collaborated with
exceptional brands and clients to provide a wide range of
design and consulting services, performing in complex
environments and achieving remarkable results.

PP. 408–411

Sergio Laskin Agency

sergiolaskin.com

Sergio Laskin Agency provides branding and marketing
services for industries such as food, real estate and more.
They partner with clients and elevate their brand value with
thoughtfully-designed experiences. Since forming in 2001,
the agency has remained at the forefront of technology and
implements tailored solutions with intentional outcomes.

PP. 310–315

Studio Bland

studiobland.com

Studio Bland is a local, purposely small, and progressive
design practice. Their process begins with a conversation
and mutual respect for client-studio relationships. With
over 25 years of collective industry experience, Studio Bland
prides themselves on adapting to and working on projects of
all sizes, enlivening brands with warmth and authenticity.

PP. 454–457

Studio Brave

studiobrave.com.au

Studio Brave is a branding and design studio based in Melbourne. For 20 years, Studio Brave has helped businesses transform and grow. Their determination to differentiate combines passion with purpose.

PP. 516–521

Studio Ingrid Picanyol

ingridpicanyol.com

Founded in 2014 and led by internationally award-winning creative director Ingrid Picanyol, the Barcelona-based studio works with clients and collaborators throughout the world with a team that deeply understands the client's needs to deliver a cohesive brand ecosystem; branding, packaging, photography and web design.

PP. 544–553

STUDIO JULY

STUDIOJULY.CO

July is an independent creation studio that challenges convention to stimulate growth, engagement and awareness through design, brand experiences and art direction. It celebrates individuality, people and spirit, the driving force behind their purpose to deliver significant work in the studio's ever-evolving culture.

PP. 180–183

Studio Miles

studiomiles.ca

Studio Miles is a graphic design studio located in Sherbrooke, Québec. Since 2017, they have been helping brands to quickly reach their full potential, designing creative, coherent and memorable visual solutions to maximise brand capital in any media. Through their co-creation process, the studio selects the best solutions for businesses.

PP. 402–407

Studio Project Noir

projetnoir.com

Studio Project Noir helps to change brands and businesses through their award-winning design and meticulous thinking. The studio concentrates on producing timeless designs and creative work that makes a difference.

PP. 358–361

Studio SPGD

sp-gd.com

Studio SPGD is a graphic design and visual communication studio based in Melbourne dedicated to fostering relationships with their clients. With a research-based process, conceptual development, and collaboration, the studio develops complete solutions for projects ranging from branding to interiors, copywriting, and fashion shoots.

PP. 016–019, 294–299

Studio Woork

studiowoork.com

Studio Woork is a design studio based in Jakarta, with services including branding, exhibition, print, product design, and also creative direction. With an independent mind, the studio constantly explores the boundaries of creativity in graphic design and experimenting with nature, humans, culture, and the environment.

PP. 120–125, 270–279, 438–453

STUDIO WORK

studiowork.com.au

STUDIO WORK is a full-service creative studio based in Gippsland. Led by Sarah Mangion, STUDIO WORK builds memorable work through elegant and minimalist design.

PP. 094–099

StudioPros

studiopros.design

Studio Pros is a design studio that focuses on branding, typography, and packaging design for both print and screen. The studio is led by art director Yi-Hsuan Li, a passionate, dedicated, award-winning designer who has worked with several international companies and events, such as Facebook, Shutterstock, and Helsinki Design Week.

PP. 362–369

StudioSmall

studiosmall.com

StudioSmall is a London based, multi-disciplinary consultancy that specialises in creative and strategic art direction across anything in print or digital media. Established in 2004, they have some 20+ years experience across fashion, design, lifestyle and luxury fields, with clients including Sunspel, Fred Perry, Begg x Co to name a few.

PP. 172–179, 348–353

SUMP DESIGN

sumpdesign.com

SUMP DESIGN is a full-service design studio that works in branding, packaging, and graphic design. Headed by creative drector Zi Huai Shen, the team is full of enthusiasm and eager to design the best work, striving to create positive impact and sustainable growth.

PP. 162–167

The Office of Ordinary Things (TOOOT)

ot.studio

The Office of Ordinary Things is a sustainability-focused, purpose-led design studio based in San Francisco. They only work with organisations that seek to benefit our earth and/or society, and create work with wit and whimsy.

PP. 494–497

Together Design

togetherdesign.co.uk

Together Design is an award-winning, London-based brand design agency founded by directors Katja Thielen and Heidi Lightfoot in 2003. Together Design specialises in bringing personality to brands, whether that is for creating new brands or repositioning existing ones. They help brands better connect with people.

PP. 474–479

Thomas Sturm

thomassturm.co

Thomas Sturm is an independent designer with a focus on branding and typography.

PP. 212–215

Untitled Macao

untitledmacao.com

Untitled Macao specialises in visual communications, graphic identities, and branding by dedicating themselves to tailoring and refining designs for clients. The international award-winning studio is frequently invited to participate in different exhibitions, with its works printed in many design publications as well.

PP. 300–305

Walk In The Park

walkintheparknz.com

Walk In The Park is a wood-working design studio founded by Woo-Lam (Sam) Choi, which produces both commercial and art objects by wood-turning. Each work pays homage to the variations of wood available. This tactile devotion extends into Sam's desire to create products that are beautiful and functional.

PP. 536–543

Yellowdot Design Ltd.

studioyellowdot.com

Yellowdot is an award-winning studio for product design and creative consultancy led by designers Bodin Hon and Dilara Kan. Founded in 2017, playfulness and optimism play a major role in the studio's projects, where stories are told and objects are brought to life through forms and materials that bring joy and surprise to the everyday.

PP. 576–579

Young & Laramore

yandl.com

Young & Laramore is an independent, full-service advertising agency in Indiana. Besides creative work that spans broadcast and digital media, mobile apps, as well as packaging and branding, its services include research and strategy, as well as multiplatform media planning and buying.

PP. 338–341

Zoo Studio

zoo.ad

At Zoo Studio, each and every one has different yet complementary educational backgrounds and professional experience. Their teamwork and the individual capacity of each team member allows Zoo Studio to work to extremely high standards with a constant spirit of surpassing expectations.

PP. 480–483

Acknowledgements

We would like to specially thank all the designers
and studios who are featured in this book for their
significant contribution towards its compilation.
We would also like to express our deepest gratitude
to our producers for their invaluable advice and
assistance throughout this project, as well as the
many professionals in the creative industry who were
generous with their insights, feedback, and time.
To those whose input was not specifically credited or
mentioned here, we truly appreciate your support.

Future Editions

If you wish to participate in viction:ary's future projects
and publications, please send your portfolio to:
we@victionary.com